Exploring Painting

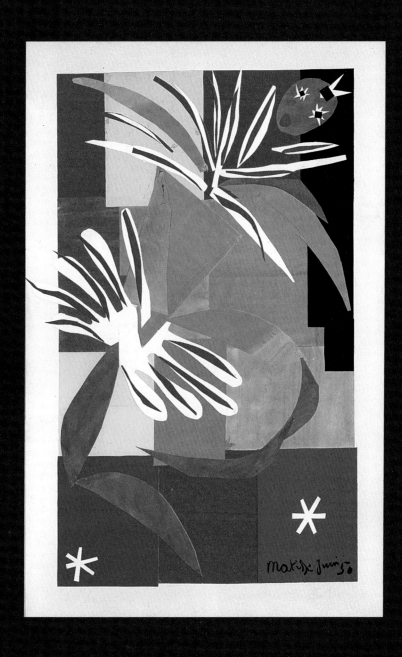

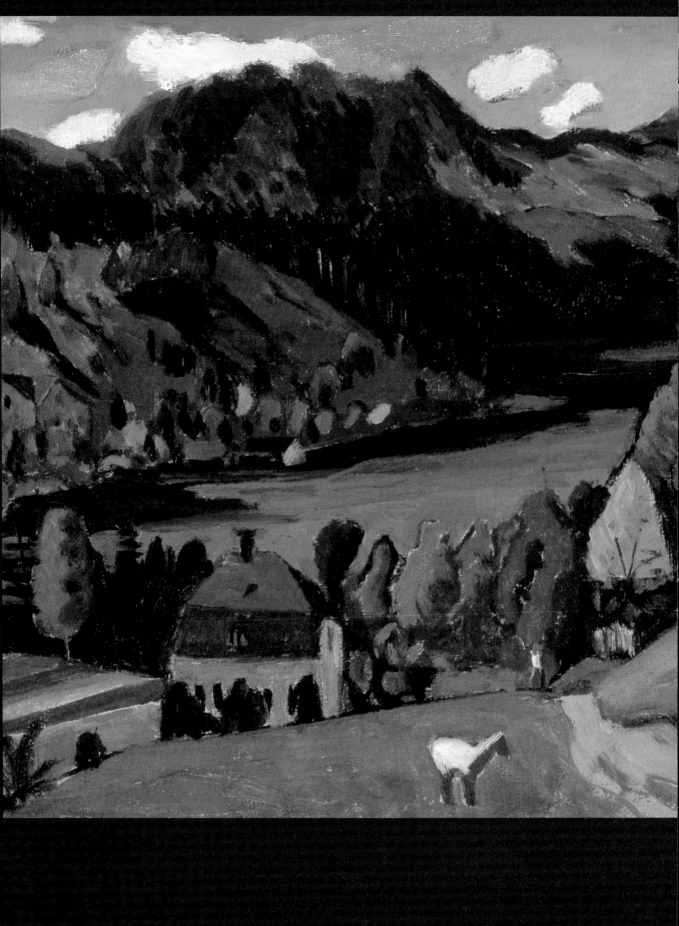

Exploring
PAINTING

Gerald F. Brommer
Nancy K. Kinne

Third Edition

Davis Publications, Inc.
Worcester, Massachusetts

Acknowledgments

Educational consultants

Numerous teachers and their students contributed artworks and writing to this book, often working within very tight timeframes. Davis Publications and the authors extend sincere thanks to:

Olene Albertson, Fairfax High School, Fairfax, VA; Janet Armentano, Holliston High School, Holliston, MA; Ken Austin, James Bowie High School, Austin, TX; Dale Baker, Eanes Independent School District, Austin, TX; Cathy Beck, Palisades High School, Kintnersville, PA; Jodee Burkett, Scripps Ranch High School, San Diego, CA; Kristen A. Clark, Marlboro High School, Marlboro, MA; Judy Conlon, Northbridge High School, Whitinsville, MA; Ray Dorosz, Floyd E. Kellam High School, Virginia Beach, VA; Kathleen Doyle, Boston, MA; Keith Farnsworth, Jerome High School, Jerome, ID; Connie Gallacher, Cox High School, Virginia Beach, VA; Mary Alice Gilley, Asheville High School, Asheville, NC; Linda Hatch, Snowden International High School, Boston, MA; Heather Henkes, Mission Bay High School, San Diego, CA; Marsha Hogue, Lake Highlands High School, Dallas, TX; Leon Hovsepian, Burncoat High School, Worcester, MA; Tim Hunt, Plano Sr. High School, Plano, TX; Cyndy Jensen, Mercer Island High School, Mercer Island, WA; Laura Kahler, Wheeler High School, North Stonington, CT; Robert Keller, Bellevue, NE; Susan Leavey, Marlboro High School, Marlboro, MA; Barbara Levine, Clarkstown High School North, New City, NY; Joan Maresh, George Washington Carver High School, Houston, TX; Louise Pierce, Drexel, PA; Alvin Quinones, Elizabeth, NJ; Katherine Richards, Bird School, East Walpole, MA; Fred Robert, Jasper High School, Jasper, IN; J. Roddy, Shrewsbury High School, Shrewsbury, MA; Jackie Rocker-Brown, Barringer High School, Newark, NJ; Dorothy Russell, Mission Bay High School, San Diego, CA; Merceda Saffron, West Springfield High School, Springfield, VA; Karen Skophammer, Manson Northwest Webster Community School, Barnum, IA; L. Spencer, Quabbin Regional High School, Barre, MA; Janice Truitt, Plano Sr. High School, Plano, TX; Sheri Tamte, Buffalo High School, Buffalo, MN; Harold Velline, Mission Bay High School, San Diego, CA; Pat Washburn, Chantilly, VA; Sharon Williams Welch, Whittier Regional Vocational Technical High School, Chester, NH; Charleen Wilcox, Wachusett Regional High School, Holden, MA; Christa Wise, Saugatuck High School, Saugatuck, MI; Frankie Worrell, Johnakin School, Marion, SC; Phil Young, Burlington High School, Burlington, MA.

Publisher:
Wyatt Wade

Editor-in-Chief:
Helen Ronan

Senior Editor:
Nancy Burnett

Contributing Editors:
Jennifer Childress, Karl Cole, Abby Remer, Kevin Supples, Mary Ellen Wilson

Content Specialist:
Kaye Passmore

Editorial assistance:
Jillian Johnstone

Design and Production:
Cara Joslin, Douglass Scott, Kathleen Hogan, WGBH Design

Production:
Victoria Hughes Waters

Index:
Florence Brodkey

Photo acquisitions:
Victoria Hughes Waters, Jillian Johnstone

Studio photography and direction:
Tom Fiorelli, Georgiana Rock, Kaye Passmore

Manufacturing:
Georgiana Rock

Image credits

Cover and Title: Gabrielle Münter (1877–1962). *Staffelsee in Autumn*, 1923. Oil on board, 13 ¾ x 19 ¼" (34.9 x 48.9 cm). The National Museum of Women in the Arts, Washington, DC. Gift of Wallace and Wilhelmina Holladay.

Half-title: Henri Matisse (1869–1954). *Creole Dancer*. Musée Matisse, Nice, France. Photo: Gerard Blot. Réunion des Musées Nationaux/Art Resource, NY. © 2002 Succession H. Matisse, Paris/Artists Rights Society (ARS), New York.

Table of Contents: Robert Carter, *Mornin' News #3* (detail), 2001. Mixed media, 65" x 39" (165.1 x 99 cm). Courtesy of the artist.

Charles Demuth, *Plums*, 1925. Watercolor and graphite on wove paper mounted on board, 18 ⅛" x 12" (46 x 30cm). Museum purchase, 1934.5. ©Addison Gallery of American Art, Phillips Academy, Andover, Massachusetts All Rights Reserved.

Christine Wright, *Kaleidoscope of Dreams*, 1998. Pen and ink, 16" x 16" (40.5 x 40.5 cm). Marlboro High School, Marlboro, Massachusetts.

Jane Smaldone, *If They Could See Her Now (My Chinese Daughter)*, 1997–98. Oil on canvas, 26 ¼" x 23" (67 x 58 cm). Nielsen Gallery, Boston. Photo by Susan Byrne, Brookline, Massachusetts.

Iza Wojcik, *Lonely Stairway*, 1996. Oil, 18" x 24" (46 x 61 cm). Lake Highlands High School, Dallas, Texas.

Kaitlin Carleton, *Birch*, 1999. Watercolor, 7 ½" x 13" (19 x 33 cm). Bird Middle School, Walpole, Massachusetts.

Wu Guanzhong, *Pine Spirit*, 1984. Chinese ink and color on paper. Spencer Museum of Art, University of Kansas, Lawrence. Museum purchase: Gift of E. Rhodes and Leona B. Carpenter Foundation.

"...Art is not a profession but the highest expression, the greatest necessity."

Lyonel Feininger (1871–1956)

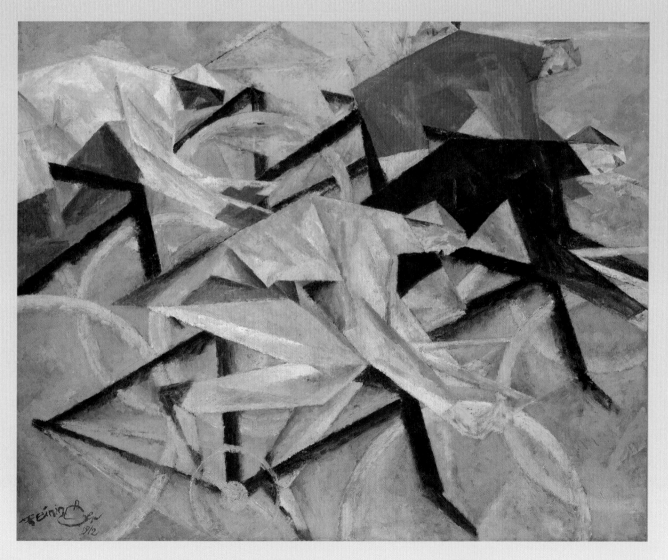

Lyonel Feininger (1871–1956). *The Bicycle Race*, 1912.
Oil on canvas, 31 ⅝ x 39 ½" (80 x 100 cm). National Gallery of Art, Washington. Collection of Mr. and Mrs. Paul Mellon. #1985.6417.

Contents

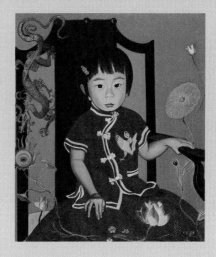

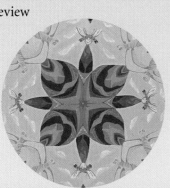

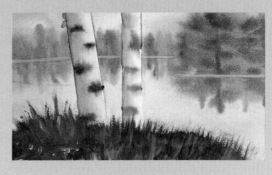

Owner's Manual for *Exploring Painting*

To get the most out of any tool it is valuable to understand its key features and intended uses. In detailing the unique design and features in this textbook, the following will help make *Exploring Painting* the most valuable tool in your painting studio.

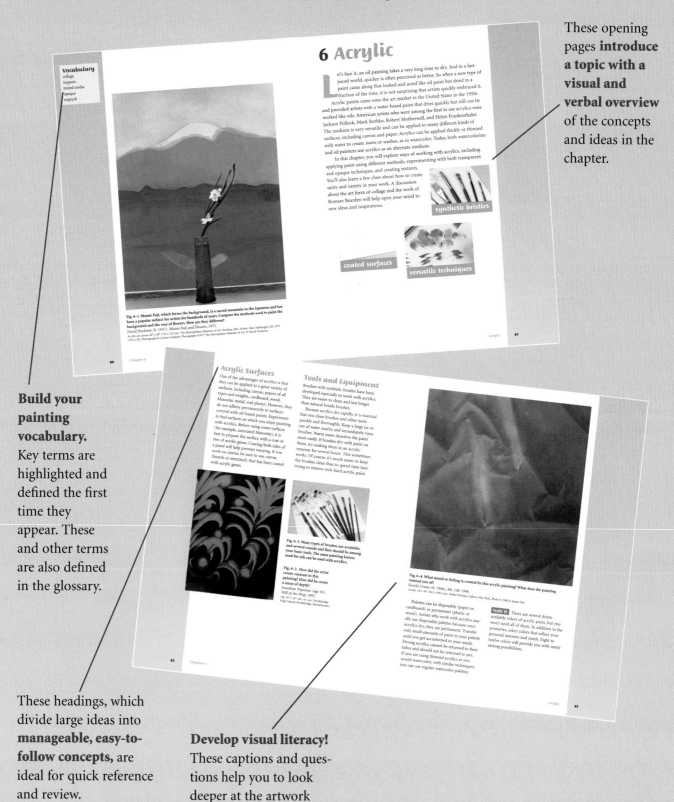

These opening pages introduce a topic with a visual and verbal overview of the concepts and ideas in the chapter.

Build your painting vocabulary. Key terms are highlighted and defined the first time they appear. These and other terms are also defined in the glossary.

These headings, which divide large ideas into **manageable, easy-to-follow concepts,** are ideal for quick reference and review.

Develop visual literacy! These captions and questions help you to look deeper at the artwork

Art is not made in a vacuum. These in-depth profiles **highlight the historical and cultural influences** that have shaped a work of art.

These illustrated, step-by-step studio guides will help you **master fundamental techniques and skills.**

Interviews with professional artists dispel the myth of "the poor starving artist" and set a course for a career in art.

Samples of student art in each studio-rich chapter encourage peer sharing and critique.

Don't miss the **illustrated History of Painting, exhibition tips,** and **glossary** in the **Student Handbook**

Denyse Thomasos, *Virtual Incarceration*, 1999.
Acrylic on canvas, 132" x 240" (335 x 610 cm). Lennon Weinberg, Inc., New York.

Part One

Getting into Painting

Vocabulary

communication
pigment
binder
solvent
vehicle
Photo-Realism
style

Fig. 1–1. The message expressed by this artwork is clear, both from the title of the work and the image itself. What other message, besides weariness from a day's work, does this painting communicate?

Jonathan Green (b. 1955), *Quitting Time*, 1990.

Oil on canvas, 72" x 55" (183 x 140 cm). Courtesy of Gary E. Gardner.

1 Painting Is Communication

A picture is worth a thousand words. This statement means that a single image can communicate in a moment something that it takes hours to describe in words. Do you agree?

Communication is a way of telling others about our thoughts, opinions, reactions, and feelings. Most of the time, people communicate verbally. But visual images are also a powerful way to communicate. How is communicating with words different from communicating with pictures?

Unlike reading a book, where your eyes focus on one word at a time, when you look at a painting, your eyes take in many impressions at once. And, most important, visual communication is universal. Although people speak and write in many different languages, pictures and images are easily understood almost anywhere in the world. Art is a direct, immediate, and universal language.

Creating your own paintings will give you the chance to reveal what you see, share something you think is unfair or unusual, record an important event, or alter the world to suit your own ideas. All you need is a brush, some paint, and your imagination. And with the additional help of this book, you will discover a variety of new ways to express yourself. You'll learn to search for ideas and to see things in your everyday world from a new viewpoint. Each chapter will introduce you to a painting medium or subject matter and help you create meaningful and successful artworks. Let's begin the exploration of your own personal artistic style.

seeing

style

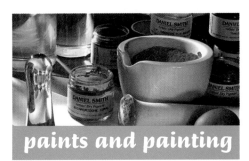
paints and painting

About Paints and Painting

What is painting, and why do people paint? Painting is the art of applying color to a surface. Painters use the language of art to express a personal point of view or a unique way of seeing the world. They are able to choose from a wide variety of media, including watercolors, tempera, acrylic, and oil, in their art-making. Their choice of media often depends on the message they are trying to send in their artwork.

All paints are composed of three ingredients: pigment, a binder, and a solvent. **Pigments** are the colored particles that give the paint its color. They may be made from natural ingredients, such as minerals, or manufactured using completely synthetic materials. Pigments are ground into fine, dry powders and mixed with a **binder,** a sticky substance that holds the pigment particles together. A liquid **solvent** is added to thin the mixture to a spreadable consistency. Together the binder and solvent make the **vehicle.** (See the chart on page 7.)

Other ingredients are often added to paint recipes. *Driers, extenders, wetting agents,* and preservatives may be required. Generally, the pigments used to make each type of paint are the same, with the recipes varying only in regard to binders and solvents.

The following is a simple chart to introduce you to many of the painting media available to artists. It can help you to compare them and understand some of their differences.

Note It Depending on the pigments used to make them, some paints are permanent, whereas others may fade in bright sunlight.

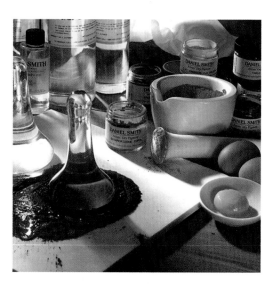

Fig. 1–2. It is important for manufacturers of artists' paint to use lightfast pigments, which prevent colors from fading.
Photo courtesy of the Daniel Smith Manufacturing, Seattle, Washington.

Fig. 1–3. After powdered pigment and water are mixed together, the mixture is ground with added liquid on a three-roll mill. Then the binder is added.
Photo courtesy of the Daniel Smith Manufacturing, Seattle, Washington.

Fig. 1–4. Many oil paints are very thick and are not easy to apply fluidly with a brush. Some artists like thick, textured brushstrokes. Others add more linseed oil to achieve a smoother look.

Karl Cole, *Forsythia*, 1998. Oil on canvas, 16" x 11" (40.6 x 27.9 cm). Courtesy of the artist.

Name of Paint	Vehicle	
	Binder	Usual Solvent
Watercolor (transparent)	Gum Arabic Solution	Water
Acrylic	Acrylic Polymer Emulsion	Water/Acrylic Medium
Gouache	Gum Arabic Solution	Water
Egg Tempera	Egg Yolk and Water Solution	Water
Tempera	Vegetable Glue and Water	Water
Pastel	Gum Tragicanth	
Oil	Linseed Oil	Turpentine/Mineral Spirits
Oil Pastel	Linseed Oil	Turpentine

The Search for Ideas

Art begins with ideas, and ideas do not always come easily. Before you start painting, you should have a plan, subject, or theme in mind. What do you wish to portray, explore, express, or communicate? When searching for subject matter, it helps to be able to see your environment in new and fresh ways—to forget what you think things look like and really experience colors, shapes, textures, and patterns.

The first thing to do is to relax and just enjoy looking. Observe what is around you and note its unique qualities. Look carefully to increase your visual sensitivity. Think about how you will communicate what you see. Don't dismiss a visual impression by

Fig. 1–5. This work's title, *Virtual Incarceration,* offers a clue to the artist's intended message. Do you agree that the complex web of modern communications is a kind of prison? Why or why not?
Denyse Thomasos (b. 1970), *Virtual Incarceration*, 1999.
Acrylic on canvas, 132" x 240" (335 x 610 cm). Lennon Weinberg, Inc., New York.

instantly attaching an old label to it. Open your mind to the ordinary and the familiar and put aside your long-established opinions. This refreshed attitude will allow you to find inspiration in a multitude of unexpected places.

Shape

Shape is a two-dimensional area created when real or implied lines meet and surround a space. In painting, artists create shapes using actual lines or by changes in color, value, pattern, or texture. They use shape to structure their composition. The main subject forms the positive shape; it is also called the figure. The background forms a negative shape, but you must train your eye to see it. Shapes also have visual impact in a painting. Precise geometric shapes have a hard feeling, whereas irregular, unique organic shapes create a softer effect.

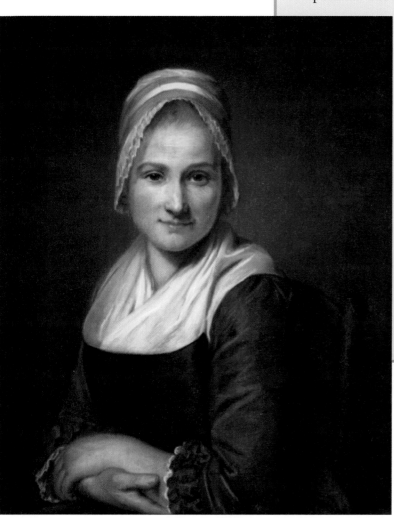

Fig. 1–6. Portraits often communicate subtle information about the sitter. From the poses and gestures to the expressions and clothing, an artist can convey the subject's personality, attitude, or nature. Marie-Genevieve Navarre (1737–95), *Portrait of a Young Woman,* 1774.
Pastel on paper, 24" x 19 ¼" (61 x 50.2 cm). The National Museum of Women in the Arts, Washington, DC. Gift of Wallace and Wilhelmina Holladay.

Learning to See

If you were to describe a tree in words, you could say that a tree has green leaves and a brown trunk and branches or that a tree can be an apple, oak, or palm. How are these verbal descriptions different from direct observation? If you actually look at a tree, you will note blue-greens, silver-greens, and yellow-greens. You can see dancing shapes that create a pattern of blotches against a blue background. The verbal description evokes a common, stereotyped image, but the visual impression can communicate much more about the unique aspects of the subject.

Look, as if for the first time, at things you usually pass by. Notice such simple, everyday things as chipped paint on a door or cracks in a sidewalk. Examine the center of a flower or an old, decayed tree stump. Study the surfaces of a piece of fruit or wood. And look closely at shadows, reflections, and highlights. Notice different styles of fabric, wrapping-paper designs, and the details of old buildings.

Time spent just looking is an important part of painting. What strikes you as unusual or exciting? Does something awe you with its beauty or amaze you with its

Fig. 1–7. For most of his career, this painter filled his gridlike compositions with simple, everyday symbols and objects. Among his favorites were fish, clock faces, and heart shapes. What do you think the symbols in this work are meant to communicate?
Joaquín Torres-Garcia (1874–1949), *Constructive Composition*, 1932.
Oil on board, 41 ½" x 29 ¹³⁄₁₆" (105 x 76 cm). Museum of Art, Rhode Island School of Design; The Nancy Sayles Day Collection of Twentieth-Century Latin American Art. Photography by Cathy Carver. © 2002 Artists Rights Society (ARS), New York/ADAGP, Paris.

Fig. 1–8. What "new" things do you see when you study this close-up image of an everyday object? How could you express these details in a painting?
Photo courtesy of Helen Ronan.

detail? Does a pleasing pattern or a startling color combination surprise or interest you? Be constantly aware. Keep a notebook or sketchbook of your observations or add them to a mental diary. You may even decide to take photographs or slides to remind you of things you have discovered with your "new" eyes.

Photo-Realism

Look at the artwork shown in Fig. 1–9. Did you think at first that it was a photograph? This amazingly detailed work is an example of **Photo-Realism**, an art movement based on creating paintings that are so minutely detailed and realistic that they look like photographs.

Artists began working in a photo-realistic style in the 1960s. The movement is also sometimes called New Realism and is related to Pop Art, because painters tend to use ordinary scenes and people for their subject matter. The works, which usually have no visible brushstrokes, can also be seen as a reaction to abstract and nonobjective works. Photo-Realist paintings display great skill in capturing difficult effects, including overlapping layers of transparent materials. They often seem to

convey little emotion; in fact, such works do communicate an intense interest in surfaces and textures as well as the pleasure of a highly organized composition.

Most Photo-Realist paintings are created from photographic images, and Richard Estes, whose work is shown in Fig. 1–9, works from his own photographs. His cityscapes are instantly recognizable and often feature views of New York or other cities, focusing on the streets and buildings of the urban environment.

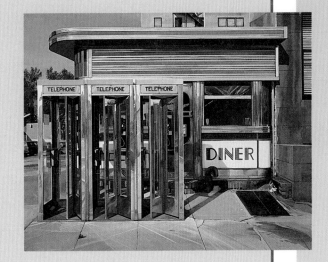

Fig. 1–9. Estes uses acrylic to first sketch his scenes on canvas and oil paint to capture the highly detailed surfaces. Although this diner actually exists on Tenth Street in New York City, the artist added the row of three phone booths.
Richard Estes (b. 1932), *Diner*, 1971.
Oil on canvas, 40 ⅛" x 50" (102 x 127 cm). Hirshhorn Museum and Sculpture Garden, Smithsonian Institution, Museum Purchase, 1977. Photo: Lee Stalsworth.

What Is Style?

What comes to mind when you hear the word *style*? Perhaps you think of the way a person dresses or how they act or behave. One of the definitions of style is "a distinctive manner of expression." How does this definition apply to art?

When discussing art, the term **style** refers to the distinctive and consistent similarities in a group of artworks, either those of an individual artist (individual style) or group of artists, or those from a particular place (cultural style) or time period (historical style).

An artist's individual style is like his or her voice; it is the way an artist communicates with the viewer. And, like a voice, an artist's style is both recognizable and unique. Artists develop their individual style while observing and reacting to the art of the past as well as the present. They are influenced not only by other artists but also by the culture and time period in which they live.

To determine if artworks share a common style, you must examine the way the artist has used the medium as well as the elements and principles of design. Let's use the artwork shown in Fig. 1–10 as an example. This work is immediately recognizable because of its style: the distinctive treatment of the figures, the use of flat shapes and patterns formed by the repeating symbols (the hieroglyphs), and the handling of the paint all clearly identify this work as Egyptian. Recognizing an artwork's style can help you to place it within a particular time period or geographic location; such information is valuable as you study art and learn to create artworks in your own style.

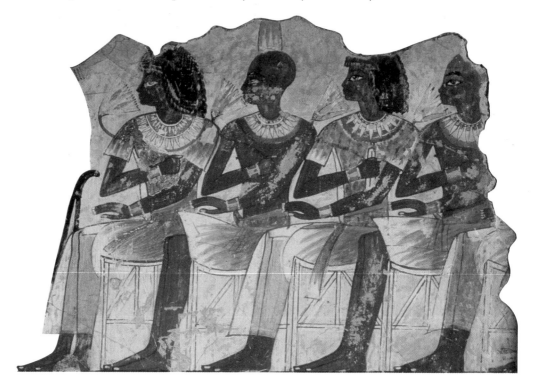

Fig. 1–10. This wall painting is an example of both cultural and historical styles. Compare the style of this painting to that of Fig. 1–11. How are they similar to and different from each other?
Thebes, Egypt, *Wall Painting from the Tomb of Nebamun,* 18th dynasty (1550–1295 BC).
Paint on dry plaster. © Werner Forman/Art Resource, NY. British Museum, London, Great Britain.

Form and Value

Form is a solid, three-dimensional mass. Painters create the illusion of form on a two-dimensional surface through the use of *value*—the range of light to dark tones of a particular color. They must think about where the light source is located and use that as a guide for placing the light values (highlights) and dark values (shadows) of the object. The subtle changes in value create the illusion that the object comes forward and recedes in space. It seems to have not only height and width, as a shape, but also depth.

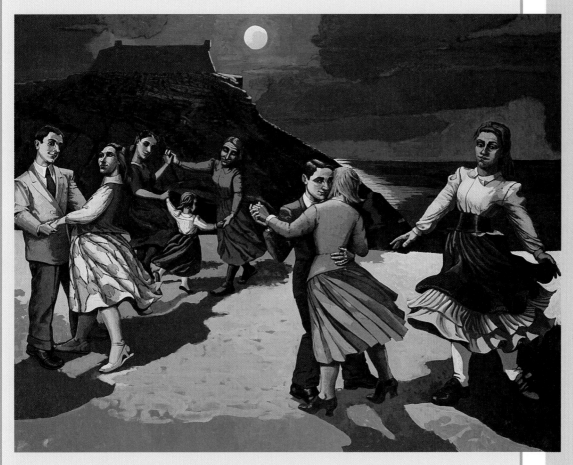

Fig. 1–11. In her paintings, the Portuguese artist Rego repeatedly depicts figures with large heads, stocky bodies, and solid legs. What makes her style distinctive?
Paula Rego (b. 1935), *The Dance*, 1988.
Acrylic on paper on canvas; 84" x 108" (213.3 x 274.3 cm). Tate Gallery, London.

Developing a Style

Painters develop an individual style after many years of working. If you look at the works of an artist who has pursued one medium for a long time, you'll probably see some similarities. He or she may repeatedly use similar subject matter or emphasize the same element of design. Individual styles can be difficult to describe, but you'll begin to recognize them the more you study paintings and other works of art.

Developing your own style may take a long time. As a beginning painter, you'll probably be most concerned with learning how to organize a composition, how to mix and combine colors, and how to use various materials effectively. But you'll find that the longer you paint, the more obvious your strengths and preferences will become. You may find that you are fascinated with lighting effects, or winter landscapes, or the depiction of motion or that you are drawn to distort your subjects so that shapes and spaces become much more abstract. Such choices will become clearer as you decide what to communicate through your art and how you can develop your style to best express your message.

Whatever form it takes, your style will evolve and develop as you continue to create works of art. In the meantime, experiment with a wide range of media, subject matter, and techniques. If you have a favorite painter, think about how to create your own work in his or her style. You can learn a lot by reproducing the effects that make that artist's work special.

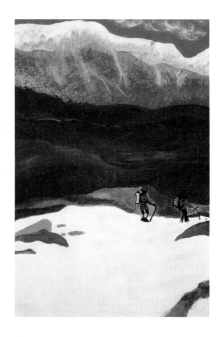

Fig. 1–12. How would you describe the style of this painting?
Brandon Griffin (age 16), *Untitled,* 2002.

Tempera on paper, 12" x 18" (30.5 x 45.7 cm). Mission Bay High School, San Diego, California.

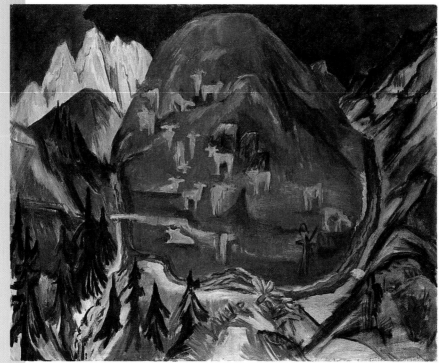

Fig. 1–13. Kirchner's style of using pure colors, sharp angles, and bold, rough brushwork often carries strong psychological undertones. What, do you think, was the artist trying to communicate in this landscape?
Ernst Kirchner (1880–1938), *Galtviehweide,* 1918.

Oil on canvas, 47" x 59" (120 x 150 cm). ©Visual Arts Library/Art Resource, NY. Private Collection.

Robert Carter

Art is a powerful means of communicating for Robert Carter, whether he is working in stage design, illustration, sculpture, or relief painting. He focuses primarily on the human body: "The figure is simply a joy to use as a vehicle. I find the figure a very special way to communicate. Figures are a conduit for an idea or concept."

Fig. 1–14. Robert Carter.
Photograph by Dave Green.

Carter states that he knew at age three that he would be an artist. His background made this an unusual choice—neither his family nor community was art-oriented. He felt blessed with parents who supported his interest and recalls: "Being the first to graduate from college, my family could have said, 'Look, I'll pay for you being a lawyer, an accountant, or a dentist. Art just doesn't make sense.' But I was always encouraged."

Carter's success is also tied to his fearlessness. After college and before graduate school, he accepted a job—without any prior experience—building sets at a television station in Louisville, Kentucky, becoming one of the first African Americans in the region to have such a responsibility.

The artist's first foray into fine art occurred when he created a painted fish from an old piece of weathered wood. He then began to put several pieces of wood together, creating figures. Today, Carter cuts or builds his images out of plywood. After the construction and layout, he paints both the back panel and the figures. The paintings provide a rich surface and also help integrate the real-life collage elements, which range from wallpaper for dresses to actual clotheslines and clothespins. Carter finishes by applying a coat of resin, which visually unifies the work by creating a uniform surface that reflects the light.

Fig. 1–15. An actual clothesline, clothespins, and fabric add to the realism of this artwork.
Robert Carter, *Mornin' News #3*, 2001.
Mixed media, 65" x 39" (165.1 x 99 cm). Courtesy of the artist.

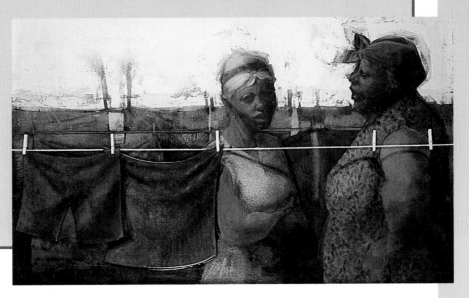

Studio Experience
Book Cover Design

In this studio experience, you will design a book cover for a favorite story or piece of writing. Think about illustrated books that you have read. How do the pictures help communicate information about the setting, time, and mood or atmosphere of a story? Although illustrators use many media, watercolor is one popular choice. It allows an artist to work quickly, and its bright colors create appealing illustrations.

Before You Begin

● At the local library or bookstore, look through a variety of illustrated children's books. What can you learn about the book just by glancing at the illustrations? Take notes about the examples that you find particularly interesting.

● Choose a favorite poem, short story, or book that does not already have illustrations. Think about what the writing communicates. What will be the subject of your illustration? What typeface will best communicate the idea of the story or poem?

Create It

1. Experiment with your subject by quickly drawing a group of small pencil sketches on sketch paper. Think about what shape your illustration will take. Will it fill the-

cover or part of the cover? Will it be a silhouette or contained within a box? Also think about whether your illustration will have a border or interact with the title type in some way.

2. Choose your best idea for the illustration. What information will it communicate about the time, place, or characters? Will it capture the mood or atmosphere of your selected poem or story? For a detective story, for example, perhaps emphasize shadows to communicate a sense of drama and mystery. Decide upon a size that will make it comfortable for you to paint the scene. Where will you place the title type? Make any necessary changes and adjustments to your sketch.

3. Select a piece of watercolor paper as the working surface for your finished painting. Create a detailed drawing on a piece of paper that is similar in size. Then lightly transfer your plan to the watercolor paper, making sure to work on the correct side of the watercolor paper.

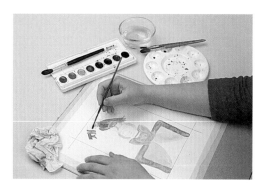

2 Fig. 1–17.

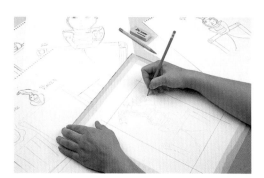

1 Fig. 1–16.

4. Begin your painting. Refer to page 74 for a demonstration of one possible water-color technique. If you choose to work with wet paint on a wet surface, first tape your paper to a flat board to prevent buckling and warping.

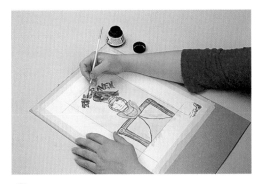

③ Fig. 1–18.

5. When your painting is dry, you may rework it or add lines and details with a fine brush. Add outlines, shading effects, and details with pen and ink.

Check It

Does your illustration and choice of type communicate information about your chosen poem or story, such as the setting, time, mood, events, or characters? Does your finished painting match your plan? Do you think you used the medium successfully? Explain. What did you learn from this project? What would you do differently the next time you create an illustration?

Sketchbook Connection

Draw several of your favorite objects that you might like to include in a painting. Study the objects carefully as you draw, noticing how light suggests the objects' texture and form.

Rubric: Studio Assessment

4	3	2	1
Idea Communication · Style of illustration · Subject of illustration · Choice of typeface			
Original style; final image shows great insight into literary tone. Sensitive, original, fresh	Original style; final image shows sensitivity to literary tone. Satisfactory, aligned	Illustration and type need further thought. Literary tone somewhat misunderstood. Some misinterpretation	Illustration and type need much more thought. Literary tone misunderstood or ignored. Major misinterpretation
Composition · Elements/Principles · Integration/Unity · Appeal			
Sophisticated integration of illustration and type. Unified and appealing. Advanced use of compositional device. Sophisticated, smooth, eye-catching	Full integration of illustration, type, and compositional device. Unified and appealing. Competent, appealing	Some disconnection between illustration and type. Compositional device attempted. Needs refinement	Extensive disconnection between illustration and type; OR one or the other not used. Fragmented, incomplete
Media Use · Drawing skills · Watercolor technique			
Composition fully planned. Expertly applied washes. Excellent brush technique. Abundance of realistic details. Skillful, controlled, appropriate	Adequate experimentation. Successful washes. Appropriate use of brush techniques. Sufficient realism. Skillful, appropriate	Insufficient practice. Inconsistent washes OR brush technique needs improvement. Realistic details underdeveloped. More practice indicated	Minimal planning. Uncontrolled washes; careless brush technique. Little attempt at realistic details. Rudimentary difficulties
Work Process · Research · Sketches · Reflection/Evaluation			
Thorough documentation; goes above and beyond assignment expectations. Thoughtful, thorough, independent	Complete documentation; meets assignment expectations. Meets expectations	Documentation is somewhat haphazard or incomplete. Incomplete, hit and miss	Documentation is minimal or very disorganized. Very incomplete

Web Links
www.getty.edu/ artsednet
View the kinds of lesson plans art teachers create, and much more.

www.d.umn.edu/ artedu/
Provides links to a variety of useful art education information and web sites.

Art Teacher/Artist
Debra Priestly

Born in 1961 in the small town of Springfield, Ohio, Debra Priestly didn't know any professional visual artists personally. She originally thought that being an art teacher was her only option. Working

Fig. 1–19. Debra Priestly with a student at The Cooper Union for the Advancement of Science and Art.
Photograph by Tony Gonzalez.

on her undergraduate degree at Ohio State University, Priestly realized she wanted to teach at the college level. To do so, she needed to be a working artist as well. After earning a Master of Fine Arts degree from Pratt University in New York, Priestly became a visiting artist and adjunct professor at various schools, until settling down in a full-time position at Queens College.

What attracted you to teaching?
Debra It's exciting to watch people discover things. They're already there, but you open their eyes in a different way to moments of new awareness. It's always rewarding, even if some aren't interested in

becoming professional artists. It's about broadening students' perceptions.

How is teaching at the college level different from working with younger students?
Debra In foundation courses, we're really focusing on building students' perceptions through, say, color, painting, drawing, and so on. But at the more advanced level, we're helping students to build their own personal vocabulary and also to learn about being a professional artist. With younger children, you're not trying to prepare them to be a professional artist.

What do colleges look for when hiring new faculty?
Debra They consider your teaching abilities and your exhibition track record—your commitment as a fine artist is examined more closely than when teaching younger students.

Do you think of yourself as a teacher and/or an artist?
Debra I see myself as both and take both quite seriously. Actually, it's important to see myself as a teacher, artist, and a student simultaneously. You have to have the same kind of attitude toward your own work that you want your students to have. Plus, when teaching, you always learn from your students.

I think teachers who do their own work are most beneficial to students. But it's a balancing act. What's great about teaching at the college level, however, is that during the summer and on breaks, you can focus on your own creative work and rejuvenate.

Fig. 1–20. Debra Priestly makes mixed-media objects, which incorporate painting, digital imagery, assemblage, and installation. What, do you think, is she trying to communicate with this artwork?
Debra Priestly, *Lookin Glass #4*, 1999.
Birch, pine, latex, acrylic, glass, brass, hair, and sweet pickles, 76" x 96" x 6" (193 x 243.8 x 15.2 cm). Courtesy of the artist.

Chapter Review

Recall Of what three ingredients are paints composed?

Understand Why is the search for ideas an important part of the artistic process?

Apply In a drawing or painting, use value to make a flat shape appear three-dimensional. For example, shade a circle to look like a sphere.

Analyze In what art style was *Diner* (Fig. 1–9) created? How is the painting typical of this style?

Synthesize How are paintings and writing alike? How are they different?

Evaluate Is the style of your illustration, or another work of art you have recently created, closer to that of Ernst Ludwig Kirchner (Fig. 1–13) or Richard Estes (Fig. 1–9)? Explain.

Fig. 1–21. Despite their small size, postage stamps can communicate a powerful message. What does this stamp design communicate about Norway?
Stine W. Kornmo, *Stamp of Norway*, 2002.
Tempera, 22 ½" x 14" (57.2 x 35.6 cm). Mission Bay High School, San Diego, California.

Portfolio Tip

How would you define art? In your opinion, what makes a work of art "good"? Write an artist's statement for your portfolio explaining your thoughts and beliefs about art. Occasionally review the statement to see if you have changed the way you think about art.

Writing about Art

Artists often strive to communicate enduring ideas. A painting that was created five hundred years ago sometimes can capture a viewer's imagination as easily today as it did when it was first painted.

Select two paintings that date before 1900 from any chapter in the text. Each should be from a different time period or culture but should communicate some common ideas. After examining the works carefully, write a short essay describing these common ideas and indicate why you think these paintings do or do not communicate as well today as they did in their time and place of origin.

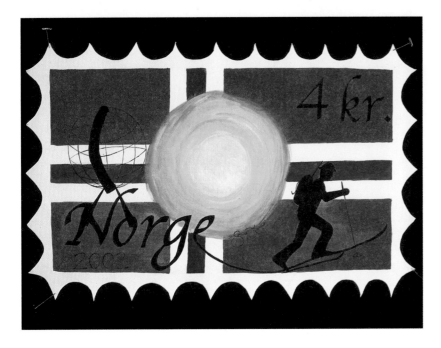

Fig. 2–1. How did the artist use line and color to create contrast in this painting?
Helen Frankenthaler (b. 1928). *Jacob's Ladder*, 1957.
Oil on unprimed canvas, 9' 5 ⅜" x 69 ⅞". Gift of Hyman N. Glickstein. (82.1960) Museum of Modern Art, New York, N.Y., U.S.A.
(c) The Museum of Modern Art/Licensed by SCALA.

2 Elements and Principles of Design

I f art is a language, what is its grammar or structure? To achieve your goals as a painter, you must understand the basic elements and principles of design. The elements and principles will help you to organize your paintings. They will give you the vocabulary you will need to talk about your art and your visual environment, and they can help you to more easily understand complex concepts.

The **elements of design**—*line, shape, form, space, color, value,* and *texture*—can be considered the "grammar"; they are the building blocks of art. When you study the world around you, you'll notice that these elements never appear by themselves. When you look at a geranium, for example, you see color (red and green), shape (the outline of leaves and flowers), line (the stem, the veins of the leaves), and texture (the smoothness of the petals or the furriness of the leaves).

The **principles of design** are like the rules of grammar; they form the guidelines that artists follow when they combine the various elements of design. These principles are *unity, variety, balance, contrast, emphasis, pattern, proportion,* and *movement* and *rhythm.* As with the elements of design, you see these principles everywhere—in the unity of a glass skyscraper, the pattern of a plaid scarf, or the movement of a flying bird. The principles of design are the structure that gives order to art and makes it understandable to the viewer.

elements

In this chapter, you will examine this basic vocabulary of art. Once you have studied each element and principle, you will use this visual language to create a mixed-media artwork.

principles

Line

Everywhere you look there are lines. In nature you can see the lines of tree branches, a spider's web, or a curving river. The manufactured world provides more examples: lines formed by wires, edges of buildings, and winding roads.

Lines can have many qualities. They can be curved or straight; vertical, horizontal, or diagonal; thick or thin; smooth or fuzzy; light or dark; and continuous or broken. In a painting, straight lines generally suggest directness and clarity, whereas curving lines imply gentleness and movement. Vertical and horizontal lines provide structure. Vertical lines can give a painting strength, whereas horizontal ones convey calmness and tranquility. Diagonal lines provide action and energy, just as a lightning bolt or a falling tree. When a line is very thick, it is strong and can almost be thought of as a shape. A thin line generally looks weak or delicate. Fuzzy lines have a softness about them, but smooth ones often denote harder surfaces. When repeated, lines can create textures, patterns, and even rhythms.

Lines can also be real or implied. A real line is one you can see. An *implied line* is the suggestion of a line. It exists when you see two objects that overlap—the shared edge of the objects functions as a line. An implied line may also be suggested by a string of objects, such as a series of footprints in the sand.

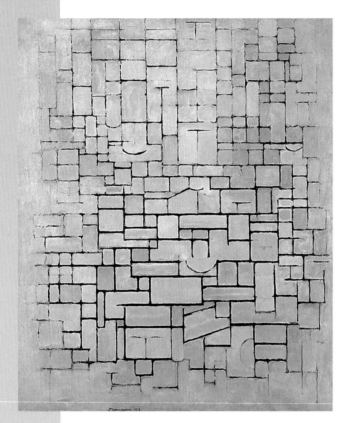

Fig. 2–2. In this painting, the Dutch artist Piet Mondrian carefully balances both horizontal and vertical black lines. The visible brushstrokes and subtle gradations of color add visual interest.
Piet Mondrian (1872–1944), *Composition No. 7 (Façade)*, 1914.

Oil on canvas, 47 ½" x 39 ⅞" (120.6 x 101.3 cm). Kimbell Art Museum, Fort Worth, Texas. Gift of the Burnett Foundation of Fort Worth in memory of Anne Burnett Tandy, 1983. Photo: Michael Bodycomb 1998. © 2002 Mondrian/Holtzman Trust, c/o Beeldrecht/Artists Rights Society (ARS), New York.

Fig. 2–3. The artist used bold, black lines to outline the geometric shapes in this work. What makes this use of line so effective?
Susan Vaclavik (age 18), *Collecting the Mice*, 1998.

Oil pastels, 20" x 24" (50.8 x 60.9 cm). Plano Senior High School, Plano, Texas.

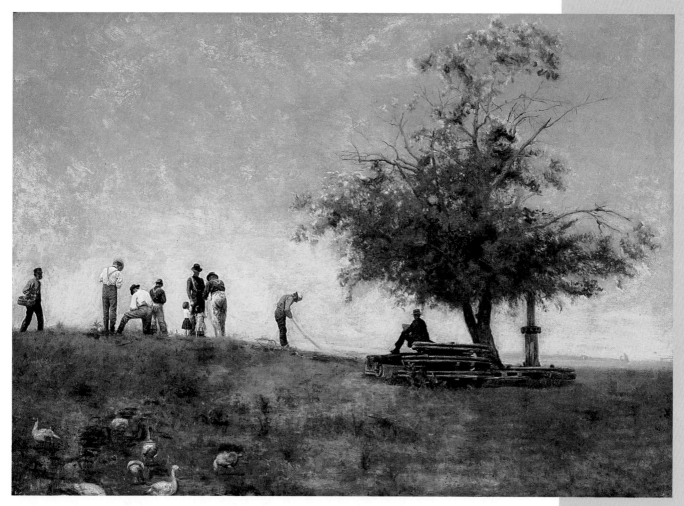

Fig. 2–4. How did the artist emphasize the relationship between the positive and negative shapes in this composition?
Thomas Eakins (1844–1916), *Mending the Net*, 1881.
Oil on canvas, 32 ⅛" x 45 ⅛" (82 x 115 cm). Philadelphia Museum of Art, Philadelphia.

Shape and Form

A two-dimensional shape is flat; it has height and width but no depth. Shapes can be either geometric or organic. *Geometric shapes*—circles, squares, or rectangles—are regular and precise. *Organic shapes,* on the other hand, are irregular. Plant leaves, seashells, and many manufactured objects all have organic shapes.

A painting is often made up of both positive and negative shapes. The positive shapes are usually the solid objects that the artist depicts, such as a vase of flowers or a seated figure. The negative shapes are formed by the areas around or between these objects.

A form is three-dimensional; it has height, width, and depth. Like shapes, forms can be regular and geometric or irregular and organic. Three-dimensional art, such as sculpture, architecture, and many crafts, is composed of forms. In painting and other two-dimensional art, artists can only create the illusion of form. (See page 13 for a discussion of techniques artists use to create the illusion of form in a painting.)

Space

In a painting, space is limited to the two-dimensional picture plane. You can make the space appear busy or full of movement by filling it with shapes, colors, lines, and textures. Or you can create a lonely or tranquil feeling by including only a few objects.

An artist can manipulate space in other ways, too. With the use of color or value, you can make objects appear to come forward or recede in space, and thus produce the illusion of depth. Shapes with clear surface detail seem more in focus and appear nearer to the observer than fuzzy, plain shapes. When objects overlap, those that are partially blocked seem farther back, as do objects placed higher up in a design. You can also use the system of **linear perspective**, in which parallel lines that recede toward a common vanishing point create the illusion of three-dimensional space on a two-dimensional surface. (See pages 161 and 165 for a further discussion of different types of perspective.)

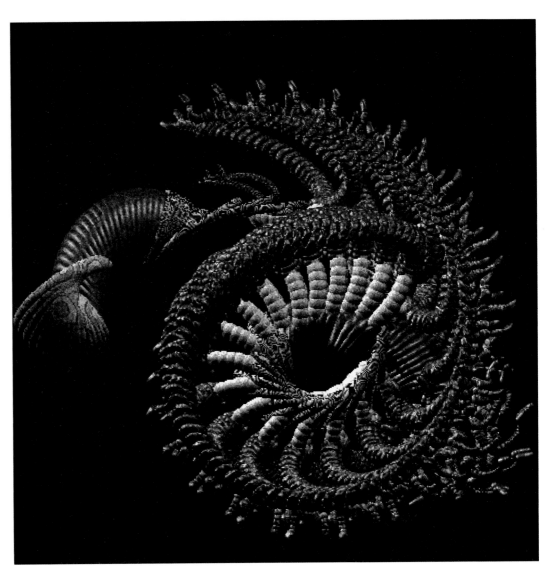

Fig. 2–5. How did the artist create a sense of space in this computer-generated image?
William Latham (b. 1961), *Untitled*, 1993.
Computer art. Photo: William Latham.

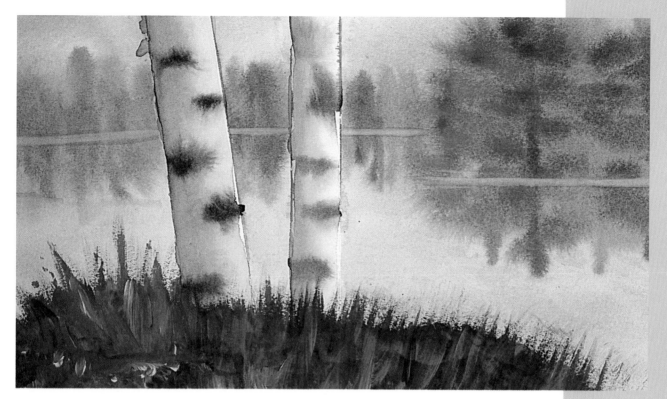

Fig. 2–6. How do the texture effects of this painting compare to those in Fig. 2–7?
Kaitlin Carleton (age 14), *Birch*, 1999.
Watercolor, 7 ½" x 13" (19 x 33 cm). Bird School, Walpole, Massachusetts.

The Surface Qualities of Color, Value, and Texture

Color and value can be combined with the elements of line, shape, and space to make things appear to recede or come forward, sink or rise, seem bigger or smaller, or appear dominant or weak. Just as line and the placement of shapes lead a viewer's eye around a painting, so areas of color can create a pathway that a viewer follows from one place to another.

Texture is the tactile quality of a surface, such as rough, smooth, sticky, soft, fuzzy, or slick. Like line, texture can be real or implied. A real texture is one that can be felt, such as a piece of sandpaper, a woven straw mat, or the fur of an animal. In a painting, real texture may be created through the use of thickly applied paint or by shiny smooth glazes. A fairly dry brush or a rough painting surface, such as burlap, can also create a textured effect. *Implied texture* is the illusion of texture created by an artist, such as the smooth water or prickly grasses shown in Fig. 2–6.

Now that you are aware of the basic elements of design, scan the artworks shown throughout this book to find examples of their use and combination.

Fig. 2–7. How did the artist create a strong sense of unity in this painting? Why, do you think, did he add the small, yellow tea bag label?
Peter Plamondon (b. 1939), *Still Life with Tea Bag*.
Acrylic on linen, 43" x 50" (109 x 127 cm). Chase Gallery, Boston.

Unity and Variety

Unity is a sense of cohesiveness, a feeling that all of the parts of something belong or work together. When parts of things are missing or obscured—for example, when some letters of a neon sign are burned out—a person often imagines the missing parts and sees the complete form. This effect is called forming closure.

Unity is important in a painting. A unified work looks complete and orderly; its meaning seems clear. There are many ways to create unity as you paint. A dominant theme, idea, or subject matter can unify a work, or a texture or repeated color can be the main attraction. Other ways of adding to a work's unity include repeating or overlapping lines or shapes, creating linear pathways that lead from object to object, or adding shadows to tie a group of objects together.

Variety generally accompanies unity in an artwork; it adds visual interest to a work by giving the eye different things to focus on. Artists create variety by including contrasting colors, shapes, textures, or other elements. As a painter, your challenge is to create a unified, visually exciting artwork that the viewer will want to look at again and again.

Balance

In design, there are three basic kinds of balance: symmetrical, asymmetrical, and radial. *Symmetrical balance,* or formal balance, occurs when one side of an object or painting is identical (or nearly so) to the other side. A human face, a butterfly, and the pattern of a Navajo blanket are all examples of symmetrical balance. Symmetry creates calmness and formality, but it can sometimes be visually uninteresting.

Asymmetrical balance, also called informal balance, occurs when the two sides of a design are balanced but different. Small objects farther from the center may balance large objects nearer to the middle. Or large areas of light color or value may balance small darker areas. You'll find that asymmetrical balance can be both subtle and exciting.

When a design exhibits radial balance, its parts spread out from the center. The spokes of a wheel are an example of radial balance. *Radial balance* is formal and symmetrical, and it often produces a graceful rhythm or a sense of turning.

Note It Take a closer look at some of the artworks in this chapter. How did the artists create a sense of balance in their paintings?

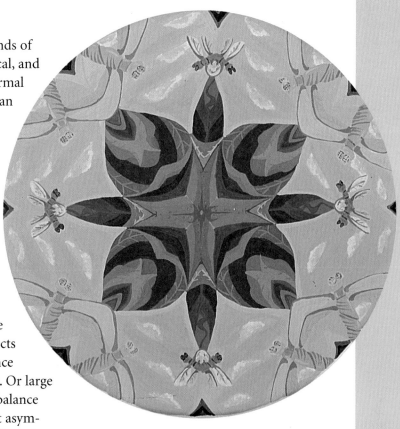

Fig. 2–9. This graceful artwork shows radial balance. How did the artist create a sense of unity? How did she show variety?
Christine Wright (age 16), *Kaleidoscope of Dreams,* 1998.
Pen and ink, 16" x 16" (40.5 x 40.5 cm). Marlboro High School, Marlboro, Massachusetts.

Fig. 2-8. What kind of balance has this artist created? What other elements and principles of design did she use?
Susan Briggs (b.1967), *Wynton 2,* 2001.
Watercolor on paper, 26" x 34" (66 x 86.4 cm).
Courtesy of the artist.

Contrast

The world around you is full of contrasts: a red flower on a green plant, a smooth pond surrounded by a rough shoreline, a fragile spider web attached to a sturdy fence post.

Contrast creates interest. If you find that your painting lacks variety, introducing a source of contrast can add the necessary visual interest. A strong contrast of light and dark will draw the viewer's attention to a particular part of the artwork. In addition to contrasts of light and dark, the jux-taposition of areas that are shiny and dull, bold and subtle, warm and cool, straight and curved, or plain and patterned will also create contrast. Almost every visual entity has its opposite.

Discuss It Where do you see contrast in the spaces around you? What other examples of contrast can you find in the paintings shown in this book?

Fig. 2–10. What are at least two different ways that this artist used contrast? What does the work communicate to you?
Catherine Murphy (b. 1946), *Eric*, 1990.
Oil on canvas, 37" x 29 ½" (94 x 75 cm). Courtesy Lennon Weinberg, Inc., New York.

Fig. 2–11. What is the artist emphasizing in this work? Where is the center of interest and how did the artist draw your eye to that part of the composition?
Jeri Rogher (age 18), *Speak to Me,* 1996.
Acrylic, 25" x 30" (63.5 x 76 cm). Lake Highlands School, Dallas, Texas.

Emphasis

In any painting, many elements and principles work together, but almost every successful painting emphasizes something. It may be a central idea that answers the question "What is this work about?" Or it may be a certain technique, mood, or style. One artist may feel that a sense of mystery is most important in his or her work. Another may value humor above all else and try to make that stand out in each painting.

Artists use emphasis to create a **center of interest**—the part of the work they want the viewer to notice first. Sometimes an artist chooses to emphasize a single element of design—color, line, texture, and so on—to create a center of interest. Another way artists create emphasis in a composition is by isolating the main subject from its surroundings. Making the subject matter the largest object and placing it in the center of the composition also creates a center of interest, as shown in the portrait *Eric* (Fig. 2–10).

Berthe Morisot

Study the painting shown in Fig. 2–12a. The everyday subject matter and loose brushwork were very different from what the French art academy favored at the time. In fact, the art critics of the day scorned the style and attacked such paintings for being unfinished and crude.

Two years after Berthe Morisot finished this work, she decided to join a group of artists whose paintings had been rejected by the organizers of the official French exhibition. The group, which included Paul Cézanne, Claude Monet, and Edgar Degas, decided to have their own show. They became known as the Impressionists, and their painting style is called **Impressionism**, named for the "impression" that the artists created as they tried to capture a quick, true glimpse of a subject. (The name was officially coined after the title of Monet's 1872 painting *Impression, Sunrise.*) Morisot helped to organize the Impressionists as a group and also supported them financially by buying works of other painters.

Morisot's family was wealthy; her father was a government official and also an amateur painter. Growing up, both she and her sister Edmé showed artistic talent. They began exhibiting together, and in 1868 Morisot met the French painter Edouard Manet. She modeled for Manet and became his student, and through him she was introduced to other painters working in Paris.

Morisot, who married Manet's brother in 1874, remained loyal to the Impressionist style even after some of the other painters had given it up. She continued to explore her favorite subjects—women, children, and domestic scenes, as seen in *The Cradle.*

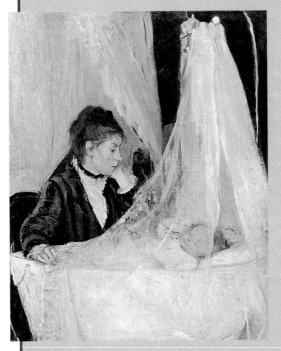

Fig. 2–12a. Notice how the artist balanced the sweeping diagonal line of the fabric with the implied diagonal line created by the mother's gaze toward the child's face. The model for the mother was one of Morisot's sisters.
Berthe Morisot (1841–1895), *The Cradle*, 1872.
Oil on canvas, 22" x 18" (56 x 46 cm). Copyright Réunion des Musées Nationaux/Art Resource, NY. Musée d'Orsay, Paris, France. Photo: R.G. Ojeda.

Fig. 2–12b. Edouard Manet (1832–1883), *Portrait of Berthe Morisot with a bouquet of violets*, 1872.
Oil on canvas, 16" x 20" (40.5 x 50.5 cm). Copyright Réunion des Musées Nationaux/Art Resource, NY. Musée d'Orsay, Paris, France. Photo: Hervé Lewandowski.

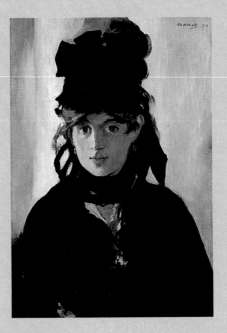

Pattern

Individual units or motifs repeated again and again produce a pattern. In nature, the hexagonal shapes in a honeycomb, the stripes of a zebra, and the petals of a daisy all form patterns. In the manufactured world, patterns can be found in the columns of a building, on a polka-dot tie, or in the rows of seats in a movie theater.

Many patterns are planned and precise, such as the geometric tread on a tire, but they may also be random, as seen in the scattered stars in the night sky or the small and large freckles on a face. In a painting, an artist can use various patterns to decorate shapes or to add texture to the entire surface. Or he or she may add a pattern to a small area to add visual interest or create contrast.

Discuss It Look for patterns around you. How do they change the appearance of objects and surfaces? Find examples of planned and random patterns in the paintings shown in this book.

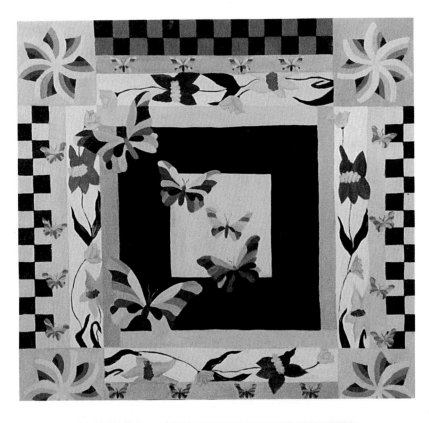

Fig. 2–13. Notice how the artist used several examples of geometric patterns, which help unify the work. How did she create contrast?
Alexandria Peterson (age 17), *Quilt with Butterflies*, 1996.
Acrylic, 24" x 24" (61 x 61 cm). Palisades High School, Kintersville, Pennsylvania.

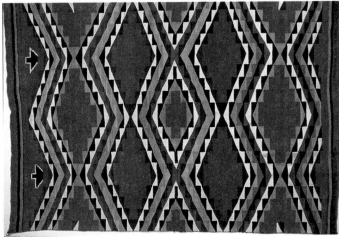

Fig. 2–14. Most Navajo rugs feature a regular pattern. What other patterns do you see in daily life?
Native America (Navajo), *Blanket*, Transitional Style, c. 1885–95.
Handspun wool, 92" x 62 ½" (234 x 159 cm). Private collection.

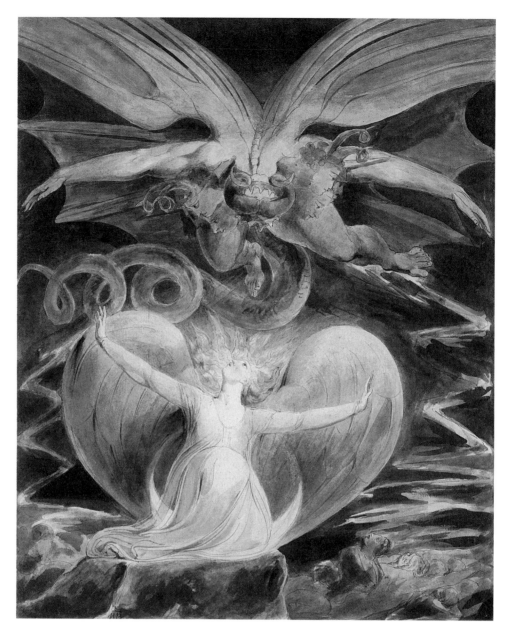

Fig. 2–15. Blake was an experimental British artist and writer, whose paintings were often created as illustrations for books. How did he use line and shape to add a sense of movement in this work?
William Blake (1757–1827), *The Great Red Dragon and the Woman Clothed with the Sun*, c. 1805.
From *Bible for Thomas Butts*. Pen and ink with watercolor over graphite, 16 1/16" x 13 1/4" (41 x 34 cm). Rosenwald Collection, Photograph © 2002 Board of Trustees, National Gallery of Art, Washington, DC.

Proportion

People share common, general proportions—that is, the size or placement of one body part in relation to another or to the whole body. When making a portrait, such as the one shown in Fig. 2–17, artists usually try to create figures that are accurately proportioned and realistic-looking.

In art, proportion is the relationship between the size of one part of the image to another part as well as to the whole. For example, a painting that is mostly green

with a tiny bit of red and yellow is said to have a small proportion of warm colors.

Scale is the relative size of one thing compared to the size of something similar, the environment, or the human figure. We view objects in terms of human scale, or how the size of the object relates to our size. A ten-foot-tall pencil would surprise us with its unusual scale. Artists often manipulate scale—by making objects larger or smaller than normal—but retain accurate proportions.

Movement and Rhythm

In a painting, movement may be the course that a viewer's eye takes as it moves across the surface. Moving from color to color, shape to shape, or value to value, the eye traces a path around the picture. An artist often adds elements—such as spirals, curves, arrowlike shapes, or diagonal lines—to convey a sense of movement. Such devices may direct the viewer's attention to the center of interest. In other cases, these elements may even lure the eye to move off the edge of the painting.

Rhythm is a pattern of movement caused by colors, shapes, values, and lines that occur in organized repetition. If the size, shape, or color of the repeated units is the same and if the distance between them remains constant, the rhythm is predictable and may even be monotonous. This type of rhythm is often seen in wrapping paper or on wallpaper. To add variety and visual excitement, an artist changes the size, color, or shape of the repeated units or varies the spacing between them.

Note It When you look at a painting, pay attention to how and where your eyes move. Do you find yourself stopping abruptly or gliding smoothly across the surface? When would an artist want eye movement to be smooth? When might jerky movement be appropriate?

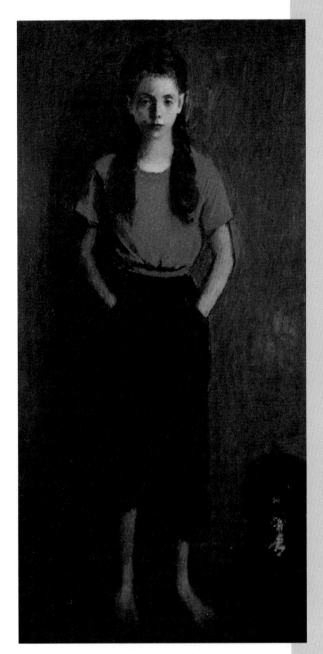

Fig. 2–17. Soyer painted many realistic portraits of family and friends. Here, he creates a sense of tension between the intimacy of the figure's gaze and pose and the isolation of her surroundings.
Raphael Soyer (1899–1987), *Portrait of a Young Girl,* c. 1946.
Oil on canvas, 59" x 29" (150 x 74 cm). ACA Galleries.

Fig. 2–16. This artist has used a variety of brushstrokes and repetition of shapes to create a sense of rhythm and movement.
Emilie Huysman (age 18), *Confusion,* 1998.
Watercolor, 9" x 9" (22.9 x 22.9 cm). Stonington High School, Pawcatuck, Connecticut.

Studio Experience
Mixed-Media Collage

Sometimes a painter chooses to recycle an old or unwanted work to create a new one. In this studio experience, you will reuse one of your own paintings to create a new mixed-media collage that has a center of interest, is balanced, and shows a strong sense of unity. Do you have a painting that wasn't a complete success or that you liked only part of? You can repaint part of a picture or reuse parts of a painting in a new composition. Available technologies for reproducing images—including a camera, photocopier, or scanner—can also help you to recycle a painting.

Before You Begin

● Choose one of your old, damaged, or discarded paintings done on paper. If you don't have one, use a photograph or large reproduction. Study the artwork. What is one strong point of the work? Is there a pattern, texture, color, or shape that you want to reuse as part of a new composition?

● Decide how you will reuse the artwork to make a new mixed-media collage. Will you use it as a background onto which you will add new materials? Or cut or tear it up and combine some (or all) of its pieces with other materials on a new work surface?

Create It

1. Draw a few quick sketches to help you explore ideas for reusing your artwork. Experiment with different ways to create a center of interest. Also think about possible ways to balance the composition. Jot down any ideas that you have for other materials or painting media.

2. Collect the materials that you will combine with your chosen artwork to create a new mixed-media work. Assemble a selection of fabric scraps, handmade papers, found materials, or pieces from a second

discarded artwork that was created using a different medium. If your original artwork will not be your work surface, select a new surface that is the appropriate size and weight for your plan. Also select an adhesive.

❶ Fig. 2–18.

3. Experiment with different ways of arranging your materials. Choose one or two pieces (or a group of pieces) to create the center of interest. How can you use other pieces or additional materials to help balance the composition? Remember: You can rework the collage later to strengthen the sense of unity.

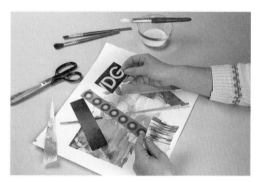

❷ Fig. 2–19.

4. Glue the collected materials onto your work surface, according to your plan. Apply

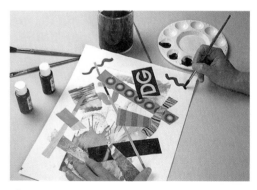

❸ Fig. 2–20.

a coat of glue to both your work surface and the collage paper. You may start at the upper left corner of your composition or glue down the larger pieces first. Use a stiff brush to smooth out any bubbles and to seal the surface.

5. When you have finished gluing down all of the pieces you plan to use, review the resulting composition. If your work doesn't convey a sense of unity, use another medium—such as tempera or pastel—to help you create a sense of harmony or connectedness. Be sure to choose a medium that is appropriate to the weight of your work surface.

Check It

How does your new mixed-media collage compare to your original painting? Does the new composition have a clear center of interest? Is the work balanced and unified? Explain. Did you use your chosen materials successfully? Are all pieces glued down neatly and securely? What did you learn from this project? Describe what you would do differently the next time you recycle an old painting.

Sketchbook Connection

Make a sketch of your completed collage with pencil. Use light and dark values to show textures and contrasts. How does changing the medium of your artwork change its meaning?

Rubric: Studio Assessment

4	3	2	1
Composition · Center of interest · Balance · Unity			
Solidly balanced with easily identifiable center of interest. Strongly unified atypical solution. Fluent, interesting, unusual	Balanced with identifiable center of interest. Achieves unity. Satisfactory, pleasing	Somewhat balanced, recognizable center of interest; approaches unity. Needs refinement	Inconsistency in achieving balance and unity, center of interest unclear. Fragmented
Media Use · Range of mixed media selected · Recycles older artwork · Collage technique			
Excellent reuse of older painting. Well-chosen materials expertly glued. Effective use of additional media. Skillful, controlled, appropriate	Appropriate selection of materials, reuse of older painting. Few mistakes using glue. Competent use of additional media. Competent, appropriate	Insufficient use of materials OR materials haphazardly glued. Older painting not well integrated. Inconsistent use of additional media. More practice indicated	Poor selection of materials. Unsatisfactory reuse of older painting. Careless technique. Rudimentary difficulties
Work Process · Brainstorming · Sketches · Reflection/Evaluation			
Thorough documentation; goes above and beyond assignment expectations. Thoughtful, thorough, independent	Complete documentation; meets assignment expectations. Meets expectations	Documentation is somewhat haphazard or incomplete. Incomplete, hit and miss	Documentation is minimal or very disorganized. Very incomplete

Theatrical Scenic Designer
John Lee Beatty

In the first grade, **John Lee Beatty** (b. 1948) saw the play *Peter Pan* and returned home knowing that he wanted to design scenery. Years later at Brown University, Beatty majored in English and minored in studio art, and he later earned a

Master of Fine Arts degree from Yale School of Drama. Today, Beatty works as a theatrical scenic designer, a career that satisfies his fascination with both literature and art.

Fig. 2–21. John Lee Beatty.

You worked as a director, actor, and scenic and costume designer in your formative years. When did you select theatrical scenic design?

John In my first year of graduate school, I studied with a working scenic designer who wasn't starving to death. I realized that this was actually a career. But there's a lot of overlap. As a designer, I do what an actor does on stage—interpret the material—but I clearly have different skills.

Take us through the design process.

John A producer hires me, and I read through the show, first as a work of literature, then thinking about design. The director and I discuss ideas and interpretations as well logistical issues, like how actors will enter and exit the stage.

After more meetings, I do ground (floor) plans and pencil sketches, honing the design. For the final rendering, I work with tempera, gouache, acrylics, pen and ink, or watercolors, depending on the feeling and color the show will reflect.

The director, the producer, and sometimes the show's author see this final, full-color painting. Of course, it's not really "final," because the painting has to be translated into technical drawings (similar to architectural drawings, with measurements, to scale, and so on). Ultimately, scenic painters complete the work, bringing the vision to the stage.

How do you use the elements and principles of design?

John Theatrical design is driven by the performer, whom you are supporting. Issues of scale are how big the scenery should be in relationship to the actor and to the theater environment. Then you make choices—both intellectually and instinctively—about what it should look like. And color is about activating surfaces according to what feels right—after a lot of thinking and reading of the play.

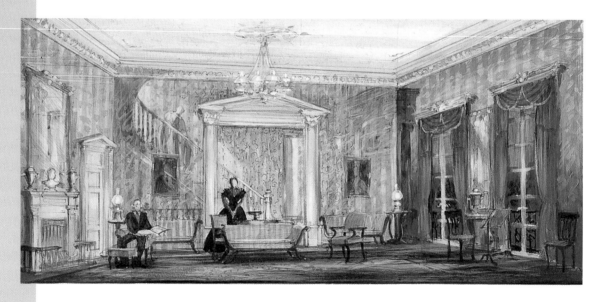

Chapter Review

Recall List the elements and principles of design.

Understand For each element of design give an example of something that you have seen in nature that features that element. For example, grass stems often look like straight lines.

Apply Draw a symmetrically-balanced design and then a similar design with asymmetrical balance.

Analyze How did student artist Julie Gunnin emphasize her center of interest in *Nesting* (Fig. 2–23)?

Synthesize Create a poster illustrating each of the art elements and principles. You may draw and paint some examples, as well as use copies or scans of artworks.

Evaluate In *Jacob's Ladder* by Helen Frankenthaler (Fig. 2–1), what elements did the artist select to create variety in her work? In your opinion, do the selected elements work? Could the artist have used another element successfully? Why or why not?

Portfolio Tip

Create a personal portfolio in which to save examples of your art. Tape two sheets of posterboard together. On the front cover create a design that features your name. This might be in a heraldic crest, a radial design, or your name written in an unusual way. If your name is hard to read in the design, print it again clearly on your portfolio cover.

Writing about Art

We can see everyday things from a new perspective if we consider them in terms of the elements and principles of design. Select a human-made object that you carry with you or use every day. Write a descriptive paragraph (don't mention its name) using the terminology of the elements and principles of design. Include as many of the elements and principles as possible. Do the same for a natural object that you encounter in daily life. While making these observations consider why it would be important for artists to engage in this kind of careful looking.

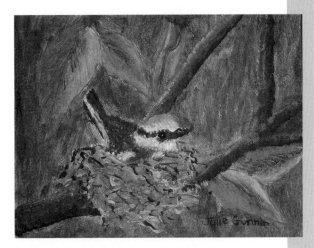

Fig. 2–23. What elements and principles of design has this artist used? What features from nature do you think influenced her choices?
Julie Gunnin (age 14), *Nesting*, 1999.
Acrylic, Johnakin School, Marion, South Carolina.

Fig. 2–22. A set shouldn't draw audience attention away from the play. In some ways, a good scenic design is similar to a painting, and the performers, action, and dialogue are the center of interest.
John Lee Beatty, *The Heiress*.
Rendering. Courtesy the artist.

intensity
value contrast
color contrast
illuminated
 manuscript
monochromatic
analogous

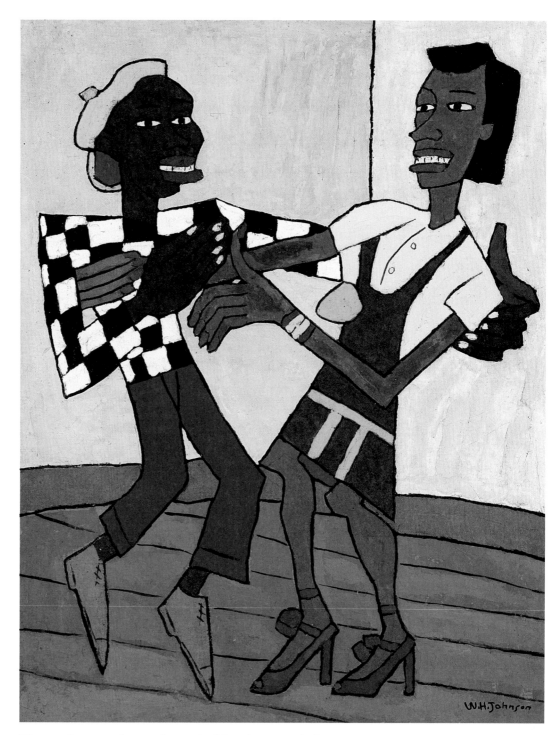

Fig. 3-1. Compare the two figures in this painting with those in Fig. 3–11. Describe the way these dancers are painted.

William H. Johnson (1901–1970), *Jitterbugs I*, 1940–41.

Oil on plywood, 39" x 31" (101 x 79 cm). © Smithsonian American Art Museum, Washington, DC/Art Resource, NY. Smithsonian American Art Museum, Washington, DC.

3 Working with Color

Imagine yourself in a dark room. There is no light. You cannot see where the floor ends and the wall begins. You may be able to make out shapes or forms, but they are shrouded in blackness. You have just imagined a world without color. Is this world one that you would want to live in?

Fortunately, there is light, and with light comes color. In fact, for most of us, color is everywhere. Trees, flowers, and sky create a colorful background. Bright clothes attract our attention, billboards make us look twice, and magazines and web sites bombard us with statements in color.

There are literally thousands of colors—from brilliant to dull, pastel to dark. Colors are powerful; they can make objects in a picture seem to glow, to come forward or recede, to appear bigger or smaller. Colors can also be symbolic, with meanings that change from culture to culture. A color may symbolize an object or thing, such as blue for water or green for the earth. Or it may symbolize an emotion or idea, such as red for love, yellow for fear, blue for sadness. A trained artist is familiar with all of these magical options. He or she can select and combine colors to successfully create a desired impression or to evoke a certain mood.

In this chapter, you will learn how to choose, eliminate, mix, and combine colors. This knowledge will enable you to use color to create the effects you want in a painting.

color wheel

theory

schemes

Color Theory

Color, as you probably know, is a property of light. When we say an object is red, we mean that its surface absorbs certain wavelengths of light and reflects others. If our eyes see only the long wavelengths that we call red, we identify the object as being red in color. If all wavelengths of light are absorbed, we identify the object as black; if all wavelengths are reflected, we see a white object.

When we talk about color, we are concerned with three basic variables, or characteristics: *hue, value,* and *intensity.* These words help make talking about color easier and clearer. Hue is the color we see—red, for example. Value is the relative lightness or darkness of that color; for example, maroon is a dark value of red, and pink is a light value. **Intensity** is the brightness of the color. Some reds are bright and clear, whereas others appear muddy or dull. You'll know an intense red when you see one. But try not to confuse intensity with value, or lightness and darkness with brightness and dullness. A light value of red can be less intense or less bright than a dark one and vice versa (Fig. 3–2).

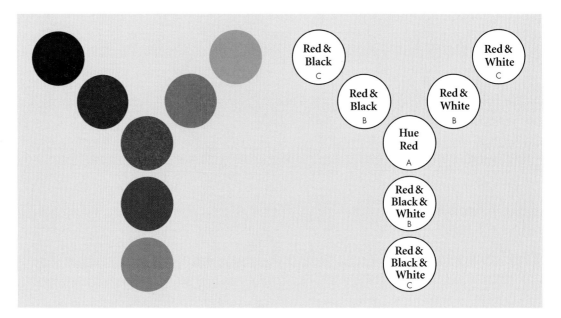

Fig. 3–2. This chart shows the difference between value and intensity. The lowest circle shows a light value of red with the lowest intensity in this chart. Can you see how the red circle in the center is darker in value, yet brighter in intensity, than the lowest circle?

And The Real Primary Colors Are...

Before we can determine what the real primaries are, we need to understand that *different kinds of art media have different primaries.* Each system has its own set of primary colors, as pigments operate differently when used in different mediums. Pigments may also look different on different backgrounds. One key thing to remember is that, regardless of what the theories propose, pureness of pigment and the quality and composition of art materials play a large role in how colors REALLY mix. Theories are valuable guides to color mixing, but *nothing substitutes for actual experimentation.*

Fig. 3–3. A color wheel displays the colors of the visible spectrum—red, orange, yellow, green, blue, and violet—in a circle.

The Color Wheel

In other art classes, you may have encountered the color wheel (Fig. 3–3), which is one system of organizing and classifying colors. The colors around the rim of this wheel are hues. Red, yellow, and blue are the *primary colors*. These three colors are used to mix all other hues. Mixing two primary colors—red and yellow, for example—creates what is known as a *secondary color*, in this case orange. Mixing a primary color (red) with a secondary color (orange) creates red-orange, which is an intermediate color.

Colors located across from each other on a color wheel are called *complementary colors*. Red and green are complementary colors, as are blue and orange. Artists often pair such colors in a painting because the line where complementary colors meet seems to vibrate. If you mix complementary colors, you can create a neutral gray color. You can also lessen the intensity of a color by adding a small amount of its complement.

Try It Magenta (a bright, cool pinkish red), yellow, and cyan can serve as the primary colors for an alternative color wheel. Even though the results are theoretically the same, the secondary colors produced from this wheel (orange, green, and violet) are often brighter.

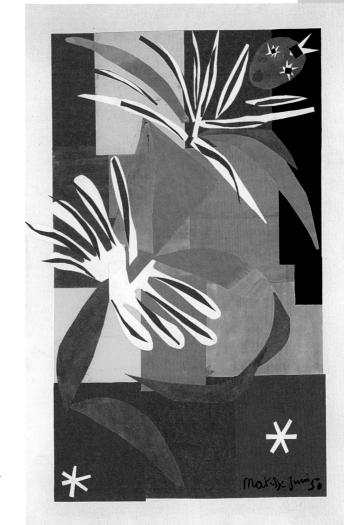

Fig. 3–4. The artist Matisse is known for his combinations of vibrant colors. What effect do the colors in this work create?
Henri Matisse (1869–1954), *Creole Dancer*, 1951.
Cut-up gouache, Musée Matisse, Nice, France. Photo: Gerard Blot. Réunion des Musées Nationaux/Art Resource, NY. © 2002 Succession H. Matisse, Paris/Artists Rights Society (ARS), New York.

Tints and Shades

When white is added to a hue, the resulting color is called a *tint*. For example, pink is the tint that results when white is mixed with red. Peach is a tint achieved by adding white to orange. Adding white also lowers the intensity of a hue.

Adding black to a hue produces a *shade*. Navy blue is a shade of blue, and maroon is a shade of red. Shades tend to come forward in a picture. They make objects look bigger and appear closer to the viewer. Tints, on the other hand, tend to recede or go back in a picture. They make objects look hazy and distant.

When you alter a color by making it lighter or darker, you are changing its value. As you'll recall, value is the relative lightness or darkness of a color. In order to compare values, it is helpful to look at a black-and-white value scale, such as the one shown in Fig. 3–5. A color value scale, such as the one shown in Fig. 3–6, is a column of colors produced from one hue.

Note It To help you identify colors of the same value, try to imagine how the colors would look if you photographed them in black and white. Would they be a similar shade of gray? Squint at the colors. Do they seem to have a similar amount of light reflected from them?

Fig. 3–5. The values in this scale range from white (high value) to black (low value), with gray values in the middle.

Fig. 3–6. In this color value scale, the tints appear above the central hue, and the shades appear below.

Fig. 3–7. This artist has explored some of the powerful effects that color can create. What is the color scheme?
Rebecca Carson (age 17), *Blue Night Out,* 1997.
Oil, 18" x 24" (46 x 61 cm). Lake Highlands High School, Dallas, Texas.

Warm and Cool Colors

Have you ever noticed that colors seem to have different temperatures? Reds, oranges, and yellows are *warm colors.* They remind us of fire or the sun and can add a feeling of excitement, boldness, or happiness to a painting. Warm colors make objects seem larger and appear to come forward in an artwork.

Greens, blues, and violets are *cool colors.* They are reminiscent of lakes, distant mountains, sky, and foliage. Cool colors tend to be calm and restful. They recede into the distance and make objects seem smaller.

Yellow-green and red-violet can function as either warm or cool colors because they contain elements of both. In a blue and green painting, yellow-green or red-violet would add some warmth. In a color scheme of warm reds and yellows, however, they would act as a cooler accent.

Note It Any painting that uses a pair of complementary colors will automatically contain both warm and cool colors.

Fig. 3–8. How did the artist use color contrast and value contrast in this painting? Terry Winters (b. 1949), *Field of View,* 1993. Oil and alkyd on canvas, 75 15/16" x 96 7/16" (192.88 x 244.95 cm). Whitney Museum of American Art, New York; purchase, with funds from the Painting and Sculpture Committee 94.37.

Using Contrast

Value contrast occurs when you place light values next to dark ones. The greatest possible value contrast is between white and black. If all the colors in a painting are of the same or similar value, the painting has little or no value contrast. You may also use value contrast to help distinguish among the different parts of a painting. For example, an area of bright values will stand out against a dark-value background and create a center of interest, or emphasis. Using colors of widely different values will add visual interest and greater impact to a painting.

Color contrast occurs in a painting when a color is affected by the color that surrounds it. A color will look brighter or stronger if placed against its grayed-down complement of the same value. On the other hand, if you place a fairly dull color against a bright, intense hue of itself, it will look even duller. Similarly, a color can appear darker or lighter depending upon its environment. For instance, a dull pink painted near white will seem darker than when it is painted near black or any other dark color.

A painting can have color contrast without value contrast, just as it can have value contrast without color contrast. For exam-ple, a red and a green of the same value have color contrast, but no value contrast. Pink and maroon have more value contrast than color contrast. Pink and black have both value and color contrast.

Fig. 3–9. Value contrast predominates in this painting.

Fig. 3–10. The use of complementary oranges and blues creates strong color contrast. The value contrast is not as strong.

Persian Illuminated Manuscript

Do you know what the artwork shown in Fig. 3–11 is called? The painting is an example of the art of manuscript illumination. An **illuminated manuscript** is often a religious text, whose sheets of paper or animal skin are decorated with drawings or paintings. The tradition of decorating manuscripts became a major art form in Europe during the Middle Ages, when monks and sometimes nuns copied prayer books or Bibles and decorated the illustrations with gold, silver, or other bright colors that seem to glow with light.

The tradition of making illustrated books has also been an important art form in many Islamic cultures. The small painting *Kai Khusraw Giving His Testament* is a page from the Persian epic the *Shahnama*. (The Persian culture was located in what is now Iran, in the Middle East.) The book was made for a sultan, or ruler, and originally contained more than three hundred illustrations. In this scene, the ruler Shah Kai Khusraw is shown in the center. The text added around the painting tells that he is giving away his possessions to the seven warriors seated around him.

Notice how the artist completely filled the composition, leaving few empty spaces. The floor, back wall, and clothing are all brightly colored and decorated. This overall decoration is typical of Persian art at the time and can also be seen in tiles, carpets, and pottery. Also notice that the artist did not use the system of linear perspective (see page 165) to show depth. Rather, the floor and back wall appear to be one continuous flat surface, and the artist simply overlapped the figures—those further back are placed higher than others.

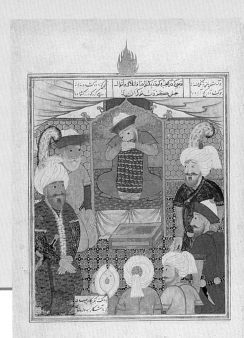

Fig. 3–11. According to Islamic tradition, Persian artists did not depict living things. But in the 1200s, the Mongols spread knowledge of Chinese art when they invaded the Middle East. Soon after, Persian artists began to show their prophet, Mohammed, and others in illuminated manuscripts.
Persian (Gilan), *Kai Khusraw Giving His Testament*, from the *Shahnama of Firdausi*, 1494.
Opaque watercolor on paper, 13 5/8" x 9 1/16" (34.6 x 24.2 cm). Worcester Art Museum, Worcester, Massachusetts.

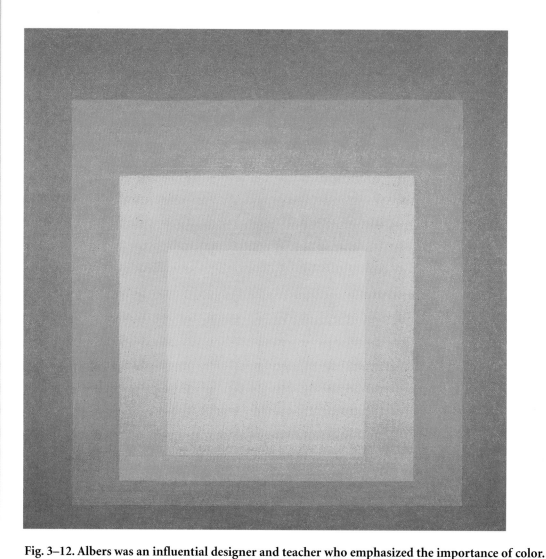

Fig. 3–12. Albers was an influential designer and teacher who emphasized the importance of color. This study is for one painting in a series that explored interactions among colors.
Josef Albers (1888–1976), *Study for Homage to the Square: Departing in Yellow*, 1964.
Oil on board, 30" x 30" (76.2 cm x 76.2 cm). Tate Gallery, London. Copyright Tate Gallery, London/Art Resource, NY. © 2002 The Josef and Anni Albers Foundation/Artists Rights Society (ARS), New York.

Choosing Colors and Color Schemes

Now that you have an understanding of how colors can be mixed and how they work together, you can begin to choose color schemes for your paintings with some expertise.

First, consider the mood or feeling you wish to express. Do you want hot, bright, bold colors that make an exciting or happy statement, or do you desire a soft, delicate, airy atmosphere? Perhaps you'll want to use dark, dull shades to convey an aura of mystery or cool colors to produce a peaceful and calm painting. Once you know the mood you want to convey, think about colors that suggest that mood. If you used all

the hues on the color wheel in one painting, the result would probably be confusing. Just as a chef chooses only a few seasonings for a dish, so a painter must select a few colors and eliminate many others.

There are many ways to systematically choose and eliminate colors. A set of complementary colors plus black and white or two colors next to each other on the wheel plus their complements can make attractive schemes. A **monochromatic** color scheme makes use of only one hue and its tints or shades. This may seem unexciting, but it can produce surprisingly appealing pictures. A similar but more colorful approach

is an **analogous** color scheme, made up of three or four adjacent colors on the color wheel, such as green, yellow-green, and yellow.

You can also create an exciting color scheme by eliminating four analogous colors (colors next to each other on the color wheel). You will find that the eight remaining colors, plus black and white, give you a complete palette. For example, if you eliminate blue, blue-violet, violet, and red-violet, you can still create wonderfully harmonizing colors, including a soft blue obtained by mixing magenta and blue-green. Eliminating colors teaches you to improvise and experiment—and you'll probably be surprised at the results.

Try It When planning to use a certain color scheme in a painting, first try it out on a sample paint chart.

Emphasis

Well-planned artworks usually have an emphasis—the part that the viewer notices first. Painters often use color to create emphasis. A bright color when placed against a dark background or two contrasting colors will create a center of interest. An area with many bright highlights will also stand out. Because cool colors seem to recede, a warm color appears to come forward when added to a cool color scheme.

In addition to color, the shape, size, and placement of an object will create emphasis. Often an artist will also arrange other lines and shapes to direct your eye to a particular part of the composition.

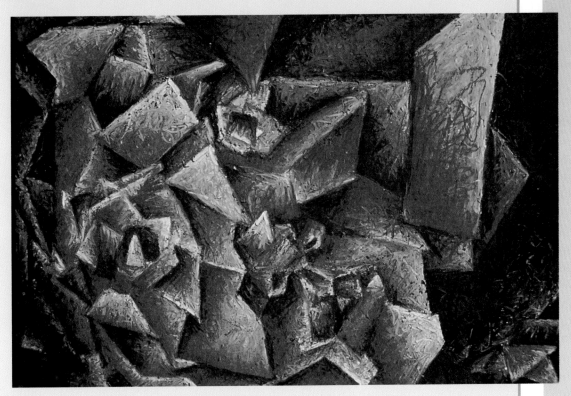

Fig. 3–13. How did the artist create contrast in this monochromatic work? How did he create a sense of drama and excitement?
Brett Crawford (age 13), *Monochromatic Landscape,* 1997.
Tempera, 12" x 18" (30.5 x 46 cm). B. F. Brown School, Fitchburg, Massachusetts.

Studio Experience
Communicating with Color

Think of a time in the last month when your mood was happy or sad, angry or elated, loving or jealous. What colors come to mind? How do artists use color to convey moods or feelings in their artworks? In this activity, you will experiment with using color to help communicate or emphasize two different feelings or moods. You'll use one of the artworks in this chapter as inspiration to create a painting whose colors convey the mood you have chosen to show. Then you'll create a second painting using colors that suggest the opposite mood.

Before You Begin

● Study the paintings in this chapter by Henri Matisse (Fig. 3–4) and Josef Albers (Fig. 3–12). Describe the color scheme in each work. How do the colors help each artist communicate his intention?

● Think about how each work would be different if the artist had chosen a different color scheme. For example, how would the mood of the Matisse painting change if the artist had used black, white, and gray?

Create It

1. Select a painting from this chapter that seems to match one of the moods you have experienced. Describe the message or feeling that you think the artist is communicating. How do the colors contribute to the work's message?

2. Create two or three sketches for an original painting inspired by your chosen work. Select one sketch as the basis for your painting. Decide what medium you will use: tempera, collage, or your own choice. Also decide the size of your painting. Jot down your ideas about how to change the color scheme to convey the opposite mood.

3. Choose a work surface appropriate to the medium and gather together all necessary materials. If you are using collage, be

① Fig. 3–14.

sure to collect materials that offer the variety of colors necessary for your plan.

4. Begin your painting. If you are using tempera, you may refer to the demonstration of that medium on page 60.

5. When you have finished your first painting, prepare the colors for the second painting. Remember to choose colors that evoke the opposite mood. Create your second painting.

② Fig. 3–15.

6. When both paintings are complete, write an accompanying paragraph that describes how you used color to create two different

③ Fig. 3–16.

moods. Also compare your work with the painting that inspired it. Explain why you chose the original painting and how it inspired you. If you wish, attach the paragraph to the back of your painting with a photocopy of the original work.

Check It

Compare your work to the painting that inspired it. Does your new work communicate the feeling or mood you desired? Why or why not? Explain how your second work communicates the opposite mood. Did you use the medium successfully? If you used collage materials, are they glued down neatly and securely? Does your accompanying paragraph explain your intentions? Describe what you learned from this project.

Sketchbook Connection

Sketch a landscape or still life that you would like to paint. Write notes on and around your sketch to help you remember the colors of the original subject. Even if you use colored pencils and markers for color reference, you may want to record slight color variations in your notes.

Rubric: Studio Assessment

	4	3	2	1
Understanding Color/Mood		· Understanding of other artworks · Connection to artwork in chapter	· Understanding of own artworks · Creates 2 opposite artworks	
	Personalized color associations and ideas thoroughly developed. Opposite emotions convincingly, powerfully expressed in two artworks. Sensitive, personalized, convincing	Personalized color associations and ideas well developed. Opposite emotions clearly expressed in two artworks. Aware, personalized, specific	Color associations and ideas somewhat stereotypical. One artwork may be weak or incomplete. Aware, unoriginal, generalized	Color associations in own artworks are very stereotypical or vague. One or both artworks may need much more development. Inexperienced, underdeveloped, vague
Media Use · Appropriate media choice				
	Well-developed color scheme effectively translated to chosen media. Colors clear, evocative of mood. Excellent media usage, technique. Skillful, controlled, appropriate	Appealing color scheme adequately conveys mood. Colors clear, appropriate. Informed media choice; competent usage, proper technique. Competent, appropriate	Satisfactory color scheme, but somewhat unsuccessfully translated into chosen media OR awkwardly applied. Technique needs work. More practice indicated	Poor or inappropriate color scheme; unconvincing mood. Careless media usage; lacks technique. Rudimentary difficulties
Work Process · Study of 2 paintings · Sketches, color tests · Notes · Artist's statement				
	Thorough documentation; goes above and beyond assignment expectations. Thoughtful, thorough, independent	Complete documentation; meets assignment expectations. Meets expectations	Documentation is somewhat haphazard or incomplete. Incomplete, hit and miss	Documentation is minimal or very disorganized. Very incomplete

Stained-Glass Artist
Barbara Meise

Barbara Meise grew up in Bavaria, Germany, surrounded by magnificent stained-glass windows in nearby churches. Meise became directly involved with stained glass after moving to Tenefly, New Jersey, where she began working at the famous J & R Lamb Studios. Today, Meise uses colored glass to create dazzling works of art for public and private commissions.

Describe your unusual specialty and its tradition.

Barbara I work in stained glass, meaning applying paint and design to glass. Scholars believe that glass dates back to the ancient Middle East. Stained glass as we know it today has its roots in the European Middle Ages. The Catholic Church made sure it was colorful, inspirational, and told stories of the Bible for people who could not read or write.

**Fig. 3–17.
Barbara Meise.**

Did you train in the traditional medieval apprenticeship manner?

Barbara Yes and no. When I worked at The J & R Lamb Studios, I did everything—cut glass, swept the floors, and I would always look over my shoulder at what the designers were doing. After watching a woman painting on glass, I went home and bought myself some of the oxides and a kiln. I experimented, and eventually I got it. But later I returned for more studies, getting my Master's at Columbia University. There really is no program that teaches stained glass; it's so involved. I studied art history and different medieval techniques of panel painting and iconography [the use of images and objects as symbols in art].

Do you choose your own colors?

Barbara My works are all commissions, as were those of the Middle Ages. People will throw out lots of ideas—warm hues or cool, general things. Then I show them a sheet of glass, asking if they would like that type of red or amber. They come to the studio to see the composition on a light box before it's leaded up, when pieces can still be taken out.

The black lines between the colored glass are lead, but how do you create the lines on a single piece of glass?

Barbara You mix a little mound of oxidized pigment; that gives you the black lines. Whether painting or cutting, what I like best about my work is doing it right— anticipating an outcome that will be beautiful and appreciated.

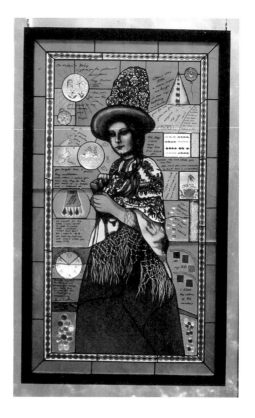

Fig. 3–18. In this work, the artist has used primarily cool colors. The use of warm brown, red, and yellow add contrast.
Barbara Meise, *Greetings.*
Stained glass, painted, fired, leaded, 53" x 32" (134.6 x 81.3 cm).
Courtesy of the artist.

Chapter Review

Recall Name two complementary colors. What color would you make if you mixed these two complements together in equal proportions?

Understand Explain the difference between value and intensity. Cite specific examples of high and low intensity colors in artworks in this chapter.

Apply Using only primary colors of paint, create the three secondary colors and six intermediate colors. Divide your paper with criss-crossed wavy or straight lines. Fill in each area with colors that you mixed, shading from light to dark by adding black or white to the color.

Analyze Describe one of the artworks in this chapter using only color terms. Can other students identify the work that you are describing?

Synthesize Create a colored design. Make a second design similar to the first but use the complement of every color you used in the first design. If you made an area blue in your first design, you would make it orange in the second one. Stare at one of your designs for about a minute and then glance at a sheet of plain white paper. Do you see the other design?

Evaluate Why would an artist choose to limit their palette to a monochromatic, analogous, or split-complementary color scheme? Select an artwork in this chapter that uses one of these color schemes. Do you think this is an effective color selection for the artist's message? Why or why not? What mood does this color scheme evoke?

Portfolio Tip

Portfolios can have many uses. When professional artists apply for jobs, clients are interested in knowing what type of art they have created. Likewise, colleges are often interested in seeing what a student has done. Portfolios are also a good place to keep your art together, to demonstrate how your skills develop over time.

Writing about Art

Whether we realize it or not, the colors in our surroundings affect us. Identify the type of color scheme that you most often select for your attire. Write a persuasive argument about the properties of that color scheme and why it should be favorably perceived by fellow students, teachers, and parents.

Fig. 3–19. How would you describe the intensity of the colors in this artwork?
Katharine Robertson, *Untitled,* 1997.
Mixed media, 14" x 36" (35.5 x 91 cm). Holliston High School, Holliston, Massachusetts.

Media and Techniques

Fig. 4–1. To begin each work, Jacob Lawrence created a well-developed underdrawing. He then reworked the sketch until he was satisfied with the composition. By reworking the composition in the sketch phase, he rarely made large changes once he had begun to apply paint.
Jacob Lawrence (1917–2000), *Celebration*, 1954.
Egg tempera on hardboard, 23 ⅞" x 17 ⅛" (61 x 43 cm). Hirshhorn Museum and Sculpture Garden, Smithsonian Institution, Gift of Joseph H. Hirshhorn, 1961. Photo: Lee Stalsworth.

4 Tempera

One day in your kitchen, you see your mother scrambling an egg in a bowl. You notice that instead of mixing in pepper, paprika, or grated cheese, she adds some powdery green stuff. "Mom," you might ask, "what *are* you making?" Why, she's making tempera paint!

Perhaps you are more familiar with tempera's other name: poster paint. But what is tempera? In historic painting, tempera is colored pigment dissolved in water and mixed with a glue (the binder), such as an egg white or yolk. Artists have been using tempera for thousands of years. The ancient Egyptians, Greeks, and Romans used tempera to create magnificent wall paintings, and medieval artists created intricate altarpieces and manuscripts that sparkle with bright colors.

Tempera may be fine for artists of the past, but why would a contemporary artist choose such a medium? Today's tempera paint is very easy to use. It comes in both liquid and powder form and in brilliant hues, including fluorescent colors and silver and gold. Artists and designers like tempera because it is opaque, it permits sharp edges and fine detailing, and it dries quickly to a smooth matte finish. It will also adhere to almost any surface, including glass if soap is added.

In this chapter, you will discover techniques for creating subtle effects using tempera, including transparent layers and the look of textures. You'll also learn tips about mixing colors and changing their intensity. These techniques will help you better express yourself with the medium of tempera.

fine-point brushes

layering techniques

durable surfaces

Tempera Surfaces

Papers of various textures, weights, and colors are suitable for tempera paint. Artists concerned with maximum durability look for paper with a high rag content, which may cost several dollars a sheet. Most painters, however, find that a heavy-grade construction paper works well. Mat board or any heavy paper with a nonshiny surface also gives good results.

Paper in a neutral gray color of middle value is best for tempera. Because such paper will not "blind" you with a glaring white surface as you paint, you will be able to better judge color relationships. Colored paper can also produce interesting effects. If you plan to leave some of the paper exposed in the finished painting, make sure that your paper is fade resistant so that the color will not change over time.

Tools and Equipment

Most of the brushes used for watercolor painting are also suitable for painting with tempera. Round brushes of synthetic combinations retain a fine point and carry a lot of paint. Use the largest brush you are comfortable with; they hold more paint and do not need to be reloaded so frequently. An assortment of sizes—#3 or #4 for detail work and #8 and #12 for larger areas—is recommended. Avoid brushes that lack resilience or are too limp, which will allow you less control. Bamboo brushes in various sizes are excellent; they have very fine points, hold a lot of paint, and let you create interesting shapes with a single stroke. If you want a stronger effect, use a stiff bristle brush. The brushstrokes will usually remain visible, and edges will not be sharp or crisp.

Fig. 4–2. A variety of brushes, including a bamboo brush, toothbrush, and stipple brushes and sponges, can be used to apply tempera paint.

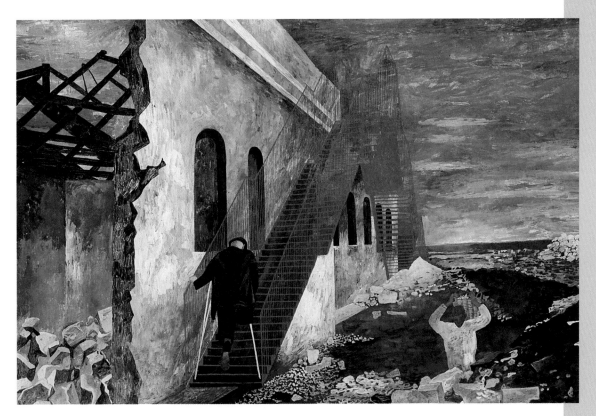

Fig. 4–3. The artist contrasted warm and cool colors to emphasize the stairway. Notice that the sky and the side of the building are painted with similar brushwork and colors to further accentuate the stairs.
Ben Shahn (1898–1969), *The Red Stairway*, 1944.
Tempera on masonite, 16" x 23 5/16" (40.6 x 59.2 cm). The Saint Louis Art Museum. Purchase.
©Estate of Ben Shahn/Licensed by VAGA, New York, NY.

Use a sponge to create texture on a painted area or to apply one color on top of another. Coat a rough textured sponge with a light layer of paint and superimpose its imprint on top of another color. Also try loading a toothbrush or a stiff stencil brush with paint and flicking it with your thumb to produce a splattered or textured effect. Spraying paint from a spray bottle can add texture or allow you to apply dots of color. Be sure to mask off all areas that you don't want sprayed.

Baby-food jars or other small sealable containers work well for storing mixed paint, and egg cartons are perfect containers for holding powdered tempera.

The **palette**, a surface on which paint is kept or mixed during painting, can come in a variety of forms. For tempera, a nonabsorbent surface works best, such as plastic or glass. A wax-paper palette or a piece of aluminum foil will also work well for mixing colors and preparing paint.

Note It It's a good idea to apply masking tape along the edges of the back of the paper before you begin painting, so that the paper will not become tattered while you work.

Basic Tempera Techniques

To retain crisp shapes, be sure an area is dry before you paint close to it. Colors will run together if they are wet. If you plan to paint over an area or to apply a second coat, paint it on gently and thickly. Using a darker color on top will help prevent the undercoat from bleeding through. You can also minimize bleeding by mixing the undercoat with liquid starch instead of water and letting it dry before applying a second coat. Sometimes two coats are necessary to completely cover a dark color.

It's simple to mix colors, whether you use liquid or powdered tempera. To mix powdered colors, roll a damp paintbrush into the tops of two small piles of dry powder and then mix the colors on a palette of aluminum foil. Mixing the powder with liquid starch or acrylic gel medium instead of water will produce a more durable paint surface and allow you to build up transparent layers of paint without smearing the undercoats. If you use acrylic gel, however, make sure to wash your brushes thoroughly before they dry, as acrylic gel can ruin them.

Layering paints with a "dry" brush (a brush with little color or water on it) can also produce an interesting textured effect.

Try It Thinning tempera with more than the usual amount of water or starch will make it transparent and dilute the intensity of the color. If you wish to imply transparency with overlapping colors, mix the two (or more) colors and apply that color to the area where you intend them to "overlap." The resulting color will create the illusion of one color showing through another.

Elements of Design

Color

Colors are the wavelengths of light perceived by the human eye. In art, painters can mix hundreds of colors by using the primaries plus black and white. Mixing two primaries will create a complementary color, and adding white or black will produce tints or shades.

When mixing colors, it is often useful to begin with the lighter color and add small amounts of the darker color until the desired hue is achieved. To mix tints, begin with a small amount of the color and add white; for shades, begin with the color and add small amounts of black. To change the intensity of a color, add a small amount of its complement, which will result in a duller color.

Fig. 4–4. This artist has successfully overlapped colors to produce the look of a plaid fabric.
Courtesy of Kaye Passmore.

Fresco

Fresco painting is one of the oldest art techniques. To create a **fresco**, pigment is suspended in lime water and brushed onto a freshly plastered surface. The lime and pigment bond with the plaster and the painting becomes a part of the wall. It survives as long as the wall itself.

Fresco is a difficult painting technique. Artists can prepare only enough plaster and paint to use in a single day, and if the plaster dries too quickly, the process will fail. Fresco is generally used on large surfaces, such as a wall or ceiling, which also complicates the process. During the Renaissance, fresco was a popular medium in Italy and southern Europe, where the dry climate has better preserved the plaster. Italian Renaissance artists known for their frescoes include Masaccio, Michelangelo, and Mantegna, whose work is shown in Fig. 4–5.

Note It You can create frescolike effects by using watercolor or gouache on a shallow tray filled with damp plaster of Paris or on construction paper that has been taped down and coated with gesso. First create a **cartoon** (a full-size plan of the image and colors you'll use) and transfer it to the surface after the plaster or gesso dries. Then paint carefully—you can't hide or erase mistakes in fresco.

Fig. 4–5. This playful fresco is part of a series of works that Mantegna made for a room in the Gonzaga family palace. It creates a trompe l'oeil illusion of a circular opening at the center of the room. How did the artist create a sense of depth?
Andrea Mantegna (c. 1431–1506), *Ceiling Oculus*, 1465–74.
Camera degli Sposi, Palazzo Ducale, Mantua, Italy. Scala/Art Resource, NY.

Paint with Tempera

Tempera paintings should be well planned and approached in a step-by-step method. Here's one way to approach painting with tempera. Before you begin, make many small sketches and select the best one for your composition.

1 Make a full-size pencil drawing of your chosen sketch. After blackening the back of the sketch with pencil, transfer the drawing to heavy paper. Corrections can be made at this time, and the drawing can be trimmed if desired.

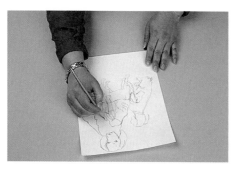

2 Choose a color scheme. On a wax-paper palette, mix the colors that you will need to paint any large objects, shapes, or areas of color.

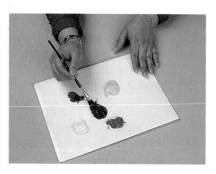

3 You may first paint in the background or save that for last.

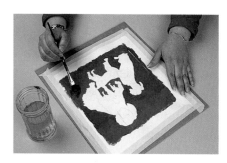

4 Once the surface is dry, add smaller areas of color and any details. Bamboo brushes work well to define shapes precisely.

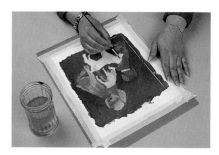

Try It Before you begin painting, experiment with different tempera techniques and color combinations on a sheet of glass or transparent acetate placed over your full-size drawing.

Egg Tempera

If you've ever tried to wash dried egg off a plate, you know how hard it becomes. This same quality makes **egg tempera**—a mixture of water, powdered pigment, and egg yolk—a durable medium. Such paint dries quickly and becomes very hard. In fact, egg tempera dries so quickly that it is difficult for artists to blend colors while working.

Centuries ago, painters had to mix their own colors. They used pigments that came from minerals, vegetables, and even animals. These included ultramarine, a blue made from the powder of a gemstone called lapis lazuli; sepia, a dark brown made from the ink of cuttlefish; and carmine, a red made from the dried bodies of dead insects. Luckily, today's artists have the convenience of purchasing tubes of ready-made egg tempera.

You can apply the medium to canvas, wood, or Masonite surfaces that have been prepared with several coats of gesso. In most cases, the paint will dry to a lighter color. Egg tempera paint can chip or fall off, so artists often paint many thin layers one on top of another. Traditionally, painters used brushes made of squirrel hair, but today's artists use all types of soft brushes with the medium.

During the Middle Ages, egg tempera was favored by artists throughout Europe. It remained popular until the end of the fifteenth century, when oil paint—which offered more colors and a slower drying time—became the first choice among painters.

Fig. 4–6. This work depicts Saint Luke, the patron saint of painters. Notice that the background is made from thin sheets of gold leaf rather than paint. This is common in historic egg tempera paintings. Simone Martini (c. 1284–1344), *Saint Luke*, after 1333.

Tempera and gold leaf on panel, 22 ¼" x 14 ½" (56.5 x 37 cm). J. Paul Getty Museum, Los Angeles. ©The J. Paul Getty Museum.

Studio Experience
Group Mural

In this studio experience, you will work with other students to create a large tempera painting or mural about the seasons in your school or community. Murals have been used to decorate walls since prehistoric times, and often emphasize such topics as nature, city scenes, religious ideas, and everyday life.

Before You Begin

● With your group decide what you will show at different times of the year. Think of activities, events, sports, and celebrations that happen seasonally. You might paint a scene at different times of the year or a theme such as seasonal tasks, sports, or festivals.

● Also decide how large your group's painting will be and if you will paint it on paper taped to the wall or large pieces of mat board or gessoed board.

Create It

1. Brainstorm possible subjects for your group mural. Will its emphasis be weather, activities, events, or something else?
2. Create sketches of scenes or objects to include in the mural. As a group review all preparatory sketches. Decide how you can include each person's ideas in the mural. Consider enlarging one or two of the sketches to become a center of interest.
3. On small pages that are proportional to the large painting, sketch several mural designs. Unify your design by overlapping objects. What will you include in the back-

1 Fig. 4–7.

ground? Will you add a border to your mural? As a group select a design or combine several students' designs into one for the mural.
4. With a ruler draw a grid of squares over the mural plan.

2 Fig. 4–8.

5. Prepare your mural painting surface. You might gesso a board or tape your paper securely to a wall or board.
6. Using a yardstick and pencil, lightly draw a grid onto the mural. It should be proportional to the one in your small plan and have the same number of squares.

3 Fig. 4–9.

7. Copy the portion of the drawing in each square of the plan onto the mural's corresponding square. Don't worry about the details.
8. Assign each group member areas and objects to paint. Review page 60 for a demonstration of one possible tempera technique. Remember to think about how the use of colors, light, and shadows will help depict any unique qualities of your given time of year. Repeat colors through out the mural.

Check It

Does your painting convey your intended purpose? Did you use color to successfully capture the feeling or atmosphere of your seasons? Explain. Did you use the painting medium successfully? Why or why not? Describe what you learned from this project. What would you do differently the next time you work on a similar group project?

Sketchbook Connection

Keep a visual record of how a plant changes over time. For example, draw a branch or tree weekly in the spring as buds begin to swell, burst into bloom, and then are replaced with leaves.

Rubric: Studio Assessment

4	3	2	1
Theme Collaborative · Seasonal · Community life · Honors individual and group			
Important and seasonal aspects of community life depicted. Separate images united by an overall, meaningful theme. Each student satisfactorily represented. Celebrates community, inclusive	Important and seasonal aspects of community life depicted. Overall theme suggested. Each student satisfactorily represented. Satisfactory, aligned	Some important aspects of community life depicted. Unequal attention may be given to different seasons, events, or students' ideas. Lack of balance	Few important aspects of community life depicted. Noticeably unequal attention given to different seasons, events, or students' ideas and work. Major misinterpretation
Composition Collaborative · Overlapping · Unity · Proportion/Scale			
Overlapping and other compositional strategies strongly unify separate images. Scale of mural appropriate to site. Unified, holistic	Overlapping unifies separate images. Scale of mural appropriate to site. Integrated, appropriate to scale	Some disconnection between individual images. Final design may have lost some compositional strength at larger scale. Needs reworking	Little integration of individual images; or final mural design has lost considerable compositional strength at larger scale Fragmented, weak
Media Use Individual · Tempera technique · Color contrast · Value contrast			
Ample experimentation. Expert paint application and brush technique to create varied effects. Sophisticated use of color, color/value contrast. Skillful, controlled, appropriate	Adequate experimentation. Competent paint application/brush use to create details. Satisfactory use of color, color/value contrast. Competent, appropriate	Some practice. Apparent mistakes or inappropriate paint usage. Inconsistent color use, color/value contrast. More practice indicated	Minimal practice. Many apparent mistakes in paint application OR uneven brush technique. Lack of color/value contrast. Rudimentary difficulties
Work Process Individual · Sketches · Discussions and critiques · Reflection/Evaluation			
Thorough documentation of idea development; very helpful in group work/ responsible for independent work. Goes above and beyond. Thorough, helpful, responsible	Complete documentation provided of idea development; helpful and responsible. Meets expectations	Some documentation provided of idea development; may need to work on group or individual responsibility. Incomplete, hit and miss	Little documentation provided of idea development. Minimal participation. Meets few assignment expectations. Little contribution

Architectural Renderer
Richard Baehr

Richard Baehr (b. 1930) has completed more than two thousand architectural renderings during his forty-year career. He began architectural drafting in high school

Fig. 4–10. Richard Baehr.

and pursued art while on scholarship at Cooper Union School of Architecture in New York City. After earning his architectural degree from the University of Cincinnati School of Applied Arts, Baehr became enamoured with rendering, a career he has passionately pursued ever since.

Why did you choose a career in rendering rather than architecture?
Richard After becoming a licensed architect, I worked for Bob Schwartz, famous for his architectural practice but also the best renderer in the United States at the time. Rendering is creative—illustrating a building that has not been built. The illustrations are used in fundraising or marketing. Rendering doesn't have the frustrations of architectural practice, such as dealing with building departments and tough competition. It's very satisfying to create something tangible out of nothing—making a

building come into being at the end of the day. And there's the look on the architects' faces when they see the rendering of their own building for the first time—they really love it!

What is your artistic process?
Richard First I make an accurately scaled and detailed line-perspective drawing on tracing paper, using the architect's plans. Then I place it on illustration board and go over every line with a very hard 9H pencil, which engraves the lines into the board. Finally, I begin to paint. For a twenty-six-story apartment building, the whole process takes about sixty hours.

Why do you work with tempera?
Richard: Even though tempera is a very flat, opaque medium, you can learn to work on glass, which can be very reflective and exciting. You can do photo-realistic renderings with tempera, and you can make changes, which is hard in watercolor or pen and ink.

What aspect of your training was most valuable?
Richard I always worked for architects during the day and went to school at night. The office experience was at least as valuable as school. There are not many courses in rendering. But any art class that helps you to really see things and represent them is important.

Fig. 4–11. The use of tempera paint and small brushes allowed the artist to create minute detail in his rendering, giving the image a near-photographic appearance.
Richard Baeher, *World Trade Center Phase II,* Xiamen, China.
Tempera rendering, 30" x 24" (76 x 61 cm). Courtest of the artist.

Chapter Review

Recall What is a fresco?

Understand Why did medieval artists mix egg into their tempera paint?

Apply Create a sampler of tempera painting techniques. Include a variety of brushstrokes made with different types of brushes and sponges. Paint colors over a solid layer of color, brush in some areas with thinned paint, and spatter paint with a toothbrush.

Analyze Describe several tempera painting techniques that either Jacob Lawrence (Fig. 4–1) or Ben Shahn (Fig. 4–3) used in their painting. For example, where did the artist use thick and thin brushstrokes and paints? What parts of the artwork do you think the artist might have painted last? Explain why you think this.

Synthesize Write an imaginary conversation between artists Ben Shahn and Andrea Mantegna as they explain their painting technique to each other and discuss what they were both trying to show in their paintings (Fig. 4–3 and Fig. 4–5).

Evaluate Imagine that you are on a committee to purchase artwork for your school. Select one of the artworks from this chapter to present to the whole committee. Write why you chose this particular piece and explain why its size, colors, technique, style, and subject matter would make it an appropriate choice for a certain location in the school.

Portfolio Tip

Include a range of different types of art in your portfolio. Keep a written reflection about each assignment, including what message you were trying to convey, what you learned by creating the art, and why you decided to save this particular artwork. Over time, your portfolio will have much more meaning to you, your teachers, family, potential employers, and college admissions officers.

Writing about Art

Using the library and Internet, expand your knowledge of either the egg tempera or fresco techniques that were used during the Italian Renaissance. Combine this new research with the information in this chapter and your experience working with tempera. Consider what it might have been like working as a painting master's assistant one August day in Renaissance Florence or Rome. Use your imagination to write a journal entry describing a full day's work.

Fig. 4–12. Why was tempera a successful choice of medium for this portrait?
David Pacific (age 14), *Cubist Portrait*, 1999.
Tempera, 12" x 15" (30.5 x 38 cm). Marlboro High School, Marlboro, Massachusetts.

Fig. 5–1. Prendergast is known for watercolors that depict the popular recreation and leisure activities of his day. What mood or feeling does the patterned surface of this work convey?
Maurice Prendergast (1859–1924), *Band Concert*, c. 1912.
Pencil and watercolor on paper, 13 ⅞" x 19 ¼" (35 x 49 cm). Mead Art Museum, Amherst College Museum Purchase AC 1951.336.

5 Transparent Watercolor

Have you ever completed an ink drawing and thought, "This painting needs something more"? Perhaps you decided to create shadows and dark areas and, dipping a paintbrush in water, "painted" the drawing to make the ink flow. If so, then you have used a watercolor technique.

Artists in the past primarily used watercolor to color ink drawings and to make sketches for oil paintings. **Aquarelle**, the French word for transparent watercolor, became popular in England in the eighteenth century, but it was in the United States that it first became a major painting medium. American artist Winslow Homer chose watercolor as his prime means of expression and brought the medium to new heights.

Contemporary artists use watercolor in a dazzling array of techniques and styles. Transparent watercolors are not completely see-through, but they differ greatly in texture, covering quality, and **luminosity** (brightness) compared to tempera and other opaque water-based media. White paint is generally not necessary. Color mixed with water is called a **wash**, and when applied to white paper, the white glows through the color. Artists can achieve different tints by varying the amount of water—the more water, the less intense the color.

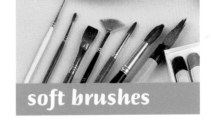

soft brushes

In this chapter, you will experiment with a variety of techniques to apply watercolor, including creating the look of textures. You will also learn how to select the best papers and brushes for watercolor, and the challenge of creating a nonobjective painting will help free you to explore the fluid, spontaneous qualities of the medium.

wash technique

absorbent papers

Watercolor Surfaces

Artists rely on white paper to produce watercolor's values and intensities, so it must be chosen carefully. The best papers are expensive and often made in Europe. The thickness and weight of paper is determined by how much a ream (500 sheets) of 22" x 30" paper weighs. Heavy watercolor papers can weigh 400 pounds per ream and are identified by their weight, such as "300 pound rough."

Paper surfaces also vary from smooth to rough. Hot-press papers are smooth, whereas cold-press papers are rough and extremely textured. The more texture the paper has, the more apparent that texture will be in a finished painting. It is wise to try several different surfaces before you begin to paint in earnest.

In addition to professional-grade watercolor papers, you may also try student-grade paper, heavy white drawing paper, oatmeal and charcoal paper, or rice paper. These papers provide a variety of excellent surfaces. Thin papers buckle when wet, but you can later flatten them under weighted

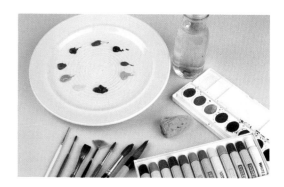

Fig. 5–2. When creating their artworks, watercolorists can select from a variety of tools and materials, including numerous types of brushes, sponges, and pan or tube paints.

boards or iron them. Some artists make thin papers more durable by first coating them thinly with gesso. Explore a number of different papers to determine the most suitable surfaces for your watercolor work.

Try It Experiment with other kinds of tools for watercolor. Make thin lines with sticks and broad lines with pieces of cardboard. Cover large areas with sponges dipped in paint. Try applying color washes using your fingers, hands, crumpled paper, or tissues.

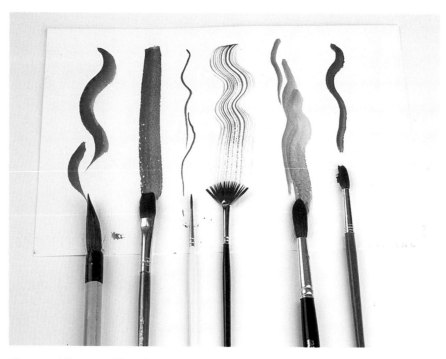

Fig. 5–3. All types of brushes come in many sizes. They are usually numbered, with the larger ones having higher numbers. Flat brushes are sometimes numbered, but are often sized by their width, from 1/8 inch to 2 inches wide. Generally, watercolorists use as large a brush as possible for each task.

Fig. 5–4. What is the style of this watercolor? Compare the technique used in this work to that used in Fig. 5–9. In what ways do they differ?
William Henry Hunt (1790–1864), *Primroses and Bird's Nest.*
Watercolor, 7 ¼" x 10 ¾" (18.4 x 27.3 cm). © Tate Gallery, London/Art Resource, NY. Tate Gallery, London, Great Britain.

Tools and Equipment

Watercolor brushes are made in almost infinite variety. Most are useful, but no one brush will serve all your painting needs. Experiment with several before choosing the ones that work best for you. It is important to remember that a few good tools are more useful in the long run than many mediocre ones.

Watercolor brushes are usually made of animal hair (including sable, ox, or squirrel), synthetic fibers, or combinations of them. Red sable brushes are expensive and favored by many professional artists. Natural/synthetic combinations are extremely popular; they produce excellent strokes, carry much water, and retain fine points. Also try bristle or nylon brushes (generally made for oil, acrylic, or tempera painting), bamboo brushes, or stencil brushes to see what kinds of marks and strokes each one makes. Applying watercolor to a surface using a toothbrush or a sponge in a variety of shapes and textures can also create interesting and unexpected effects.

Containers for holding water should be as large as possible. Quart containers, bowls, and small plastic buckets work well. Large amounts of water will help you keep your brushes clean and will make washes easier to mix. Several types of plastic palettes are available for mixing washes and arranging moist paints. Plastic plates or frozen-food trays will also work. Any palette must have space for mixing paint with a large quantity of water to make washes.

Fig. 5–5. This tiny painting on ivory is a portrait of the actress Ethel Barrymore (1879–1959). Barrymore, who made her acting debut at age fourteen, was one of the most famous stage actors in America.
Eulabee Dix (1879–1961), *Ethel Barrymore,* c. 1905.
Watercolor on ivory, 2 ⅜" (6 cm) diam. The National Museum of Women in the Arts, Washington, DC. Gift of Mrs. Philip Dix Becker and Family.

Drawing boards (½" plywood or ¼" Masonite) are excellent supports for watercolor paper because they can be slanted (on a book or two, for example) to any desired angle. Simple table easels make it easier to control the amount of slant. Be sure to use masking tape to hold the sheet of paper in place.

Try It Fill several sheets of white drawing paper with practice marks. Try a very wet brush and one that is only slightly damp. Make marks in various ways: use only the tip, press down to make broad lines, use the side, and twist the brush as you draw it across the paper.

Note It Watercolor comes primarily in tubes and pans. Tube colors, which most watercolorists prefer, remain moist and are the most intense in hue. Pan colors require vigorous brushwork to pick up color, but the colors become softer if you put a few drops of water on them before you begin to paint.

Winslow Homer

Did you know that Winslow Homer was the first Western artist to use watercolor to create finished works of art? Prior to his work with the medium, artists considered watercolor more useful for studies than for major paintings.

Born in Boston in 1836, Homer grew up in nearby Cambridge. He became an apprentice in a lithography shop at age eighteen and began his career as an illustrator. He worked for *Harper's Weekly*, a popular magazine of the time, and had his first exhibition in New York in 1860.

As a young artist, Homer became known for his scenes of the Civil War. After the war, he traveled to France, where he saw the paintings of the Impressionists (see page 191). Upon his return, Homer's paintings became brighter and more colorful, and his brushstrokes became looser. Scenes of young children, rural life, and recreational activities became his favorites.

Homer loved the outdoors, and later in life he turned his attention almost entirely to the sea. In 1883 he moved to the coastal town of Prouts Neck, Maine, where he lived alone until his death in 1910. Today, many of his watercolors are counted among the masterpieces of American art.

Fig. 5–6. Notice the strong contrast between shadows and highlights. Homer often added white gouache to emphasize the brightest spots rather than simply leave the white of the paper unpainted.

Winslow Homer (1836–1910), *Seven Boys in a Dory*, 1873.

Watercolor on paper, 9 ½" x 13 ½" (24 x 34 cm). Collection of the Farnsworth Art Museum, Anonymous Gift, 1999.

Basic Watercolor Techniques

As recently as twenty-five years ago, most watercolor paintings had a similar and distinctive look, determined by the technique and use of the medium. Today, however, watercolors are used in an ever-widening range of techniques and styles, and they are often combined with other media. Before you begin to paint with transparent watercolor, it is important to learn about its unique characteristics.

Watercolor can be applied to both wet and dry surfaces with vastly different results. By wetting a sheet of paper evenly with a sponge and then applying color with a large brush loaded with water and paint, you can achieve large areas of fluid color. By painting with a relatively dry, small brush and using only a little water, you can achieve more detail and retain greater control of the paint. Some artists splatter color onto a wet surface or lightly scratch

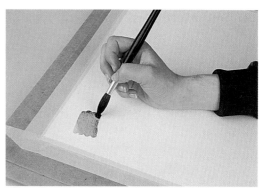

Fig. 5–7. Notice how the paper shows through this wash. Washes can cover large areas of paper evenly if they are applied carefully. Watercolorists begin at the top and brush a horizontal stroke with a large, loaded brush. They then continue, loading the brush each time and laying down another stroke just touching the bottom of the previous stroke. When you use this technique, do not go back and touch up wet areas.

Fig. 5–8. The artist has used washes and brushwork to create the textures of a meadow and cows. Notice how he has used the white paper to create flowers and markings on the cows.
Brian Gilley (age 16), *Moo Cows*, 1996.
Watercolor. Burncoat High School, Worcester, Massachusetts.

into a painted area with a stick or brush handle to add texture and variety. You can also use a bristle brush to move color and water around on the paper's surface.

Before you attempt to paint a composition, learn what the medium will do under many different conditions. Working on a flat surface usually provides the best results, but sometimes the colors may puddle. You can also slant your work surface at different angles. A slanted surface, created using an easel or several stacked books, allows colors to run and helps to produce even washes. Notice that as you work, the paper will dry, and the lines and edges you paint will become sharper. Color put into a wet surface will dry much lighter; the same color applied to a dry surface will retain much of its intensity.

Safety Note Although most watercolor paints are nontoxic, some pigments can cause allergic reactions. Read labels carefully, wash your hands often, wipe up spills immediately, and never put either end of a brush in your mouth.

Fig. 5–9. How did the artist use color in this watercolor to direct the viewer's eye across the composition? Notice also that some of the leaves are sketched in but left unpainted.
Charles Demuth (1883–1935), *Plums*, 1925.
Watercolor and graphite on wove paper mounted on board, 18 ⅛" x 12" (46 x 30 cm). Museum purchase, 1934.5. ©Addison Gallery of American Art, Phillips Academy, Andover, Massachusetts All Rights Reserved.

Paint with Watercolor

After you have chosen your subject (still life, landscape, flowers, figure, abstraction, etc.), it is often valuable to make a series of quick thumbnail sketches. Try several arrangements of the main elements. Then choose the composition you like best. Although no two watercolorists paint exactly alike from beginning to end, basic watercolor painting techniques remain generally constant regardless of subject.

1 Determine three, four, or five major elements of your composition. Using pencil, fine-line pen, or diluted paint, make a light outline of these shapes. Artists also sometimes start a watercolor by painting in the large shapes and then adding necessary lines.

3 When the paper is dry, add some darker-value washes, still working in large areas and shapes, not details. Let areas dry and then add the darkest darks, such as accents and shadows. Again, work from larger to smaller areas.

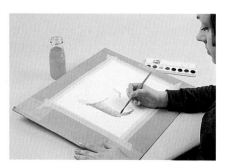

2 Determine what areas will be white and leave these parts of the paper unpainted. Apply light-value washes (made by mixing much water with a little color) to the rest of the surface. Fill the sheet as quickly as possible, so that you won't be tempted to add detail. Work from large shapes to smaller ones. Use a large, soft brush to wash in the sky, background, and other large shapes.

4 Finally, add any necessary intermediate values. Also add textures, details, and finishing touches. Begin the details at the center of interest, keeping them to a minimum. Remember to switch from larger brushes to smaller ones as your work becomes more detailed.

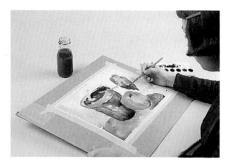

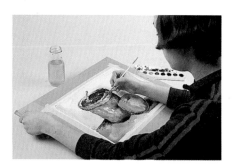

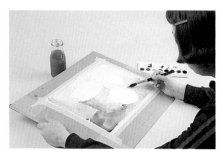

With dozens of books explaining how various artists use watercolor, it is easy to see that there are many ways to make watercolor paintings. This is only one way. It is important that you try many directions, and always try to let your own feelings come through in your work.

Texture

Texture is the way a surface looks and feels. In two-dimensional artworks, artists create implied texture, or the illusion of texture.

In watercolor, textures can be created using the dry-brush technique: a brush holding a minimum amount of paint produces a series of fine lines that can resemble grass, trees, or fur. The wet-on-wet technique (applying color to a damp surface) will create fuzzy textures. Using a toothbrush to spatter colored dots onto the paper produces different textures when done on either a dry or wet surface. Similar effects can be created by dropping salt onto washes of varying dampness, which produces a mottled, patterned texture.

Fig. 5-10. How did the artist use color and value to create the illusion of texture? Do you think she used the medium successfully?
Rachael Youngs (age 17), *Dance*, 1998.
Watercolor, 18" x 24" (46 x 61 cm). Wachusett Regional High School, Holden, Massachusetts.

Try It Transparent, cool washes (blue or bluish purple) can be pulled over warm areas to suggest shadows or to unify the surface of the painting. Washes can also be pulled over a rich crayon drawing to create a resist.

Note It Some artists enjoy working on each part of the painting separately, finishing one at a time. Others prefer to develop all of the parts of the painting at the same time so that the painting grows as a unified entity.

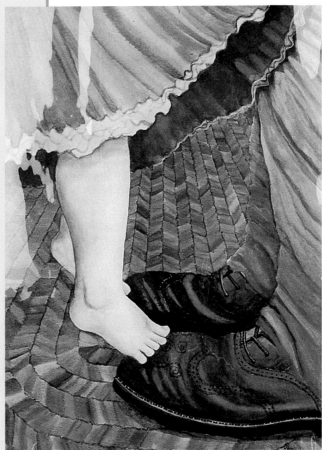

Studio Experience
Nonobjective Watercolor

Do you ever listen to music while you paint? The abstract aspect of music can serve as a rich source of inspiration for a **nonobjective** painting—one that does not show any recognizable objects. In this studio experience, you will create a work that does not have a realistic image of a specific subject, which will allow you to freely explore the possibilities of the watercolor medium. Various tools, hand movements, and methods of application can help you achieve feelings and effects similar to those conveyed through the music.

Before You Begin

● As a class, choose at least two pieces of music that have distinct rhythms or styles and that convey different moods. For example, try an instrumental soundtrack from a popular film and a piece of jazz music. Or select a classical piano concerto and a recording of world music, such as Andean folk music, the ragas of India, or African Mandinka and Fulani music.

● Listen to each musical piece and describe each one. What makes them different? What moods or feelings does each convey? Explain. Think about the kinds of colors, lines, shapes, and textures that will help you to convey similar effects. For example, a section of loud, rhythmic beats may be recorded by painting a series of bold, evenly spaced strokes. Discuss the methods of application that you think best suit each musical piece.

Create It

1. Gather the materials that you will need, including watercolor paper; paints; brushes, sticks, and/or sponges; water and water containers; a palette; and an easel. If you choose to work with wet paint on a wet surface, first tape your paper to a flat board to prevent buckling and warping. Refer to page 74 for a demonstration of one possible watercolor technique.

❶ Fig. 5–11.

2. Listen carefully to the first musical piece. Create a series of strokes, lines, shapes, or areas of color that reflect your interpretation of the music. Pay careful attention to changes of instruments, loud versus soft sections, and the rhythm. If possible, try to paint your marks so that they are spread out over the entire surface of the paper.

3. When the piece of music ends, stop painting. Use paper towels or a dry brush to absorb any excess watercolor. Then carefully set aside your painting to dry.

4. Repeat steps 2 and 3 for each additional piece of music.

❷ Fig. 5–12.

5. Compare your watercolors to those of your classmates. In what ways are the paintings similar? How are they different? Can you tell which piece of music inspired each work? Explain.

6. Select one of your paintings to rework into a finished composition. Think about how to add color, lines, textures, or details to create a center of interest and to help unify the work. Use pencil, ink, or any other materials to help you create a satisfying composition.

3 Fig. 5–13.

Check It

Does your painting reflect the mood or feeling of the musical piece that inspired it? Does your finished composition convey a sense of unity? Did you use the medium and materials successfully? Why or why not? Explain what you learned from this project.

Sketchbook Connection

As you listen to your favorite music, imagine what it would look like as a drawing. How could you show the beat, and suggest the rhythm and mood? Would you repeat thick or thin strokes, make curved lines flow across the page, or make jagged jumpy marks?

Rubric: Studio Assessment

4	3	2	1
Ideas and Connections · Rhythm, movement, color, and mood in art and music · Nonobjective · Musical interpretation as inspiration			
Sensitive to obvious and subtle aspects of musical selections. Final artwork is completely nonobjective, presents convincing, highly personalized interpretation. Nuanced, convincing, personalized	Attentive to general and specific aspects of musical selections. Final artwork is nonobjective; convincing interpretation of musical selection. Attentive, convincing	Aware of some obvious aspects of musical selections. Final artwork is mostly nonobjective; emerging interpretation of musical selection apparent. Aware, unimaginative, generalized	Visual interpretations are vaguely related to musical selections. Final artwork may include many literal images. Undeveloped, vague or literal
Media Use · Watercolor technique · Markmaking/Color field · Additional media			
Inventive experimentation. Skillful application of washes. Excellent use of brushes/tools to create textures, details. No apparent mistakes. Skillful, controlled, appropriate	Adequate practice. Proficient use of washes on wet/dry surfaces. Competent brush technique. Few mistakes. Competent, appropriate	Some experimentation. Insufficient understanding of technique resulting in muddy washes, OR inappropriate usage of brushes, tools. Lack of consistency. More practice indicated	Minimal practice. Many apparent mistakes in handling of paint and/or brushes; failed washes, lack of textures, details. Rudimentary difficulties
Work Process · Study of 2 or more musical scores · Intuitive color sketches · Class discussions · Reflection/Evaluation			
Thorough documentation; goes above and beyond assignment expectations. Thoughtful, thorough, independent	Complete documentation; meets assignment expectations. Meets expectations	Documentation is somewhat haphazard or incomplete. Incomplete, hit and miss	Documentation is minimal or very disorganized. Very incomplete

Web Links

www.scbwi.org
Web site for the Society of Children's Book Writers and Illustrators

www.hbook.com/cooney.shtml
The late Barbara Cooney's story about how she became a children's book illustrator.

Children's Book Illustrator
Chris Soentpiet

Chris Soentpiet (pronounced Soon-peet) (b. 1970) was born in Seoul, Korea, where he lived for eight years, until an American family from Hawaii adopted him and one of his sisters. In Korea, other children had always asked Soentpiet to draw, which he did while looking at a model. Soentpiet continues to use models today when drawing illustrations for children's books. Each book takes from four to six months to complete.

**Fig. 5–14.
Chris Soentpiet.**

When did you decide to become a professional artist?
Chris My high school art teacher in Portland, Oregon, secretly sent out my pictures to art colleges around the country. He really saw the potential in me. I didn't know I was going to Pratt Institute in Brooklyn until I got a letter. Pratt showed me many different varieties of careers in art. I only thought there was painting and drawing.

Do you write children's books as well as illustrate them?
Chris I've written some, but usually an author writes the story, sells the manuscript to the publisher, and the publisher looks for an illustrator. Publishers mostly send me stories that deal with history and culture—true stories that are realistic.

Do you paint your scenes with watercolors right off?
Chris First, I make rough sketches from live models and do a lot of research to make the details authentic. I create separate final pencil sketches on tracing paper for each character. Then I glue them all together on a piece of paper, because it's much easier to actually move the figures up or down or make changes without having to redraw the entire scene. Next, I photocopy the final pencil sketch and cover the back with a lot of lead from a soft pencil. I turn the copy over onto watercolor paper and go over each line with a very sharp pencil. Now I begin to paint. I use watercolor because I can achieve the vibrancy through layering. The watercolors tend to be transparent, so I can change a color just by layering different tones.

What's the best part of your job?
Chris I get to go into different elementary schools and speak to children about how I actually put these books together to encourage them to read and write and appreciate art more.

Fig. 5–15. Watercolor paints allow the artist a great deal of versatility and control over the color he wants to achieve.
Chris Soentpiet, *Dear Santa, Please Come to the 19th Floor*, 2001.
Watercolor on paper. Courtesy of the artist.

Chapter Review

Recall Who was the first Western artist to use watercolor to create finished works of art?

Understand Explain the difference between the actual texture of an object and implied texture. Cite an example of each.

Apply Create a smooth watercolor wash that covers an area at least 4" x 4".

Analyze Describe how Charles Demuth uses watercolor in *Plums* (Fig. 5–9). Where are the lightest and the darkest areas? Where are the greatest contrasts? Why do you think he left some of the leaves unpainted?

Synthesize Write a diary entry that either Maurice Prendergast (Fig. 5–1) or William Henry Hunt (Fig. 5–4) might have written as he painted his artwork. What was the artist most interested in showing? How quickly or slowly did he work? What brushes and colors was he using? How did he mix his colors? What was around him as he painted?

Evaluate Select one of the paintings in this chapter that you feel best shows the personality or mood of one or more people. Explain how the artist's composition and watercolor techniques suggest this personality or mood.

Portfolio Tip

Include examples of your watercolors in your portfolio to demonstrate your mastery of this medium. Keep examples of several different techniques, including wet-on-wet and dry brushwork.

Writing about Art

Write a rhymed or free verse poem about the nonobjective watercolor that you created for the studio experience in this chapter. It can be descriptive or can act as an accompanying piece. After you have completed the poem, play the music that inspired the watercolor. Do the painting, poem, and music form a tightly-knit trio? Or are the poem and music quite different from one another? Consider how artists, writers, and musicians find inspiration in other art forms. Also recognize that creative work can continually focus on a single idea or explore divergent directions.

Fig. 5–16. What textures did this artist create? What techniques did he use to create them?
Jaime Cann (age 14), *San Juan Islands*, 2000.
Watercolor, 18" x 14" (46 x 35.5 cm). Kamiakin High School, Kirkland, Washington.

Vocabulary
collage
impasto
mixed media
opaque
triptych

Fig. 6–1. Mount Fuji, which forms the background, is a sacred mountain to the Japanese and has been a popular subject for artists for hundreds of years. Compare the methods used to paint the background and the vase of flowers. How are they different?
David Hockney (b. 1937), *Mount Fuji and Flowers*, 1972.

Acrylic on canvas, 60" x 48" (152 x 122 cm). The Metropolitan Museum of Art, Purchase, Mrs. Arthur Hays Sulzberger Gift, 1972 (1972.128). Photograph by Lynton Gardiner. Photograph ©1977 The Metropolitan Museum of Art. © David Hockney.

6 Acrylic

L et's face it, an oil painting takes a very long time to dry. And in a fast-paced world, quicker is often perceived as better. So when a new type of paint came along that looked and acted like oil paint but dried in a fraction of the time, it is not surprising that artists quickly embraced it.

Acrylic paints came onto the art market in the United States in the 1950s and provided artists with a water-based paint that dries quickly but still can be worked like oils. American artists who were among the first to use acrylics were Jackson Pollock, Mark Rothko, Robert Motherwell, and Helen Frankenthaler. The medium is very versatile and can be applied to many different kinds of surfaces, including canvas and paper. Acrylics can be applied thickly or thinned with water to create *stains* or washes, as in watercolor. Today, both watercolorists and oil painters use acrylics as an alternate medium.

In this chapter, you will explore ways of working with acrylics, including applying paint using different methods, experimenting with both transparent and opaque techniques, and creating textures. You'll also learn a few clues about how to create unity and variety in your work. A discussion about the art form of collage and the work of Romare Bearden will help open your mind to new ideas and inspirations.

synthetic bristles

coated surfaces

versatile techniques

Acrylic Surfaces

One of the advantages of acrylics is that they can be applied to a great variety of surfaces, including canvas, papers of all types and weights, cardboard, wood, Masonite, metal, and plaster. However, they do not adhere permanently to surfaces covered with oil-based paints. Experiment to find surfaces on which you enjoy painting with acrylics. Before using some surfaces (for example, untreated Masonite), it is best to prepare the surface with a coat or two of acrylic gesso. Coating both sides of a panel will help prevent warping. If you work on canvas, be sure to use canvas (boards or stretched) that has been coated with acrylic gesso.

Tools and Equipment

Brushes with synthetic bristles have been developed especially to work with acrylics. They are easier to clean and last longer than natural-bristle brushes.

Because acrylics dry rapidly, it is essential that you clean brushes and other tools quickly and thoroughly. Keep a large jar or can of water nearby and immediately rinse brushes. Warm water dissolves the paint more easily. If brushes dry with paint on them, try soaking them in an acrylic remover for several hours. This sometimes works. Of course, it's much easier to keep the brushes clean than to spend time later trying to remove rock-hard acrylic paint.

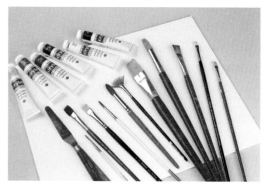

Fig. 6–3. Many types of brushes are available, and several rounds and flats should be among your basic tools. The same painting knives used for oils can be used with acrylics.

Fig. 6–2. How did the artist create contrast in this painting? How did he create a sense of depth? Jonathan Papazian (age 16), *Will of the Wisp,* 1997.

Oil, 18" x 24" (46 x 61 cm). Northbridge High School, Northbridge, Massachusetts.

Fig. 6–4. What mood or feeling is created by this acrylic painting? What does the painting remind you of?
Koichi Urano (b. 1944), *Mt. 148*, 1998.
Acrylic, 38 x 38" (96.5 x 96.5 cm). Walter Wickiser Gallery, New York. Photo © 1998 D. James Dee.

Palettes can be disposable (paper or cardboard) or permanent (plastic or wood). Artists who work with acrylics usually use disposable palettes because once acrylics dry, they are permanent. Transfer only small amounts of paint to your palette until you get accustomed to your needs. Drying acrylics cannot be returned to their tubes and should not be returned to jars. If you are using thinned acrylics as you would watercolor, with similar techniques, you can use regular watercolor palettes.

Note It There are several dozen available colors of acrylic paint, but you won't need all of them. In addition to the primaries, select colors that reflect your personal interests and needs. Eight to twelve colors will provide you with many mixing possibilities.

Mixed Media and Collage

In your search for something new and exciting in your painting, have you ever thought about adding unusual materials, to give your work another dimension or area of interest? Contemporary artists often do just that. Howardena Pindell used three kinds of paint, cattle markers, and vinyl type in her **mixed-media** artwork (Fig. 6–5). Mixed-media artists combine more than one art medium in one artwork. For example, they might add pastel lines to a watercolor painting; or print on canvas, and then glue on bits of fabric before brushing with oil paint.

One popular form of mixed-media artwork is **collage**—the pasting or gluing of paper or other materials to a surface. French artists Pablo Picasso and Georges Braque began adding pieces of wallpaper, newspaper, and oilcloth to their paintings, to create the first collages about 1912. Almost every artist or group of artists in the twentieth century—including the Cubists, Expressionists, and Surrealists—experimented with some form of collage. Notable artists who have worked with the medium are Henri Matisse (see Fig. 3–4, *Danseuse Créole*) and contemporary artist Jaune Quick-to-See Smith (Fig. 28, page 197), whose collages often explore issues faced by Native Americans in contemporary American society.

Collage materials can be combined with almost every medium that painters use. They can blend comfortably with painted surfaces or stand in bold contrast to them. Artists may apply collage techniques to create abstract or realistic drawings and paintings as well as three-dimensional compositions.

Mixed-media and collage artists continually experiment with common objects and are always on the lookout for new materials. They use paper, fabric, or manufactured materials such as screening, or they may incorporate handmade papers or found natural objects, such as leaves, grasses, or flowers. In short, the possibilities for mixed-media artworks are nearly endless, and the art form is an exciting way to experiment with textures, surfaces, and dimensions.

Fig. 6–5. The face in the center of this artwork is the artist's self-portrait. How does her unusual mix of media enhance the artwork's meaning?
Howardena Pindell (b. 1943), *Autobiography: Water/Ancestors/Middle Passage/Family Ghosts*, 1988.
Mixed media on canvas, 118" x 71" (300 x 180 cm). The Wadsworth Atheneum Museum of Art, Hartford, CT. The Ella Gallup Sumner and Mary Catlin Sumner Collection Fund, 1989.17.

Basic Acrylic Techniques

Because of their versatility, acrylic paints can be used for almost any technique, from transparent, watercolor-like washes to **impasto**, in which the paint is applied thickly so that it stands out from the surface.

Most acrylics dry to a semimatte finish. Adding one of several liquids, such as water or acrylic medium, can change the quality of the dried surface. They can produce glossy or matte surfaces or can make the paint transparent without affecting the brushing consistency. To use a technique in which the paint is **opaque**, or cannot be seen through, try using paint directly from tubes or jars and applying it with synthetic

Fig. 6–6. Acrylic brushes and other tools are used to create a variety of marks and brush-strokes.

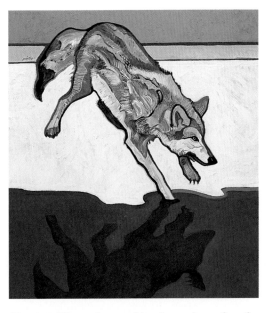

Fig. 6–7. The artist combined a variety of surface textures within a single work—heavily textured for the wolf, subtly textured for the snow, and smooth for the water.
John Nieto (b. 1936), *Alpha Wolf Testing the Water*, 1999.
Acrylic, 44" x 40" (112 x 102 cm). Ventana Fine Art, Santa Fe, New Mexico.

Fig. 6–8. This work is called a triptych, because it is made from three panels. How does the painting change from panel to panel?
Sally S. Bennett (b. 1935), *Running Off,* 1999.
Acrylic on canvas, 36" x 72" (91.5 x 183 cm) triptych. Courtesy of Koelsch Gallery, Houston, TX, the artist, and a private collector.

brushes or knives. Brush the paint out flat or leave textured strokes. Be sure to use a surface that is sturdy enough to support the paint, such as canvas, cardboard, or wood.

When artists use acrylic paint transparently, they often work on the same papers used for watercolors or on cold-pressed illustration boards. The white paper glowing through layers of transparent color produces true watercolor effects. You must dilute the paints with water or acrylic medium to the desired transparency (test it continually) and paint with large, soft brushes. If you thin the color drastically, you will need to add some acrylic medium so that the paint retains a brushing consistency. To extend the drying time of the paint, you can add acrylic retarder. This will give you more time to blend strokes.

Combining techniques (for example, applying glazes over textured brushstrokes) produces surface qualities unobtainable in any other single medium. Many overlays of color (transparent and semitransparent) can create areas rich in color and texture. You can even sprinkle sand and other materials onto the wet surface. Line work

Fig. 6–9. Notice how the artist layered small patches of red paint over stripes of black and greenish gray. What effect is achieved by this layering?
Alma Woodsey Thomas (1891–1978), *Red Sunset, Old Pond Concerto,* 1972.
Acrylic on canvas, 68 ½" x 52 ¼" (175 x 134.5 cm). Smithsonian American Art Museum, Washington, DC.
© Smithsonian American Art Museum/Art Resource, NY.

can be done by thinning acrylics and using a soft, pointed brush. Before you start a painting, try several techniques on scraps of paper or cardboard.

Try It It's easy to paint a new acrylic painting on top of a previous one. This reuse helps you to recycle materials, and it can also produce a painting with an interesting surface texture. Be sure to first cover the old, dry painted surface with acrylic gesso.

Note It Because acrylic paints dry rapidly, immediately replace the caps on tubes or jars. Wipe off excess paint from edges and rims to prevent lids from adhering to containers.

Fig. 6–10. Notice the variety of brush-strokes the artist used to paint this image. How has he created unity and variety?
Barthosa Nkurumeh, *Ojemba: Moonwatch*, 1997.
Acrylic on board, 42" x 32" (107 x 81 cm). Courtesy of the artist.

Unity and Variety

In art, unity creates a feeling of wholeness, whereas variety creates visual excitement. A unified artwork that has no variety can seem visually uninteresting. So artists often keep in mind both of these design principles as they work.

In acrylic paintings (or paintings made using other media), unity may be achieved through the use and repetition of similar elements, such as color, line, shape, and so on. Such repetition "links" all of the parts of the composition. A dominant element can also create unity. Variety can be added through the use of contrasting elements or materials.

Fig. 6–11. Where did the artist use acrylic transparently? How did he use line to draw your eye to the center of interest?
Michael Seng (age 16), *Rush*, 1998.
Acrylic, 16" x 20" (40.5 x 51 cm). Asheville High School, Asheville, North Carolina.

Paint with Acrylic

The versatility of acrylic paints makes it possible to use a variety of techniques. Experimenting with several methods is important, because it will help you to determine your personal preferences. Following is a demonstration of one method you can try. Begin by making several sketches of your subject, exploring various arrangements. Sketch until you feel comfortable with your subject.

To observe ways to work transparently, refer to the watercolor demonstration on page 74; you can apply these same techniques to acrylic work. Demonstrations in the tempera and oil chapters can suggest ideas for working opaquely. At times, try combining these two extremes—transparent and opaque—to make unique statements.

1 Use a round brush and a neutral paint color thinned with water (light gray-green, for example) to roughly sketch in your composition. Because you will be using opaque paint, corrections can be made immediately in the sketch. Details are unimportant at this time. You may also use charcoal or pencil for the sketch.

2 Using thinned acrylic washes (water and matte medium can be used for thinning), quickly brush large areas of color over the surface to cover most of the white canvas. Colors need not be the final hues.

3 With a flat brush, apply paint directly to the surface. Add major elements and supporting shapes and objects. No detail is needed yet, and color shapes are left flat.

4 With a flat brush, add details and create texture. Here, brushstrokes are allowed to remain visible. Change any colors and shapes as necessary. Also add dark tones to suggest shadows and three-dimensional forms.

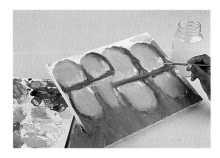

Squint your eyes to check for contrasts in your painting. Continue to add highlights and to darken shadows by using lighter tints and darker shades of the colors already used.

Romare Bearden

Fig. 6–12.
Romare Bearden.
Photo by Marvin E. Newman. Courtesy of the Bearden Foundation.

What profession do you think you would like to pursue as an adult? Romare Bearden always liked math, and at one point he planned to attend medical school. But along the way he became an artist.

Romare Howard Bearden was born in Charlotte, North Carolina, in 1911, but soon after his family moved to Harlem in New York City. A childhood friend taught him how to draw, and as a young man Bearden worked as a cartoonist and painted murals, among other jobs. He also studied at New York University, Columbia, and the Sorbonne, a renowned institution in Paris. After studying the works of the old masters, Bearden said: "I learned a great deal about the way a painting is put together."

Early in his career, Bearden worked mostly in watercolor, mixed media, and tempera, and his style was clearly influenced by the abstract compositions of Pablo Picasso. In 1964 he began a series of collages based on the experiences of African Americans. It was through his use of this medium that the artist found his artistic voice. Bearden's collages contain references to his childhood experiences, and he often included such images as guitar players or other musicians reminiscent of the Harlem jazz age of the 1930s.

Although Bearden achieved great success as a collage artist, he was always trying something new. During his long life, he was codirector of the Cinque Gallery in New York City and taught at Williams College and Yale College. He also wrote popular music and more than one book and designed sets for the Harlem-based Alvin Ailey Dance Company. In 1987, one year before he died, Bearden was awarded the President's National Medal of the Arts, an award that honored his outstanding contributions to American culture.

Fig. 6–13. How did Bearden create a sense of unity between the two seated figures? Also notice how the artist used cuts instead of painted or drawn lines to delineate details, such as folds in the clothing.
Romare Bearden (1914–1988), *The Family*, 1988.
Collage on wood, 28" x 20" (69 x 51 cm). Smithsonian American Art Museum, Washington, DC. © Romare Bearden Foundation/Licensed by VAGA, New York, NY.

Studio Experience
Acrylic Triptych

In this studio experience, you will create a unified, three-part acrylic painting of a subject of your choice. Historically, artists created a **triptych**—a painting made on three panels—by painting on two side panels that closed like doors over a central painting. Today, artists continue to use this traditional three-part structure, although contemporary paintings usually have three panels side-by-side rather than side panels that open and close.

Before You Begin

● Study the triptych by Sally S. Bennett (Fig. 6–8). Conduct research using art books, an encyclopedia, and/or the Internet to find additional examples of modern and historical triptychs. How does each artist divide his or her composition among the three panels? How do the contemporary triptychs compare to those painted centuries ago?

● Think of a composition suited to a three-panel format. For example, depict a scene or setup from three different views, in three styles, or at three different times of day or year. Your triptych may also reflect a sequence, such as three images that show you in elementary, middle, and high school or a setting before, during, and after a particular event.

Create It

1. Select a subject for your painting. Draw a pencil sketch for each panel. Decide whether each panel will be the same size or if the central one will be more prominent. Think about how to create a sense of unity across the three panels.

2. Decide whether you will paint three separate acrylic paintings and attach them to each other or whether you will divide a single work surface into three sections. If you choose the former, work out a system to secure the panels together. Decide at what size your composition will work best.

❶ Fig. 6–14.

3. Gather the materials that you will need, including paints, working surface(s), brushes, palette, easel, and containers.

❷ Fig. 6–15.

4. Review your preparatory drawings. On the painting surface, sketch in the main shapes and lines of your composition, using a pencil or thinned paint. Don't worry about any details at this point. Make sure that the relationships among the three drawings accurately reflect your intended plan.

❸ Fig. 6–16.

5. Begin painting. See page 88 for a demonstration of one possible acrylic technique. Be sure to unify the three parts of the painting, but remember that a unified artwork that lacks variety will appear unexciting.

Check It

Does your finished painting successfully convey your intentions? Do the three panels or sections seem unified? Why or why not? Did you use your painting medium successfully? Explain. What did you learn from this project? Describe what you will do differently the next time you create a painting with multiple parts or sections.

Sketchbook Connection

Make three drawings of objects or scenes that have the same theme or subject. These might be three different views of the same object or the same location at three different times of the day or year.

Rubric: Studio Assessment

4	3	2	1
Contextual Understanding · Historical · Personal			
Highly sensitive to obvious and subtle connections between format and content of artwork. Sophisticated, deep, subtle	Detects obvious, important connections between format and content of artwork. Hits the mark	Detects a few obvious connections between format and content of artwork. Surface understanding	Little detection of connections between format and content of artwork OR connections seem vague, unfounded, or unrelated. Vague, disconnected
Composition · Unity · Variety			
Achieves strong unity across all three panels; variety also effectively used to create compelling interest in each work. Integrated, balanced, compelling	Achieves sufficient unity across all three panels; variety used to create interest in each work. Satisfactory, interesting	Approaches unity across all three panels OR one panel may be incomplete or needs significant reworking. Rework or completion needed	Inconsistency in achieving unity across all three panels OR two panels may be incomplete or need significant reworking. Disjointed, incomplete
Media Use · Acrylic media · Panel construction			
Well-executed sketch. Inventive use of washes, impasto. Expert depiction of details, form. Well-crafted construction. Expert, experimental, well crafted	Successful sketch. Proficient washes, impasto. Imaginative details; convincing forms. Strong construction. Competent, appropriate	Inadequate sketching. Some unsuccessful washes, impasto, OR careless work, unconvincing forms. Construction needs work. More practice indicated	Lack or incorrect use of washes. Minimal details. No understanding of form. Inadequate construction. Rudimentary difficulties
Work Process · Research and notes · Sketches · Critiques · Reflection/Evaluation			
Thorough documentation; goes above and beyond assignment expectations. Thoughtful, thorough, independent	Complete documentation; meets assignment expectations. Meets expectations	Documentation is somewhat haphazard or incomplete. Incomplete, hit and miss	Documentation is minimal or very disorganized. Very incomplete

Web Links

transit.metrokc.
gov/programs_
info/sheltermural/
shelter_mural.
html

*Learn about how
King County
(Seattle, WA)
involved students
and other community
members in a
bus shelter mural pro-
gram.*

www.muralarts.org
*Web site for Mural
Arts, an organiza-
tion that provides
art as a "city service"
to the neighborhoods
of Philadelphia and
features a mural arts
program for city
youth.*

Muralist
Dorothy Gillespie

Dorothy Gillespie was born in 1920 in Roanoke, Virginia, where "nice girls" didn't become professional artists. Nevertheless, she attended the Maryland Institute of Art in Baltimore and then studied in New York City. In the 1940s, Gillespie saw the explosive art of the Abstract Expressionists, and her life was changed forever. She abandoned realism but found abstraction challenging at first. Gillespie soon learned how to move beyond simply creating good designs to creating good art.

Fig. 6–17.
Dorothy Gillespie.
Photograph by
David McIntyre.

When and why did you begin working with acrylics?

Dorothy I started when acrylics first came out because I wanted to master any medium. I use everything. I say, "I'm a pig! I want it all."

Acrylic suits me because it dries fast, the colors are brilliant, and it mixes well with other media, such as pastels. Now I'm using acrylics on vinyl. I take one of my small four-by-six-inch paintings to a printer, who scans it in by computer. The image comes out ten-by-six feet onto vinyl, and then I work on top of that with acrylics. It's very exciting.

Why do you like working large for your murals?

Dorothy Well, why not! I don't have any limitations. Actually, I work very small, or very large, or in between. I also sometimes work in sections. I'll have units that are two inches apart, but I'll have sixteen of them. I think big. Some of my work is six stories high. I do a twelve- or fifteen-foot work on my own, but anything bigger than that is usually a commission.

The murals are not like billboards. They're art. So from any distance they say something to you. If you're up close, they have detail. If you're far away, they're strong enough to still communicate.

What is most essential to becoming a professional artist?

Dorothy Whether you're going to be realistic or abstract, you must learn the basics—life drawing, design, color, color mixing, and such. Then no matter what style or medium you use, you have the basics. For instance, anyone can learn to paint with acrylics from a book. It's the vision that's important. I always say to young people, it takes eight million brushstrokes to be an artist.

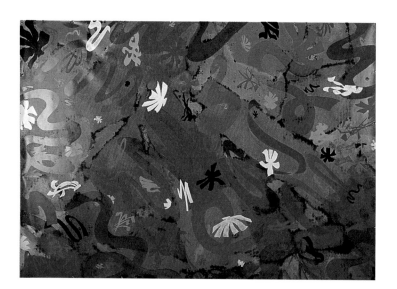

Fig. 6–18. This artwork provides a good example of the versatile nature of acrylic paints.
Dorothy Gillespie (b. 1920), *Celestial Celebration,* 1994.
Acrylic on vinyl, 9' x 6' 4" (2.7 x 1.9 m). Courtesy of the artist.

Chapter Review

Recall Where and when were acrylics first widely used?

Understand Why do many contemporary artists paint with acrylics instead of oils?

Apply Demonstrate the versatility of acrylic paints by creating an impasto and a transparent, watercolor-like wash.

Analyze Describe how Howardena Pindell created unity and variety in *Autobiography: Water/Ancestors/Middle Passage/Family Ghosts* (Fig. 6–5).

Synthesize Consider yourself the artist of one of the paintings in this chapter. Write a poem about the process of painting the work. You may focus on one aspect or several, such as choosing and applying color, working with the brush, or searching for ideas, meaning, or mood. Try to make the cadence and rhythm of the words fit the mood and movement within the art.

Evaluate Imagine that you are a newspaper art critic reviewing an art show at a local gallery featuring Sally S. Bennett's *Running Off* (Fig. 6–8) and Alma Thomas' *Red Sunset, Old Pond Concerto* (Fig. 6–9). Explain why your readers might enjoy seeing these paintings. Describe the style and colors so that viewers will know what to expect. Include as much detail relating to the acrylic medium as you are able to observe.

Portfolio Tip

What is happening in your world as you create your art? Artists are part of their community and world. Events affect their art, sometimes in subtle and not so subtle ways. Write reflections about what is happening around you, what you are thinking about or concerned about, and how these might have affected your art. Include the reflections in your portfolio.

Writing about Art

The medium of acrylic has its roots in Europe and the United States, yet artists across the world use it today. Research a contemporary artist from Africa, Asia, India, Latin America, or the Middle East who works in acrylic. Think about the principle influences on this artist. What are influences from the artist's own culture? Can you see traces of the European, or Western, tradition? Write a short essay explaining your ideas, or interpretations, of these influences on the artist.

Fig. 6–19. How did the artist create the look and texture of stone in this artwork?
Anthony P. Weinstock (age 15), *Tom Wolfe in Stone*, 1998.
Acrylic, 11" x 14 ½" (28 x 37 cm). Westboro High School, Westboro, Massachusetts.

Vocabulary

primer
scumbling
underpainting
Surrealism
self-portrait

Fig. 7–1. This Mexican painter is known for a large series of self-portraits. How did she create a sense of balance in this work?

Frida Kahlo (1910–1954), *Self-portrait with Thorn Necklace and Hummingbird*, 1940.

Oil on canvas, 24 3⁄8" x 19" (62 x 48 cm). Iconography Collection, Harry Ransom Humanities Research Center, The University of Texas at Austin. © 2002 Banco de México Diego Rivera & Frida Kahlo Museums Trust. Av. Cinco de Mayo No. 2, Col. Centro, Del. Duauhtémoc 06059, México, D.F.

7 Oil

Imagine that you are a painter in the mid-nineteenth century. Before painting, you must crush minerals into powdered pigments, add the binder, and store your paints in casings made of animal bladder—but only for a short time because the containers are not airtight, and the paint quickly dries out. The process may take hours. One day, a fellow artist gives you a tin tube with a replaceable cap. You squeeze the tube and what do you see? Oil paint—mixed and ready to use!

The 1841 invention of collapsible tubes for paints changed the art world. The tubes provided premixed paints; prior to that time, most artists mixed their own paints or had apprentices do it for them. They also allowed artists to paint outdoors, a practice embraced by the Impressionists and artists ever since.

The history of oil painting began in Northern Europe in the fifteenth century, during the early Renaissance. Over the centuries, artists continued to expand the medium's techniques and possibilities. In the early twentieth century, Pablo Picasso and Henri Matisse set the stage for contemporary work in oils by exploring abstraction, distortion, and unusual uses of color.

stiff bristles

In this chapter, you will learn some helpful hints for setting up a painting station, thinning paints, and mixing colors. You'll also study the works of two artists who created dreamlike paintings that surprise and puzzle the viewer and create a self-portrait painting that allows you to share a personal message or feeling in your work.

layering colors

primed surfaces

Oil Surfaces

Oil painting surfaces range from wood to paper to traditional canvas (linen or cotton). Most surfaces will first need a coat of a **primer**, the glue or *size* (such as gesso), used to prepare a painting surface. It prevents the oil paint from seeping into the surface. Watercolor or charcoal paper can be used as is or primed with a thin wash of gesso. Preprimed canvas is available in rolls to be cut and stretched on stretcher bars or in prestretched sizes. Canvas boards come ready to use. Wood, plywood, chipboard, and Masonite must be primed with gesso before painting.

Fig. 7–2. Although some traditional oil paints and thinners are toxic, there are nontoxic alternatives available.

Tools and Equipment

The brushes most often used for oil painting are made of stiff, white hog bristles. They come in three types: long bristles with rounded tips *(filbert)*, long bristles with square tips *(flat)*, and short bristles with square tips *(bright)*. Fan-shaped brushes are used for blending colors on the canvas, and thin *riggers* are used for fine lines and detail. All brushes should be cleaned thoroughly in turpentine and wiped with a cloth when painting sessions are over, because oil buildup will quickly ruin brushes. In addition to brushes, a palette knife can be used to mix colors on a palette, to scrape paint off a palette or canvas, or to apply paint. Palette knives are thin and flexible and are available in several shapes.

Fig. 7–3. Although this work is abstract, the artist was inspired by nature. The title, which is in French, means "dirty snow." What elements in the painting call to mind this image? Joan Mitchell (1926–1992), *Sale Neige*, 1980. Oil on canvas, 86 ¼" x 70 ⅞" (219 x 180 cm). The National Museum of Women in the Arts, Washington, DC. Gift of Wallace and Wilhelmina Holladay.

Palettes come in a variety of forms. Traditional wooden palettes should be cleaned regularly and given a coat of linseed oil each time. Tear-off wax-paper palettes are convenient because you can begin each session on a fresh sheet.

A floor or table easel is essential. It will help to keep your painting surface in an upright position so that you can work comfortably. An easel will also enable you to view your painting surface at a good angle. To work on paper surfaces, tape them to a board placed on an easel.

It's quite simple to make a brush washer. Punch holes in the bottom of a small, empty pet-food or tuna can. Place the can, with the bottom facing up, in a wide-mouthed glass jar. Fill the jar with turpentine to at least a few inches above the can. You can easily clean brushes, and the dis-

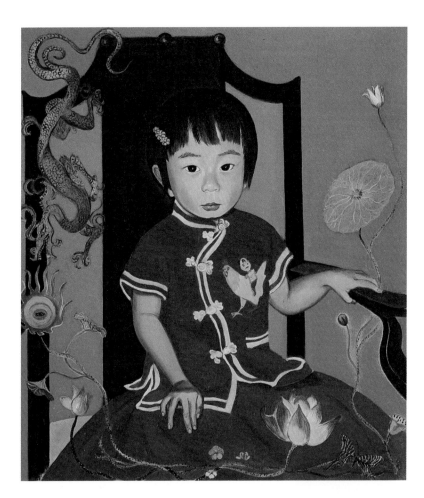

Fig. 7–4. Notice that the artist added a dragon and floral motif curling around the sides of her composition. How does this motif change the mood or feeling of the portrait? Jane Smaldone (b. 1953), *If They Could See Her Now (My Chinese Daughter)*, 1997–98.

Oil on canvas, 26 ¼" x 23" (67 x 58 cm). Nielsen Gallery, Boston. Photo by Susan Byrne, Brookline, Massachusetts.

carded paint will sink through the holes to the bottom of the jar. Palette cups or small tins can also be used to hold small quantities of linseed oil or turpentine.

Safety Note Use turpentine only in an area with active ventilation.

Note It Oil paint is a versatile medium, but some artists consider its lengthy drying time a drawback. In recent years, several manufacturers have developed fast-drying oils, called alkyds. Quick drying, however, eliminates the extended workability of the medium, one of oil's favored characteristics.

Of course, you may choose the colors you prefer, but the following list is a good beginning. It contains pairs of each hue—one bright and the other subdued. Make sure you get a large tube of white paint; you'll use it often, mixing it with most other colors to create tints.

Blues: Ultramarine and Phthalocyanine
Reds: Cadmium Red* and Alizarin Crimson
Yellows: Cadmium Yellow* and Yellow Ochre
Green: Viridian.* (Mix others with yellows and blues.)

Browns: Burnt Umber* and Burnt Sienna
Black: Ivory Black
White: Zinc White or Titanium White

*Make sure you are using the nontoxic alternative to these pigments. Check with your teacher if you are unsure, or avoid them altogether.

Basic Oil Techniques

Oil paints have been popular for centuries, in part because of their versatility. Artists have used the medium in many ways, from thin, transparent washes to applying it directly from the tube. Oil paint is a thick paste that is spreadable with a stiff brush. For a more fluid quality, thin the paint with linseed oil, turpentine, or a fifty-fifty mixture of the two. Thin washes can be applied to most surfaces and can be used over previously painted areas. If you are using water-soluble oil paints, water is the only thinning agent you'll need.

Beginning painters often work on scrap paper or cardboard to practice. By experimenting with different brushes, you will become familiar with the characteristic strokes that each one makes. Adding a few drops of turpentine will make colors more spreadable and also help to cover a painting surface more completely. Mix colors on a palette before applying them or place two colors next to each other on a painting surface and then mix them with a brush or knife. Scratching into a painted area and applying small amounts of paint directly from a tube also creates interesting results. Also try **scumbling**, in which you apply an opaque color over a dried first layer of a different color. Then, using a brush or a sponge, remove some of the opaque color to create textures and to allow the bottom color to show through in spots. After a bit of practice, you'll be ready to try your first oil painting.

Although there are many different painting techniques, one popular method is to build up layers of paint. First, an artist creates a monochromatic **underpainting**—the first layer of a painting—to sketch in the main shapes. This layer is usually done with thin washes of paint that will dry quickly. When this layer is dry, the artist builds up increasingly thicker layers of paint, allowing each to dry before continuing. It is important to work from thin layers to thick ones. A thin layer that has dried will not remain flexible; if a thick layer beneath it continues to dry and shrink, the thin layer will crack and flake off. Another technique is painting wet into wet, known as *alla prima*. Painting alla prima means that the artist completes the work in one session, mixing and blending directly into the wet underlayers. This technique is especially useful when working outdoors or if you wish to create a fresh surface with soft highlights. Although this method may sound simple, it is easy to overwork the surface; it is then necessary to scrape off the paint with a palette knife and begin again.

Fig. 7–5. Soft-hair brushes and synthetic-fiber brushes make strokes that are different from hog bristle brushes. The palette knife is used for mixing paint and for cleaning palettes.

Contrast

Contrast is a great difference between two things. Artists use contrast to add excitement or drama to a work.

In oil paintings, artists often use complementary colors—for example, painting a red object on a green background—to create a strong contrast. Such effects can also be created through the use of black and white or strong shadows and highlights. Artists can create contrast by using strong differences between shapes, lines, textures, patterns, and other elements. Adding a different material to an oil painting, such as collage or other art medium, will also create contrast and add interest to the artwork.

Fig. 7–6. The artist used thin washes of paint to create a muted, mysterious image. What part of the painting has contrast? What effect does this element create?
Iza Wojcik (age 18), *Lonely Stairway,* 1996.
Oil, 18" x 24" (46 x 61 cm). Lake Highlands High School, Dallas, Texas.

Fig. 7–7. Study this painting of Duchamp's two youngest sisters. What elements or principles of design did he emphasize?
Marcel Duchamp (1887–1968), *Yvonne and Magdeleine Torn in Tatters,* 1911.
Oil on canvas, 22 3/4" x 28 7/8" (60 x 73 cm). Philadelphia Museum of Art, Philadelphia. The Louise and Walter Arensberg Collection, 1950. © 2002 Artists Rights Society (ARS), New York/ADAGP, Paris/Estate of Marcel Duchamp.

Oil paints need time to dry—often many days, which is a disadvantage if you are in a hurry or without storage space. But the slow drying time can be an advantage if you want to rework areas several days later. Be sure to store all works-in-progress carefully to avoid smearing and smudging.

Try It Explore the use of short, choppy strokes; long, loose strokes; and scrubbing strokes. Try using the tip, sides, and edges of a brush to see what kinds of marks they make. Use paint directly from the tube but also try painting with thin washes.

Safety Note Be especially careful when using oil paints and solvents such as turpentine. Make sure there is active ventilation. Wash your hands frequently. And never put brushes—even the handles—in your mouth or near your eyes.

Most oil pigments are nontoxic, but some can irritate your skin and be harmful to breathe. Avoid the following pigments if they are labeled as toxic: Naples yellow; cobalt pigments such as cobalt violet, blue, green and yellow; chromium oxide green; viridian; chrome yellow; zinc yellow; strontium yellow; cerulean blue; flake white; manganese blue and violet; raw and burnt umber; Mars brown; vermilion; all cadmium pigments.

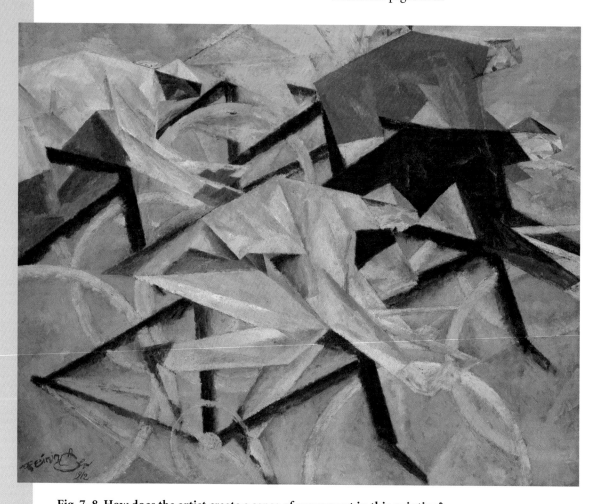

Fig. 7–8. How does the artist create a sense of movement in this painting?
Lyonel Feininger (1871–1956), *The Bicycle Race*, 1912.
Oil on canvas, 31 ⅝" x 39 ½" (80 x 100 cm). Photograph © 2002 Board of Trustees, National Gallery of Art, Washington, D.C. Collection of Mr. and Mrs. Paul Mellon. #1985.6417.© 2002 Artists Rights Society (ARS), New York/VG Bild-Kunst, Bonn.

René Magritte's
The *Empire of Lights*

Look closely at the painting *The Empire of Lights* shown in Fig. 7–9. Do you notice anything odd? Although the work appears to be painted realistically, the artist combined a daytime sky with a nighttime street scene.

This painting is an example of **Surrealism**, an artistic movement that became popular in Europe in the 1920s. It officially began in 1924, when the writer André Breton wrote the "Manifesto of Surrealism." The movement was not limited to painters but included artists of all kinds—sculptors, filmmakers, printmakers, and writers. The Surrealists explored a world of dreamlike images, and their works were meant to show people a "surreality," a world above or beyond conscious thought. Surrealist painters combined images or objects in a way that is some-times humorous, sometimes frightening, and almost always surprising.

René Magritte was born in Belgium in 1898. After his mother died when he was thirteen, he persuaded his father to send him to art school in Brussels. As a young man, Magritte supported himself by painting roses in a wallpaper factory and designing advertisements. The straight-forward, realistic technique that the artist learned at that time is one that he relied on for the rest of his career.

Magritte's contradictory image *Empire of Lights* is characteristic of the Surrealist aesthetic. As with many of his paintings, this work is oddly unsettling. The intense realism of the scene upsets our sense of the "normal" and makes us question what unnatural event caused such an occurrence. Magritte and the Surrealists enjoyed creating these mysterious worlds in which the ordinary is extraordinary, thus forcing us to imagine a world beyond the "real" one.

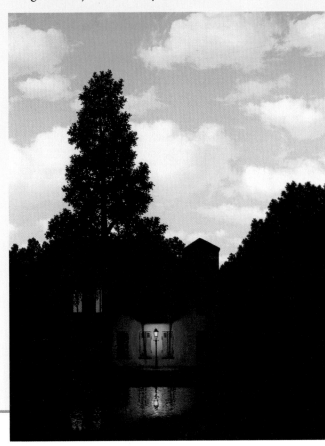

Fig. 7–9. Magritte was influenced by the American writer Edgar Allan Poe, whose mysterious tales were very popular in French translations. Many of his compositions contain everyday things, such as men's hats, clouds, pipes, forests, and musical instruments, placed in unusual or extraordinary contexts.
René Magritte (1898–1967), *The Empire of Lights*, 1954.
Oil on canvas, 57 ½" x 45" (146 x 114 cm). Musée d'Art Moderne, Musées Royaux des Beaux-Arts, Brussels, Belgium. © Herscovici/Art Resource, NY/Artists Rights Society (ARS), New York.

Paint with Oils

Painting in oils requires more patience than working with watercolors or acrylics because the drying time is much longer and the brushing techniques are more complex. Many artists feel that the extra effort is worthwhile, however, considering the unique effects possible with oil. This demonstration will guide you through important steps and help you to begin painting. Of course, these suggestions offer only a few of the many ways to work with oil paints.

1 After making several pencil sketches on scrap paper, use diluted color and a small brush to make an outline of your planned composition on the primed painting surface.

2 Use a larger brush to paint any large, bold areas. Think about your light source. Many oil painters begin with shadows or dark values and add areas of lighter value next. Some darks can be lightened later, as the painting develops. If you decide to start by adding a background color, use a thin wash that will dry more quickly.

Try It As you study the various oil paintings in this chapter and throughout the book, try to determine the methods used by different artists.

3 Fill in smaller areas using a medium-size brush. If you began with darker values, add any sunlit surfaces and light-value areas. Ease the contrast between dark and light areas by adding transitional values. Add secondary objects and shapes that overlap the larger areas.

4 With a smaller brush, add finishing touches, including textures, patterns, and other details. Make final value and color adjustments. Because oil paint takes a long time to dry, you may also make larger changes (or even scrape away areas of paint), if you wish.

Note It Oil paint shrinks as it dries, and it dries very slowly. Because most oil paintings consist of several layers, remember to paint thick layers over thin ones, rather than the reverse.

Matta

What words describe the painting *A Grave Situation*, shown in Fig. 7–10? How does it make you feel? The artist called Matta is known for nightmarelike compositions that convey a strong sense of motion and energy. This work, completed just after World War II, reflects the sense of horror and helplessness that many people felt at the time.

Matta's full name is Roberto Sebastián Antonio Matta Echaurren. He was born in Chile in 1911 but has lived in many countries, including Mexico, Italy, and Spain. A talented artist at a young age, Matta had decided to study architecture in college. His teachers recommended that he continue his career in Paris, a city with a tradition as a world art center.

After moving to France in the 1930s, Matta began painting, and his works—which were influenced by Surrealism—received immediate attention. But the young artist could not have chosen a

worse time to be in Europe. When war broke out, he and many others escaped to the United States.

Many of Matta's oil paintings are quite large, and they often include spirals, chaotic movement, and mysterious, science fiction-like scenes. In fact, Matta's artwork of the 1940s is considered to be among the first to capture a sense of the coming "space age." His personal vision influenced the work of many others, including Mexican poet Octavio Paz and American abstract painter Jackson Pollock (see page 196).

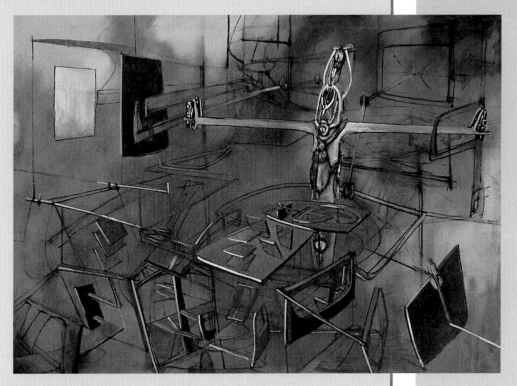

Fig. 7–10. Notice how the contrast of warm and cool colors draws attention to the strange, insectlike figure at the upper right. The word *grave* in the title may refer to both those who died in World War II and the serious hardships faced by the survivors.
Roberto Matta (b. 1911), *A Grave Situation*, 1946.
Oil on canvas, 55" x 77 ⅛" (139.7 x 195.9 cm). Collection Museum of Contemporary Art, Chicago. Gift of the Mary and Earle Ludgin Collection 1998.30. Photo © MCA, Chicago. © 2002 Artists Rights Society (ARS), New York/ADAGP, Paris.

Studio Experience
Self-portrait

An artist often chooses to make an artwork that shows himself or herself. Such works, called **self-portraits**, allow artists to share their personal feelings, to work slowly and in solitude, and to record changes in their physical appearance. In this studio experience, you will create a self-portrait oil painting that conveys a message or feeling. Oils are a good choice of medium, because they give the painter ample time for close observation, adjustments, and corrections.

Before You Begin

● Study the self-portrait by Frida Kahlo (Fig. 7–1). How did the artist portray herself? How did she compose the work? Compare Kahlo's self-portrait to the styles of the Jane Smaldone portrait (Fig. 7–4) and the double portrait by Marcel Duchamp (Fig. 7–7).

● Think about how to depict yourself in a painting and the message or feeling you want to convey. Will you work from a photograph of yourself? Will your self-portrait be realistic or abstract? Will you make an ugly face, show yourself from the side, or paint the reflection you see in a mirror or hubcap? Try shining a bright light on one side of your face to create strong shadows.

Create It

1. Draw two or three pencil sketches of yourself. Draw one in which you show your whole body and one in which you depict just your face. What type of background will surround your face or figure? How will you create a sense of unity and a center of interest in each?

2. Review your sketches. Which one has the strongest or most interesting composition? Which one best conveys your intended purpose? Choose one drawing as the basis for your painting. Remember: You may crop it or use only one part of it. Make

notes about any ideas that you have for color usage, textures, or methods of paint application.

① **Fig. 7–11.**

3. Select a working surface for your painting. Decide what size will best communicate your ideas. Gather the materials that you will need, including paints, thinners, a palette, an easel, and brushes or a palette knife. If necessary, prepare or prime your chosen surface.

② **Fig. 7–12.**

4. Using your preparatory drawing, sketch in the rough outline of your self-portrait with pencil or with thinned oil paint. Don't worry about the details.

③ **Fig. 7–13.**

5. Begin painting. Refer to your notes as well as page 102 for a demonstration of one possible oil painting technique. Remember to create a center of interest and a sense of unity in your painting. Create contrast by adding shadows and highlights. Whenever necessary, consult your photograph and/or your reflection as you work.

Check It

Does your self-portrait convey your intended purpose? Have you painted the background and main subject in a similar way to help unify the composition? Does the work have a clear center of interest? How did you create contrast? Did you use the medium successfully? Why or why not? Describe what you learned from this project. What will you do differently the next time you paint a self-portrait?

Sketchbook Connection

Try drawing a shiny object and your reflection in its surface. This might be a car's rearview mirror, a bathroom mirror, a holiday ornament, a piece of jewelry, or the chrome on a car or motorcycle.

Rubric: Studio Assessment

4	3	2	1
Idea Communication · Portrait studies · Self-portrait · Conveys message or feeling			
Deeply insightful self-exploration indicated. Portrait conveys profound, personalized feeling or message. Compelling insight, profound	Thoughtful self-exploration indicated. Portrait conveys identifiable, personalized feeling or message. Growing insight, effective	Some self-exploration indicated. Portrait conveys somewhat impersonal or indistinct feeling or message. Tentative, unresolved	Limited self-exploration. Message or feeling is hard to detect, underdeveloped. Superficial or vague, impersonal
Elements & Principles · Center of interest · Value contrast · Unity			
Distinctive center of interest, strong unity. Highlights and shadows strongly enhance expression. Unified, interesting, unusual	Identifiable center of interest, unity achieved. Highlights and shadows add expression and interest. Satisfactory, pleasing	Center of interest OR use of highlights/shadows needs more development; approaches unity. Needs refinement	Center of interest AND use of highlights/shadows needs more development. Struggles to achieve unity. Fragmented
Media Use · Oil technique			
Inventive exploration. Expert layering; use of brushes/tools to create textures, forms; and color mixing. Successful use of contrast. Expert, appropriate, fluent	Sufficient practice. Few mistakes in layering. Proficient handling of brushes/tools, mixing colors/values, use of contrast. Competent, appropriate	Some practice. Uneven layering OR color mixing techniques. Use of contrast needs work. More exploration and practice needed	Little range in application. Brush techniques result in muddy colors, lack of contrast. Rudimentary difficulties, underdeveloped
Work Process · Research · Sketches/Notes · Reflection/Evaluation			
Thorough documentation; goes above and beyond assignment expectations. Thoughtful, thorough, independent	Complete documentation; meets assignment expectations. Meets expectations	Documentation is somewhat haphazard or incomplete. Incomplete, hit and miss	Documentation is minimal or very disorganized. Very incomplete

Futuristic Illustrator
Donato Giancola

Donato Giancola (b. 1967) feels like he's been drawing since he was born. In the little town of Colchester, Vermont, Giancola and

Fig. 7–14. Donato Giancola.

his brother made gigantic drawings on thirty-foot sheets of unrolled paper. Giancola loved to depict super heroes, thus beginning his lifelong interest in science fiction and fantasy. In his senior year at Syracuse University, Giancola painted nonstop in his studio. His dedication, combined with meeting deadlines and producing high-quality work for the comic-book club at school, helped prepare him for the commercial art world.

Can you describe the relationship between realism and science fiction in your art?
Donato I try to create paintings that are more about the human stories behind all the figures. When I paint an alien, I think of that alien as being human.

I use a highly photographic realist style. Much of what I make up in my paintings actually does exist. I look at real objects as inspiration for weird contraptions, space-suits, spaceships. There is a robot I drew that is made out of watch parts. I took apart watches—I examined their internal workings to understand how to put together a robot. I created a model in my mind.

What medium do you use for painting?
Donato I work almost exclusively with oil paints, but first I play around with pencil. I save myself time by being able to just color in the lines and follow guidelines that I've laid out. I glue a photocopy of my extremely detailed drawing onto Masonite. Then I do what I did when I was five years old—I color within the lines. This tradition goes back to the Italian Renaissance and even before, when artists would do detailed preparatory studies. Their students would transfer these drawings onto a wall or canvas. Then the master would fill in the color.

What was most important about your education?
Donato The training I received was instrumental. There's no substitute for school. I had the doors of my mind opened to looking at other paintings, other illustrators, and other forms of literature. Schooling is important for opening your mind to different ideas and to growing as a person.

Fig. 7–15. Notice the photographic detail that the artist achieved using oil paint.
Donato Giancola (b.1967), *The Lord of the Rings*, 1999.
Oil on paper on masonite, 51" x 33" (129.5 x 83.8 cm). Courtesy of the artist.

Chapter Review

Recall What is usually used to thin oil paints?

Understand Why did the 1841 invention of collapsible tubes revolutionize oil painting?

Apply What happens to oil paints as they dry? How should an artist build layers?

Analyze Compare and contrast Frida Kahlo's *Self-Portrait* (Fig. 7–1) to Jane Smaldone's *If They Could See Her Now (My Chinese Daughter)* (Fig. 7–4). What does each artist tell about the person in her painting? How does she do this? How does she emphasize her center of interest?

Synthesize Complete this sentence "Oil painting is like _____ because_____."

Evaluate Select a painting in this chapter that makes effective or dramatic use of contrast. How did the artist create this contrast?

Portfolio Tip

Most university and college art departments want to see artworks by student applicants. If you visit a college for an interview, you might show them your original art, but many institutions would rather see slides or CD images of your art. Some art schools specify certain projects to include in a portfolio, such as a self-portrait or drawings. Review several university and college art department web sites or catalogs to discover how to apply to their art program.

Writing about Art

Often when looking at a work of art we think about or discuss whether or not we like it. Select an oil painting from this book (or another source) that you dislike. Write a short, clear statement indicating why you do not like it. Then write a persuasive statement arguing why it is a good work of art.

Fig. 7–16. The close focus on the eyes creates a sense of tension. What other features add to the uneasy mood of this portrait?
Kyndell Everley (age 18), *Losing Ground*, 1998.
Oil, 15" x 20" (38 x 51 cm). Plano Senior High School, Plano, Texas.

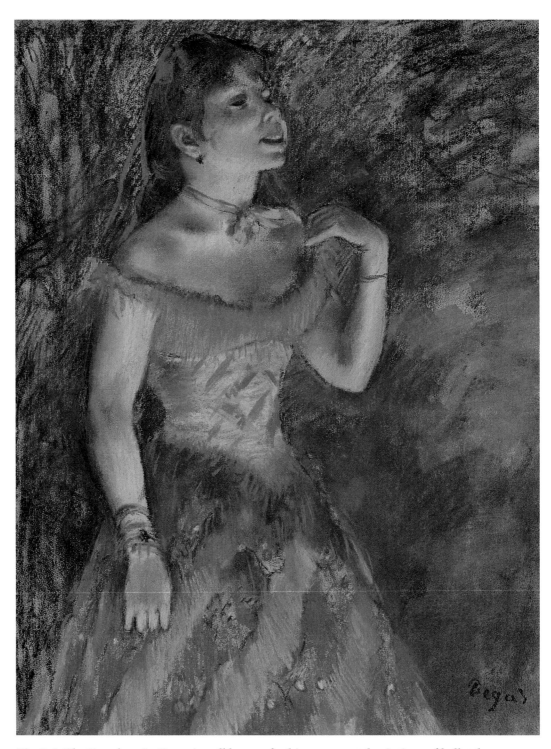

Fig. 8–1. The French artist Degas is well known for his many pastel paintings of ballet dancers. How did he create contrast and a sense of tension in this work?

Edgar Degas (1834–1917), *The Singer in Green*, c. 1884.

Pastel on light blue laid paper, 23 ¾" x 18 ¼" (60 x 46 cm). The Metropolitan Museum of Art. Bequest of Stephen C. Clark, 1960 (61.101.7). Photograph © 1987 The Metropolitan Museum of Art.

8 Pastel

When you were younger, did you ever use chalk to draw on the sidewalk? Or perhaps you enjoyed drawing on the chalkboard. As you drew, what were some of the problems you encountered? You probably remember that the chalk smudged easily but was nearly impossible to erase, or that layering colors created interesting effects but too much ruined the picture.

Although pastels shouldn't be confused with chalk, which is a harder medium, creating a chalk drawing introduced you to some of the techniques and challenges of working with the nonliquid painting medium of pastel.

The history of pastel begins in eighteenth-century France, when artists such as Rosalba Carriera and Quentin de la Tour captured the opulence of court life with soft and shimmery pastel paintings. In the late nineteenth century, Edgar Degas' pastel studies showed the intensity and drama of the ballet. In the early twentieth century, Mary Cassatt's tender portraits of mothers and their children and Odilon Redon's symbolic, dreamlike compositions exemplified the versatility and charm of pastels. Contemporary pastel artists continue to enjoy the brilliant color, subtle shading, and fresh, immediate impressions that pastels can produce.

blending tools

In this chapter, you will learn how to apply pastels, build up layers of color, and make a variety of lines. You will also create two pastel paintings of the same subject, allowing you to practice different mark-making and blending techniques as you learn to master the pastel medium.

textured papers

layering colors

Pastel Surfaces

The paper you use with pastels should have a nonshiny, textured surface to trap the grains of color. Heavy construction paper, charcoal, and rough mat board are suitable surfaces. Experiment using pastels on a variety of papers before you start on a finished work.

Colored papers also work well because they can act as part of a pastel painting's overall color scheme. Dull paper colors—tones of gray, for example—can serve as neutral backgrounds. Black is an especially striking choice of paper color for pastels; colors glow against it, and black lines may be left exposed to help define shapes and objects.

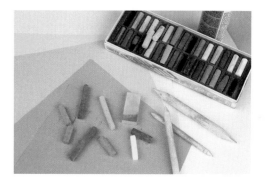

Fig. 8–3. Oil and soft pastels work well on colored papers. For more contrast, work on black or white paper.

Tools and Equipment

Soft pastels are powdered pigments mixed with resin or gum, which are then formed into sticks. Because the sticks are soft, they produce grainy textures and brilliant colors. Dipping soft pastels in water can give your work the look of a painting. Try working on damp paper for a similar effect.

Oil pastels, which are made from pigments mixed with an oil base, produce different effects from those of soft pastels. Oil pastels have a waxy consistency, apply smoothly, and produce rich, velvety colors; they can be used on paper, board, or canvas.

Colored chalk pencils, which come in a variety of colors, can also be used to create details in a pastel painting. Handle them carefully: If they are dropped, the thin stick of chalk encased within the pencil may break.

Perhaps the most important tool for blending pastels is a pencil-shaped stick of tightly rolled paper known as a **stomp** (also called a torchon). By gently rubbing the surface with the tip or side of the stomp, artists can blend colors and achieve smooth gradations of value. A short-haired brush, cotton swab, or tissue will also achieve similar effects.

Finished works done in colored chalks or pastels can be sprayed with a fixative to keep them from smearing; hair spray also

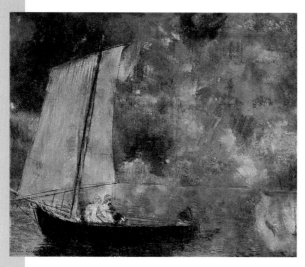

Fig. 8–2. Notice how the artist allowed the tan-colored paper to show through in certain areas of this dreamlike composition. The work also displays the soft focus often identified with pastel.
Odilon Redon (1840–1916), *Flower Clouds*, c. 1903.

Pastel, with touches of stomping, incising, and brushwork, on blue-gray wove paper with multicolored fibers altered to tan, perimeter mounted to cardboard, 17 9/16" x 21 5/16" (44.7 x 54.2 cm). Art Institute of Chicago, through prior bequest of the Mr. and Mrs. Martin A. Ryerson Collection, 1990.165. Photograph © 2002, The Art Institute of Chicago, All Rights Reserved.

works well. Be sure to spray the fixative in a well-ventilated area. Hold the can about twelve inches from the paper and spray evenly across the surface. If you want to brighten a work, you may touch up areas after they have been sprayed.

Note It You may purchase soft pastels in sets of varying sizes or as individual sticks. The minimum essential palette includes the twelve colors of the color wheel, plus black and white.

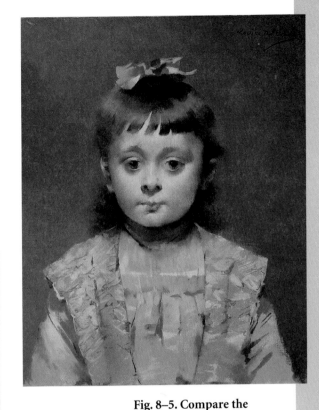

Fig. 8–5. Compare the style and texture of this work with the portrait by Rosalba Carriera shown in Fig. 8–9.
Louise Abbema (1858–1927), *Portrait of a Young Girl with a Blue Ribbon*, n.d.
Pastel on canvas, 18" x 15" (46 x 38 cm). The National Museum of Women in the Arts, Washington, DC. Gift of Wallace and Wilhelmina Holladay.

Elements and Principles

Line

Artists create line—a mark with length and direction—by moving a point across a surface. They create **implied line** by arranging the parts of an image to produce the effect of seeing a line, even though a line is not actually drawn.

Pastels of different shapes and sizes will create a wide variety of lines. Varying the pressure will create different line qualities. A light, free stroke will create a soft, thin line; a heavy stroke, perhaps with the side of the pastel, will result in a strong, dense line. Turning the pastel as you draw will cause the line to change width and texture.

Fig. 8–4. What techniques did the artist use to create shadows and highlights?
Emily Goode (age 17), *Tie It Up*, 1997.
Pastel, 18" x 24" (46 x 61 cm). Lake Highlands High School, Dallas, Texas.

Basic Pastel Techniques

Pastels require a thorough mastery of technique before any actual painting can be done. It is more difficult to correct a mistake when working with pastels than with almost any other painting medium. Because part of the charm of a pastel painting is a look of quickness and freshness, you must be confident of your skill in handling the medium.

Try applying pastels to sheets of scrap paper in various ways. Use the pastel stick at every angle, from flat on its side to touching only with its point. Experiment with creating a variety of lines. Apply texture of one color and then go over it in a different direction with another color to create a tweedlike effect. Apply pigment lightly at first, and build up the color gradually. If you put on color too heavily, the pores of the paper will become clogged, and your picture may look murky. Practice blending two colors together by placing them atop one another. You will be tempted to use your fingertips, but don't; blending with your fingers will transfer oil to the paper's surface. To achieve shading effects, try mixing complementary colors, since black tends to create muddy results if blended with soft colors.

Fig. 8–7. Dove was the first American artist to create abstract works of art. But even in his most abstract compositions, the artist makes reference to natural forms and occurrences. Arthur Dove (1880–1946), *Team of Horses*, 1911 or 1912.
Pastel on composition board, 18 1/8" x 21 1/2" (46 x 55 cm). Amon Carter Museum, Fort Worth, Texas.

As you work, blow away any loose pastel powder, or the powder may get ground into other areas of your composition and soil it. You can use a damp paper towel to remove any accidental smudges. Keep your hands clean and away from your picture. Cover areas that you have completed with a clean piece of paper so that you don't smear them as you move on to other parts of your composition. You may also use fixative to help protect finished areas.

Fig. 8–6. Notice how the artist blended colors and created shading. Do you think she handled the medium masterfully? Natalya Kaliazine (age 18), *The Entrance*, 1997.
Pastel, 18" x 24" (46 x 61 cm). Lake Highlands High School, Dallas, Texas.

Try It Before you begin your first composition, make sure you sample your colors. Lay them out in a chart, preferably in the form of a color wheel. Add tints to the outside of the wheel and shades to the inside. This will familiarize you with what the colors look like on paper, and how they appear when placed side by side.

Note It Try out your ideas on scrap paper, practicing effects and techniques before using them in a painting. That way you can work quickly, cleanly, and confidently, and your finished pastel painting will look fresh.

Colored Pencils

Does the colored-pencil artwork shown in Fig. 8–8 appear to be a "finished" work? Although this question may seem silly today, artists in the past did not use pencils to create a finished artwork. Rather, pencil sketches were a way for artists to study a subject and plan a composition before creating a final work, usually a painting.

Graphite pencils were invented in the seventeenth century. Particles of bonded graphite were shaped into the desired width and then covered in casings (often leather or metal and later wood) so that they would not rub off on the artist's hands. Recently, colored pencils—in which pigments are held together by a wax binder—have become available in up to about sixty hues. As with their graphite counterparts, colored pencils come in soft and hard leads, which determine the quality and density of line that the pencil produces.

Today, increasing numbers of artists are turning to colored pencils as their preferred medium. The pencils are easy to use and control, and they produce effects as varied and exciting as any other painting medium.

Safety Note You can sharpen colored pencils in a pencil sharpener or, if the lead is too soft, with an X-acto knife. Always cut down and away from your hands and body when sharpening by hand.

Most colored-pencil work requires the use of a fixative. Be sure to use only a nonaerosol fixative and spray in areas of active ventilation.

Fig. 8–8. Tooley's colored-pencil artworks are studies in color, texture, and pattern. What do you think was the most difficult part of creating this artwork?
Richard Tooley (b. 1951), *Cooties*, 2000.
Colored pencil on hot press illustration board, 14 ¾" x 19 ¾" (37 x 50 cm). Courtesy of the artist.

Paint with Pastels

Because pastels require a sure, swift approach, it is wise to carefully plan your composition in detail. First, select your subject matter. Make some thumbnail sketches to organize the composition and then render a drawing on practice paper the same size as your final work. A sequential, step-by-step method will help you achieve works that are orderly and controlled.

1 Attach a sheet of heavy, textured paper onto an easel. The paper can be white, black, or toned pastel paper. Use a pastel or pencil to sketch your drawing.

2 Practice your treatment of each object or area on scrap paper until you feel you can achieve the desired effects easily. Also practice shading.

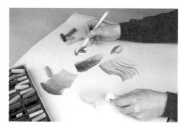

3 Start forming the objects you feel most confident about. Work swiftly and deftly—don't overwork the surface. Work on each area of your composition without smearing other parts. If you'd like, turn the paper as you proceed and work from different angles.

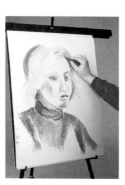

4 After the objects have been completed, decide on a background that will enhance them. Leave some paper showing to provide value contrast. Add any shadows and highlights to help bring your finished work to life.

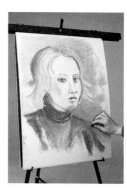

When you are satisfied with your results, spray your pastel painting with a fixative or hair spray to help protect it from smearing.

Try It Try dipping a pastel stick in liquid starch or mop oil before you apply it to paper. This procedure makes the dry, chalky pastels paintlike and somewhat greasy. When dry, your pastel painting will not need to be sprayed with fixative.

Note It To learn pastel techniques thoroughly, it is helpful to work first in only black and white or in black, white, and gray. This way, you can concentrate on blending pastels, shading techniques, and neatness without worrying about color. Start with simple shapes and work up to more complex subject matter.

Rosalba Carriera's Antoine Watteau

Imagine being such a popular portrait painter that you are unable keep up with customer demands. That's exactly what happened to Rosalba Carriera more than two hundred years ago.

Carriera was born in Italy in 1675, and as a child she drew patterns for her mother's lacemaking. Later she began painting tiny portraits, called *miniatures*, on ivory. By age twenty-five, she was well on her way to becoming a pioneer in the field of pastel painting.

Carriera and her family enjoyed traveling, and scholars believe that she was the first artist to introduce pastels to France. European nobility and royalty asked her to paint their portraits in pastels. While in France, Carriera also met the French artist Antoine Watteau, who admired her work so much that he asked to exchange one of his paintings for one of hers. In 1721 a rich **patron**, or customer, paid Carriera to create a pastel portrait of Watteau.

The portrait, shown in Fig. 8–9, is typical of Carriera's best work. The composition is simple and informal, showing just the head and shoulders of the sitter. Notice how Carriera allowed much of the paper to show, creating the background as well as interesting shadows. With masterful skill, she has captured the personality and likeness of one of the most famous artists of the time.

Even though Carriera was Italian, her successful career led her to be elected to France's Royal Academy, a great honor seldom bestowed on women. Sadly, however, the artist began to have difficulties with her vision, and by 1749 she was totally blind. Carriera died eight years later, but her skillful works continue to inspire the many pastel artists who follow in her footsteps.

Fig. 8–9. Because they can be drawn with quickly, pastels are well suited to portraits. This portrait's three-quarter pose gives the impression that the sitter was caught looking over his shoulder, unaware of the artist sketching behind him.
Rosalba Carriera (1675–1757), *Portrait of Antoine Watteau*, 1721.
Pastel, 21 5/8" x 16 7/8" (55 x 43 cm). Museo Civico, Treviso, Italy. © Giraudon/Art Resource, NY.

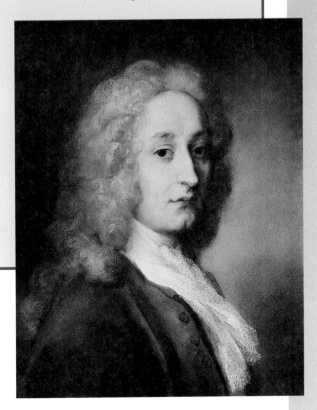

Studio Experience
Realistic and Abstract Paintings

In this studio experience, you will create two pastel paintings of the same object—one realistic and one that is **abstract**, in which you remove details to suggest just the essence of the object. Artists often abstract their subjects by changing colors to create a feeling or emotion or by distorting forms to emphasize a quality. Because pastels can be worked quickly, they are a useful medium for sketching and experimenting with a variety of views and abstractions.

Before You Begin

● Notice how artists throughout this book have abstracted their subject matter. As you look at such works, try to decide what each artist was trying to emphasize about his or her subject. Look at other examples of abstract art on the Internet and in books.

● Think of an object that has special significance to you and that you can bring to class. What makes this object meaningful? How do you feel when you think of it? How can you emphasize this feeling? What colors, lines, shapes, and textures come to mind as you remember the object?

Create It

1. Study your object from different angles to find interesting viewpoints. Use pastels to quickly sketch your object from several of these angles.

1 Fig. 8–10.

2. Choose one of your sketches to develop into a finished pastel painting. You may combine several views of the same object into one composition or focus on one large close-up of the object.

3. Make this picture as realistic as possible. First sketch the main shapes, then cover the large areas with color. Add a background, filling your painting with color.

2 Fig. 8–11.

4. Try blending colors together, shading from one color or value to another. Think about contrasts of colors and values as you work. Make one part of your composition most important. This should be where contrasts of colors, values, or textures occur. Add textures and other details. Use stomps to blend small areas and fine details.

5. Create a second, abstract pastel of the same subject. This time, simplify your subject matter so that it is no longer recognizable. Try distorting shapes, colors, and textures. Create a variety of lines that convey how you feel about this object.

6. Preserve your pastels with a fixative.

3 Fig. 8–12.

Check It

Is the object recognizable in your realistic pastel painting? Are there enough contrasts of colors, values, and textures to make the painting interesting? In your abstract painting, did you successfully show the intended emotion about your object? How did you abstract your subject? Which painting do you find more interesting? Explain.

Safety Note Always spray pastel fixative in a well-ventilated area. The fumes can be toxic.

If you have breathing difficulties, wear a paper mask over your mouth and nose so that you will not inhale pastel dust.

Sketchbook Connection

Sketch an object from your room or locker. Imagine how it would look if it exploded, collapsed, or melted. Draw this transformed view. Will someone viewing your drawing be able to recognize what the original object was and what happened to it?

Rubric: Studio Assessment

4	3	2	1
Understanding of Abstraction · Realistic image · Abstract image			
Realistic image is highly detailed, convincing, fully presented. Abstract image is not recognizable; explores original object in unusual and compelling way. Flexible, full range	Realistic image is detailed, convincing. Abstract image is not recognizable; explores particular aspect of original image. Satisfying range	Realistic image needs more attention to detail or form OR abstract image is somewhat recognizable. Growing range	Realistic image appears flat, limited detail OR abstract image is very recognizable. Little difference in levels of abstraction. Limited range
Elements & Principles · Color, value and/or texture contrast · Picture plane			
Wide exploration of color, value, and/or textural contrast. Both images effectively engage full picture plane. Unusual, effective, complete	Sufficient exploration of color, value, and/or textural contrast. Both images incorporate full picture plane. Effective, complete	Exploration of color, value, and/or textural contrast; and use of picture plane effective in only one image. Needs refinement, more time on task	Exploration of color, value, and/or textural contrast; and use of picture plane in either image needs much more attention. Unresolved
Media Use · Pastel technique · Mark-making			
Confident technique and masterful use of color and shading. Wide variety of marks, lines, textures. Expert use of stomps for blending, details. Skillful, controlled, appropriate	Appealing range of marks, textures. Competent use of complementary colors for shading. Appropriate use of stomps for blending, details. Competent, appropriate	Some accidental smudges OR lack of variety in lines/marks. Inappropriate use of black creates murky colors. Stomp used incorrectly. More practice indicated	Careless technique creates many smudges. Inconsistent use of stomps. Work incomplete. Rudimentary difficulties
Work Process · Research · Sketches · Reflection/Evaluation			
Thorough documentation; goes above and beyond assignment expectations. Thoughtful, thorough, independent	Complete documentation; meets assignment expectations. Meets expectations	Documentation is somewhat haphazard or incomplete. Incomplete, hit and miss	Documentation is minimal or very disorganized. Very incomplete

Portraitist
Lotus Do Brooks

Lotus Do Brooks, born in the early 1950s in Queens, New York, remembers her first self-portrait: while sick in bed, she drew herself covered with chicken pox. Do Brooks, whose mother is Dutch and her father Vietnamese, thought that living near

**Fig. 8–13.
Lotus Do Brooks.**
Photo courtesy of Carol Mehta.

the Japanese American sculptor Isamu Noguchi was "neat" because he too was an artist and biracial. She attended the High School of Music and Art, Cooper Union School of Art, and the University of Massachusetts in Amherst. Decades later, Do Brooks still practices life drawing, which is the backbone of her expressive, interpretative pastel portraits.

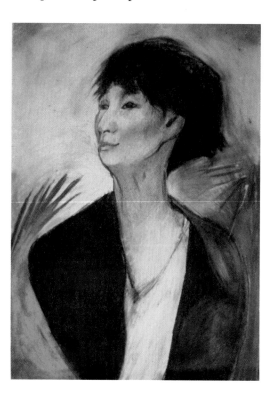

Fig. 8–14. The expressive qualities of pastel allow the artist to create portraits that show the mood of the sitter.
Lotus Do Brooks, *Yoko*, 1992.
Pastel on paper, 25" x 18" (63.5 x 45.7 cm). Courtesy of Barbara Greene Fine Art, New York, New York.

When did you start focusing on portraits?
Lotus After graduation, I was teaching some five hundred students in the Boston public schools during busing and integration [when children of color were bused into schools that originally had predominantly white students]. I taught portraiture as a vehicle for young people to understand each other. I also started painting portraits of people from different cultures, using art as a teaching tool to break down stereotypes so that people could see the individual soul of the person, regardless of the exterior.

Did you work with pastel right away?
Lotus Most of the initial portraits were in charcoal and watercolor. I moved into the pastel portraits because I love color. Actually, I did an exchange program in Santa Fe, New Mexico, with Native American artists. In Boston and New York, everyone is wearing black and white. But in Santa Fe, I became so enthralled by color. I also did an art exchange in China, Samoa, and Hawaii in the 1980s and 1990s.

What makes pastels so appealing?
Lotus I love pastels, the way they mix together. The way the little particles reflect light; they appear to glow. The color that your eye sees is really the color that is not being absorbed, so when you place certain colors together, they dance and sing— they're musical! Even if you don't get from the image what the person is about, you certainly can get it from the color. You can layer and layer, and it never gets muddy if you know your color principles. With pastels, there's just an endless variety of combinations, and that's just like people— there's an endless variety of people.

Chapter Review

Recall List four tools for blending pastels.

Understand When applying pastel, why is it important to experiment with a wide selection of background paper surfaces and colors?

Apply Create three blended strips of pastel colors. In one strip, place a primary color at one end and its complement at the other. Create a smooth transition between the complements. In the second strip, gradually blend an intense hue at one end into black at the other. In the third strip, blend from white to an intense color.

Analyze Select a portrait from this chapter that effectively uses a variety of lines. Describe the different types of lines in the picture. How did the artist indicate the mouth and nose—with lines, shading, or a combination?

Synthesize Create a timeline by locating the dates of artworks in the chapter (excluding student art). Do you notice any trends from the oldest to the most contemporary?

Evaluate Compare working with oil and chalk pastels. What are the advantages and disadvantages of each medium? With which do you prefer to work? Why?

Portfolio Tip

Ideally you will photograph your art on a plain background, on a copystand, under photoflood lamps. If this isn't possible, use a 35mm, single-lens reflex (SLR) camera to photograph your art in natural light. Use 400 ASA film for indoors, or 100 ASA for bright sun outdoors. When looking through the viewfinder, fill the frame with your whole artwork. Then shoot additional frames that show details of the work.

Writing about Art

Using the artwork in this chapter, write a brochure for a gallery exhibit of works in pastel. Include an introduction to the medium, the basic information for each piece, and a short description of each work. The descriptions should highlight the features that you think the consumers, or purchasers, will find most appealing. Indicate which image you would place on the cover of the brochure and give a reason for your selection. Finally, determine how the works would be grouped on the wall and give your reasons for these groupings.

Fig. 8–15. The artist has used a variety of lines to create an abstract portrait. How would you describe the mood of this image?
Claire Johnson (age 18), *Mardi Gras Maiden*, 1999.
Pastel, 18" x 24" (46 x 61 cm). Lake Highlands High School, Dallas, Texas.

Canaletto (1697–1768). *Venice: The Basin of San Marco on Ascension Day*, c. 1735-41.
Oil on canvas, 48" x 72" (121.9 x 182.8 cm). © The National Gallery, London.

Part Three
Subject Matter

Fig. 9–1. Do you think the artist carefully studied nature before creating this work? Did he reproduce the flowers exactly as they appear in nature? Why, do you think, did he do this?

Style of Sosetsu (mid-17th century), *Poppies,* Edo period.

Hanging scroll, colors on gold paper, 34 ½" x 14 ⅝" (88 x 37 cm). The Metropolitan Museum of Art, H.O. Havemeyer Collection, Bequest of Mrs. H.O. Havemeyer, 1929 (29.100.524), Photograph © 1999 The Metropolitan Museum of Art.

9 Natural and Everyday Objects

What does the saying "Stop and smell the roses" mean to you? For many, it means taking the time to enjoy our surroundings—to notice things we're often too busy to see. Perhaps you remember becoming fascinated with a natural or ordinary object, really "seeing" it as though for the first time. Maybe you were even inspired to reproduce the object in an artwork.

Artists throughout history have found abundant subject matter in the objects in nature and in their everyday world. Chinese and Japanese artists have excelled at creating artworks of objects from the natural world. Their traditional paintings, featuring delicate renderings of birds, flowers, and other natural objects, are invitations to reflection and contemplation.

The dramatic paintings of seventeenth-century Dutch artists, depicting mounds of vegetables and fruits or vases overflowing with flowers, often held a not-so-hidden message about the shortness of life and the passing of time. In the eighteenth century, the paintings of Jean-Baptiste-Siméon Chardin emphasized the qualities of everyday life. Over time, such artists as Paul Cézanne and Juan Gris used everyday objects as inspiration for complex paintings that were more explorations of space, color, and texture rather than realistic representations of the subject matter. Contemporary artists continue to choose natural and everyday objects as the basis for paintings in a wide range of styles.

plants/flowers

In this chapter, you will study the tradition of still-life painting. You'll learn how to set up an arrangement, plan a balanced composition, and create your own still-life painting.

still life

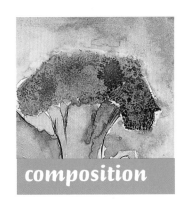

composition

Still Life

A **still life** is a picture of objects that are inanimate, meaning they do not move. Everyday items that have interesting shapes, colors, or textures, such as fruit, flowers, bottles, seashells, and pieces of cloth, can be arranged or clustered to form a still-life setup. Painters have drawn inspiration and information from still-life arrangements for hundred of years.

The still life as subject matter has many advantages. It is convenient; an artist can work in the studio and have complete control over every aspect of the subject—selecting and arranging items, experimenting with lighting, and so on. Many still-life setups remain intact for long periods, allowing the artist to study them in detail and paint them many times. Artists can also easily modify a still life by changing or rearranging objects.

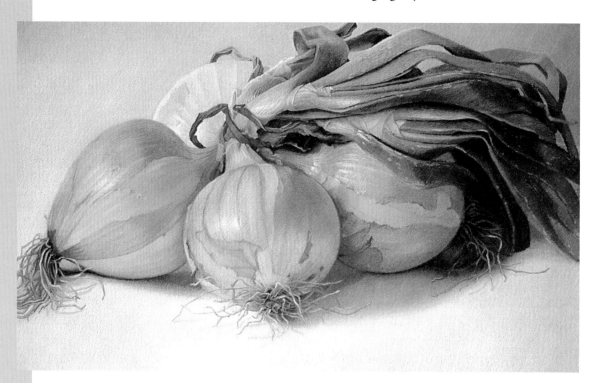

Fig. 9–2. Because the textures depicted in this pastel painting are so realistic, you might mistake the work for a photograph. What does the reddish rubber band near the center add to the composition?
Mary Anne Currier (b. 1927), *East Palatka Onions*, 1983.
Oil pastel on paper, 35 ½" x 59 ½" (90 x 151 cm). Private Collection, © Mary Ann Currier, Photo Courtesy of Mary Ann Currier.

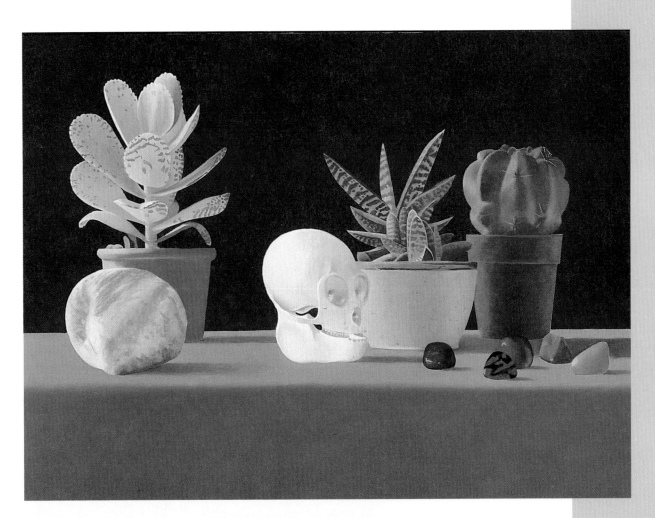

Fig. 9–3. How did the painter use repetition in this work? Also notice the earth tones that the artist used in her color scheme.
Corda Eby (b. 1934), *Monkey Skull.*
Oil on panel, 18 x 23 ½" (46 x 60 cm). Hackett-Freedman Gallery, San Francisco.

Fig. 9–4. In this still life, the artist creates a sense of softness that you might not see in the objects themselves.
Rachel Miller (age 17), *Still Life with Wine Bottle*, 1994.
Pastel on charcoal paper, 12" x 18" (30.5 x 45.7 cm). Clarkstown High School North, New City, New York.

Setting Up a Still Life

When gathering objects for a still life, try at first to find things that seem to belong together or that might be found in one place. For example, combine kitchen objects and gadgets, musical instruments and sheet music, or gardening tools and flowering and leafy plants. You can also develop a central theme, such as objects that reveal someone's personality or reflect a specific time period. Choosing related items will give your still life a sense of unity. Later, when you gain greater confidence about painting still lifes, consider using apparently dissimilar objects in a composition. Try to think of subtle qualities or functions of the objects that connect them to one another.

Once you have chosen a group of objects, think about various ways to arrange them. Look at examples throughout this chapter and elsewhere in the book to gather ideas. Try placing a group of objects on a table or chair, or create a still life on a simple box or in the corner of a room. Some artists arrange a setup on different levels to achieve a more complex composition. Experiment with draping a piece of cloth behind or under the cluster of items. Lighting is an important factor; spotlights above, below, or from the side can create a variety of interesting shadows and highlights. Lighting also helps to emphasize the textures of your chosen subject. You may even arrange your objects on a piece of glass and light them from below.

Try It Select a variety of shapes, some linear and some curved. Choose things of different sizes and try combining objects with patterned, plain, shiny, smooth, or textured surfaces. Remember also to keep color and value contrast in mind when arranging your chosen items. For greater stability, combine objects that are similar in color or that are either vertical or horizontal.

Fig. 9–5. The artist used a checked tablecloth and yellow background to unify the composition. How has she created balance?
Megan Browning (age 18), *Untitled (Still Life)*, 2002.
Acrylic on board, 12 ¼" x 12 ⅞" (31.1 x 32.7 cm). Jerome High School, Jerome, Idaho.

Fig. 9–6. The French painter Chardin is known for realistic depictions of simple subjects. Notice how the cup reflects the colors of the peaches and walnuts. Where does the light source appear to be located?

Jean-Baptiste-Siméon Chardin (1699–1779), *Still Life*, c. 1759–60.

Oil on canvas, 14 ⁷⁄₈" x 18 ³⁄₈" (38 x 47 cm). J. Paul Getty Museum, Los Angeles. © The J. Paul Getty Museum.

Balance

Artists strive to create balanced art-works so that all of the parts have equal visual weight. A still life (or other arrangement of objects) is most successful if the composition has **asymmetrical balance**, in which the parts of the composition are different yet equal in weight or interest. For example, a large, bright flower can balance two small, darker objects. A contrasting geometric shape can offset a group of organic shapes. Or an area of much detail and textures can be off-set by a calm, blank space. Such planning will create a balanced asymmetrical composition.

Organizing Your Composition

Once you have arranged your setup and are ready to begin drawing or painting, choose an interesting view. Study your setup from different angles; look at it from different

Fig. 9–7. The monochromatic color scheme unifies this composition. In what ways has the artist created emphasis?
Shawn Eldredge (age 18), *Visions of Gray,* 2002.
Acrylic on board, 10" x 13" (25.4 x 33 cm). Jerome High School, Jerome, Idaho.

sides and from above. Remember, you may paint only one part of the display. Looking through a rectangular viewfinder can help you discover a part of the composition that is unusual or visually exciting. Use the viewfinder in both vertical and horizontal positions before deciding on your final composition.

Once you have chosen a possible composition, draw several thumbnail sketches. Analyze the sketches for such design principles as unity, balance, or contrast. Think about ways to improve your arrangement. For example, balance a sloping diagonal shape with one leaning in an opposite direction. Setting up a still life will teach you a lot about organizing a composition. It is also a good opportunity to review the elements and principles of design: line, shape, form, space, color, value, texture, unity, variety, balance, contrast, emphasis, pattern, proportion, and movement and rhythm.

Emphasis, unity, and balance are especially important in a still-life painting, which can sometimes appear to be a random collection of commonplace objects. Think about one aspect of your composition that will add interest or excitement.

Fig. 9–8. The large size of this still-life painting adds a sense of monumentality to these small, everyday objects. Notice the attention to details, such as reflections and hundreds of tiny highlights.
Audrey Flack (b. 1931), *Chanel,* 1974.
Oil and acrylic on canvas, 56" x 82" (142 x 208 cm). Collection of the Neuman Family. Courtesy Louis K. Meisel Gallery, New York.

Artists sometimes choose to single out line, color, or space for emphasis. Try emphasizing the surface quality of objects, such as texture, pattern, reflection, or transparency. Shadows can add unity and drama to an otherwise unremarkable arrangement. You may also draw attention to a single object, which functions as the center of interest. What in your composition will capture a viewer's attention?

Note It As you study the artworks shown in this chapter, look for different ways that artists have used emphasis to make a statement in a still-life painting. Notice how each composition directs the viewer's attention to a center of interest.

Fig. 9–9. Note the variety of textures depicted in this eighteenth-century still life. Describe the path that a viewer's eye follows as it moves across the composition. How did the artist direct that movement?

Luis Meléndez (1716–80), *Still Life with Melon and Pears,* c. 1770.

Oil on canvas, 25 ⅛" x 33 ½" (63.8 x 85 cm). Margaret Curry Wyman Fund, 39.41. Courtesy, Museum of Fine Arts, Boston. Reproduced with permission. © 2002 Museum of Fine Arts, Boston. All rights reserved.

Janet Fish's *Green Tea Cup*

Look at the still-life painting *Green Tea Cup*, shown in Fig. 9–10. Was it difficult for you to find the "subject" indicated in the title? The cup is almost lost amidst the many reflective surfaces, sparkling highlights, and brilliant colors. It seems as if the artist, Janet Fish, wants the title to remind us what the painting is all about.

Fish, who was born in 1938 in Boston, Massachusetts, comes from a family of artists. Her grandfather was a painter, her mother a sculptor, and her sister a photographer. Fish created her first still-life paintings in the 1960s and had her first solo exhibition in 1967. Her paintings became known for their attention to detail and effects of lighting —the artist seems to delight in the difficult task of depicting overlapping, clear and semitransparent materials, such as glassware, plates, plastic cups, and cellophane.

Fish's academic training is evident in her carefully arranged compositions and her technique of building up layers of paint. Her works are minutely detailed, but her brushstrokes remain loose and seem to sit on the surface. They energize the painting, giving life to the inanimate objects in the still life. In this way, Fish seems to play with the viewer, challenging our perceptions of what is "alive."

The artist's recent paintings continue her explorations of color, pattern, and the effects of light on objects. In *Green Tea Cup*, her characteristic loose brushwork forces the viewer's eye to dance around the canvas before finally settling on the object that the artist has placed just slightly apart—the green teacup.

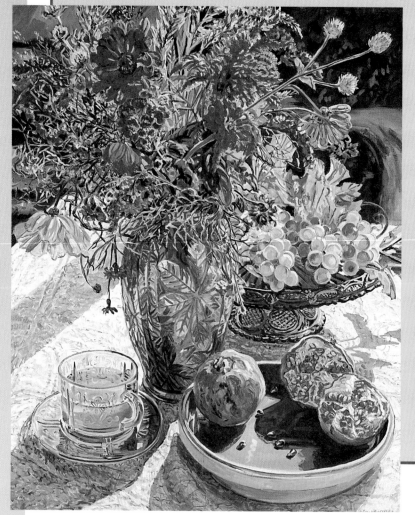

Fig. 9–10. Notice how the teacup is set apart from the rest of the objects, which also overlap each other. What else do you notice about the cup that is unlike the other objects? How does this artwork show careful planning?
Janet Fish (b. 1934), *Green Tea Cup*, 1999.
Oil on canvas, 50" x 40" (127 x 102 cm). DC Moore Gallery, New York. © Janet Fish/Licensed by VAGA, New York, NY.

Plants and Flowers

Plants and flowers offer a source of beauty and serenity in our fast-paced, industrialized world. Their glowing or subtle colors and fascinating shapes and patterns make them endlessly appealing as subject matter. Throughout the ages and in most parts of the world, **botanical** motifs—those based on nature and plants—have been used in architectural detailing, in patterns on rugs and tapestries, and for decorations on manuscripts, pottery, wall coverings, and fabric.

Many Dutch oil painters of the seventeenth and eighteenth centuries captured the beauty and variety of flowers in minutely detailed arrangements. At the end of the nineteenth century, Claude Monet created luminescent water lily landscapes, and Vincent van Gogh painted a compelling series of sunflowers. One of the artists most identified with botanical subjects in the twentieth century was Georgia O'Keeffe, whose gigantic close-up views of flowers provided viewers with a new and exciting way of looking at the subject.

Fig. 9–11. In the 1860s, Heade traveled to South America to paint the hummingbirds of that region. In this composition, he pairs a tiny male and female with an equally exotic orchid.
Martin Johnson Heade (1819–1904), *Orchid with Two Hummingbirds*, 1871.
Oil on unprepared panel, 13 ¾" x 18" (35 x 46 cm). Reynolda House, Museum of American Art, Winston-Salem, North Carolina.

Fig. 9–12. What kind of feeling or mood does this unusual painting create? How would the work be different without the addition of the smile?
Garcia-Cordero (b. 1951), *Ironic Pot*, 1999.
Acrylic on canvas, 37 ¾" x 63 ½" (96 x 161 cm). Photo: Lyle O. Reitel, Arte Contemporaneo, Santo Domingo, Dominican Republic.

Organization and Composition

Some artists like to paint flowers and plants while sitting outside. Others prefer working in a studio, using live plants, slides, or pictures as a source of information. Working outside can be challenging because of the weather and changing light. Also, if you plan to work on a composition for more than one day, your subject may change drastically overnight. Working inside from a live plant or cut flowers can give you a little more flexibility, and you will be better able to control the light. You can even use artificial flowers; they last indefinitely, and many silk flowers and plants look quite real. As with all subject matter, a variety of techniques and media may be used, including oil, acrylics, watercolor, tempera, collage, and pastels.

Traditionally, artists have depicted flowers and plants arranged in a pot or vase, featured in a landscape, or combined with people, animals, or other objects. But don't feel that you must follow these examples. Magnify a single flower, leaf, or petal or, at the other extreme, paint an entire garden or field of wildflowers. If flowers seem too simple, common, or uninteresting to you as subjects, try looking at them in a new way.

Fig. 9–13. O'Keeffe began painting flowers, in part, because she loved their forms. She painted them very large because she wanted the flowers to be noticed by people who were usually in too much of a hurry to look closely at them.
Georgia O'Keeffe (1887–1986), *Oriental Poppies*, 1927.

Oil on canvas, 30" x 40 ⅛" (76 x 102 cm). Collection Frederick R. Weisman Art Museum at the University of Minnesota, Minneapolis. Museum purchase. © 2002 The Georgia O'Keeffe Foundation/Artists Rights Society (ARS), New York.

Fig. 9–14. What makes this composition successful? How did the artist use value to create a dramatic artwork? How did she create a sense of unity? Aileen Delgado (age 17), *Hybiscus*, 1998.
Tempera, 18" x 24" (46 x 61 cm). West Springfield High School, Springfield, Virginia.

In what way is a flower like a machine? How do its parts work? What does it produce? How do the colors and shapes alter as a flower changes from bud to blossom to decaying matter?

Before you begin painting, make a series of detailed drawings. Carefully study the shapes and forms of both flowers and leaves. Notice how the flower and leaves connect to the stem. Also look for variations among flowers of the same type. Are some flowers larger, brighter in color, or different in another way? When planning your painting, keep in mind the elements and principles of design. Do you want to emphasize a smooth texture, contrasts of color, or an unusual shape? Will you choose formal balance or an asymmetrical composition? What will be the relationship between the positive and negative shapes? See pages 134–135 for further advice on setting up and painting a still life.

Try It Visit a nearby garden, greenhouse, nursery, or local florist. Notice the variety of colors, shapes, and values. If possible, look closely at the details and textures. Sketch a few plants that you find interesting. For reference, be sure to jot down information about size, color, and other details.

Studio Experience
Still-Life Painting

In this studio experience, you will create a still-life painting using tempera or acrylic. Even a common object can be the source of an extraordinary still-life painting. If you look closely at everyday items, it may surprise you to find colors, textures, shapes, and other details that you hadn't noticed before. Think about choosing an unusual arrangement or an interesting angle from which to view your subject. Such surprises will add visual interest to an otherwise simple subject.

Before You Begin

● Look at the still lifes in this chapter painted by Jean-Baptiste-Siméon Chardin (Fig. 9–6), Audrey Flack (Fig. 9–8), and Janet Fish (Fig. 9–10). What objects form the basis for each painting? How did each artist create visual interest?

● Choose a group of objects that interests you, such as a ring of keys, an eggbeater, or a wristwatch. Think about how to use the object(s) as the basis for an unusual still-life painting.

Create It

1. Draw a series of pencil sketches of your chosen object(s). View your subject from various angles and under different sources of light. Look at it upside down, on its side, and from above and below.

① Fig. 9–16.

2. Review your sketches. Which one has the strongest or most interesting composition? Select one drawing as the basis for a tempera or acrylic painting. Make notes about any ideas that you have for color usage, background, or methods of paint application. Also note the source and direction of light so that you can re-create the setup later.

② Fig. 9–17.

3. Select a working surface that is appropriate to your chosen medium. Decide at what size your composition will work best. For example, you may choose to greatly enlarge your subject to give it a sense of monumentality.

4. Gather the materials that you will need, including paints, brushes, palette, easel, and containers. If necessary, prepare or prime your chosen surface and allow it to dry.

5. Review your preparatory drawing and notes about your light source. Set up your subject on a tabletop, board, or other background surface. Then sketch in the main shapes of your still life with a pencil or thinned paint. Don't worry about the details at this point.

③ Fig. 9–18.

6. Begin painting. Carefully observe your object(s) and refer to any notes you made in step 2. Be sure to pay special attention to details, including highlights, reflections, textures, and shadows. If you are working with tempera, see page 60 for a demonstration of one possible technique. For acrylic, see page 88 for a demonstration.

Check It

Is your composition surprising, interesting, or unusual? Have you successfully captured details, such as highlights, reflections, textures, or shadows? Did you use your chosen medium successfully? Explain. What did you learn from this project?

Sketchbook Connection

Draw a piece of cloth or clothing draped over the back of a chair. Concentrate on the shape and form of the folds. Where are the darkest and lightest areas? Try shading to show the form and texture.

Rubric: Studio Assessment

4	3	2	1
Visual Interest · Composition · Detail · Use of light source · Choice of objects			
Ample compositional experimentation. Final still-life image commands sustained interest; reveals surprising or unanticipated aspects of objects. High risk, surprising, effective	Sufficient compositional experimentation; final still-life image is interesting, with a pleasing element of surprise. Moderate risk, surprising, effective	Some compositional experimentation; final still-life image is still somewhat conventional. Moderate risk, conventional	Little compositional experimentation and/or final still-life image very conventional, traditional. Low risk, conventional
Media Use · Tempera technique **or** · Acrylic technique			
Appropriate media choice. Expert brush technique to define shapes, create sense of realism using highlights/shadows, show textures and details. No apparent mistakes. Skillful, controlled, appropriate	Appropriate media usage. Good sketch. Competent brush technique and use of highlights/shadows; convincing realism. Few mistakes. Competent, appropriate	Questionable media choice OR inappropriate usage. Realism underdeveloped; unsatisfactory brush technique. Some mistakes. More practice indicated	Unpracticed technique in chosen media. Lack of knowledge of media usage, paint application. Many mistakes; unfinished appearance. Rudimentary difficulties
Work Process · Research · Sketches/Notes · Reflection/Evaluation			
Thorough documentation; goes above and beyond assignment expectations. Thoughtful, thorough, independent	Complete documentation; meets assignment expectations. Meets expectations	Documentation is somewhat haphazard or incomplete. Incomplete, hit and miss	Documentation is minimal or very disorganized. Very incomplete

Web Links

huntbot.andrew.c mu.edu/ASBA/ASB otArtists.html
The American Society of Botanical Artists, Inc. (ASBA). Site includes examples of members' works and their educational background.

wba.asn.au
The Wildlife and Botanical Artists web site provides links to other interesting sites related to botany and botanical illustration.

Botanical Illustrator
Bridget Thomas

Bridget Thomas grew up in Clyde, a town with a population of about one hundred, located outside of Pittsburgh, Pennsylvania. She spent her days drawing dogs, birds, and the surrounding woods. In college, Thomas

Fig. 9–19. Bridget Thomas.

studied both art and science, particularly biology. Later she learned that you could go to school just to learn about drawing flowers and animals. As a professional illustrator, Thomas weaves together her love of art, science, and wildlife.

Describe your work process.

Bridget I need to have something nature-based in front of me. Then I think about how it's put together and how I'd like to put it all down on paper. I've always been hugely realistic. Everything I do is very tiny and detailed.

How does your relationship to nature affect your work?

Bridget As a child, I spent lots of time in the woods as well as with my dog, my

guinea pigs, and my rabbits. I'm a "nature kinda gal." In addition to school studies, a lot of my botanical art training came from just reading and viewing on my own. Basically, I have a pretty vast knowledge of what's going on. For instance, I know what's going on inside of a flower and how it all works, and it all comes out in my painting.

What media do you use?

Bridget I do a lot of watercolor, colored pencil, and occasionally some acrylics and oil paints, but mostly watercolor. Paintings can take a long time, up to a week or so.

How do you earn a living?

Bridget I work in the anthropology department in the American Museum of Natural History in New York City, where I do lots of [illustrations of] artifacts—baskets, beads, pottery shards, tools—for scientists who are publishing articles on their discoveries. Freelance, I do flowers and botanical subjects.

Why would scientists prefer illustrations to photographs?

Bridget A lot of times photographs just don't work. Drawings can show the details and break the subject down.

What is most challenging about your job?

Bridget Sometimes it gets boring sitting in an office, and I would like to go outside and sit in the woods and draw. But I do have a nice view from my window!

Fig. 9–20. Why, do you think, do so many botanical illustrators render their subject in watercolor?
Bridget Thomas (b. 1970), *Untitled (cactus).*
Watercolor. Courtesy of the artist.

Chapter Review

Recall What 20th-century artist became famous for her large close-up paintings of flowers?

Understand Why is it important to consider the light source as you arrange objects for a still-life painting? Where did you locate the light source in your still-life painting?

Apply Draw a small asymmetrical still-life composition.

Analyze Where is the center of interest in Luis Meléndez's *Still Life with Melon and Pears* (Fig. 9–9)? How did he make this part of the painting most important? What type of balance is this composition?

Synthesize Research the artist and art style of one of the paintings dated prior to 1980 in this chapter. How is the painting characteristic of its art style?

Evaluate Which of the artworks in this chapter is most like a scientific illustration? Explain why you chose the artwork. How are science and art alike?

Portfolio Tip

Create an electronic portfolio by photographing your art with a digital camera. Use Powerpoint or Hyperstudio to arrange the works into a program with graphics, text, and sound. Store your artworks on a CD or place them on a web site.

Fig. 9–21. In what ways has the artist created emphasis? Where is the light source in this painting?
Cherri Kunz (age 15), *Broccoli*, 2002.
Watercolor, 8" x 12" (20.3 x 30.5 cm), Mission Bay High School, San Diego, California.

Vocabulary

proportions
commission
contour drawing
gesture drawing
mannequin
portraiture

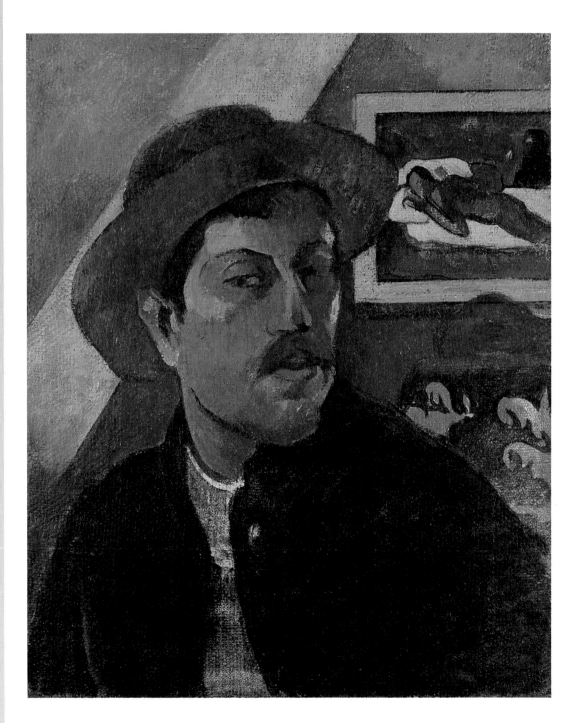

Fig. 10–1. How is this self-portrait by the French painter Gauguin different from other seated portraits in this chapter? Notice how Gauguin has included one of his own paintings in the background.
Paul Gauguin (1848–1903), *Self-portrait*, 1896.
Oil on canvas, 18 ⅛" x 15" (46 x 38 cm). Musée d'Orsay, Paris, France. Réunion des Musées Nationaux/Art Resource, NY.

10 The Human Figure

People are fascinated with other people—what they look like, the clothes they wear, how they live; in short, who they are. When someone asks you to describe yourself, is your first instinct to say: "I'm a freethinker who wears two different shoes and believes in life on other planets"? Probably not. Most of us are more likely to respond with a physical description, such as, "I'm five feet tall, have brown eyes and black hair and lots of freckles."

Our physical bodies are one important clue as to who we are. We use them to communicate, and they can reveal much valuable information that helps others discover something about our nature, personality, or attitude.

Artists throughout history have reflected the fascination with the human body. These artworks are often a record of how people looked, dressed, wore their hair, and lived. When early photographic processes began in the 1830s, artists' reasons for painting people began to change. Because the camera provided a way to create detailed, realistic portraits, portrait artists began to explore other issues, such as mood, style, and personal vision, in their paintings and drawings of people.

design

In this chapter, you will learn the basic guidelines of human proportions and understand how artists use them to accurately portray the human figure. A discussion of design and composition will help you create successful paintings of people. And you'll explore issues of style, abstraction, and realism by creating your own nontraditional portrait painting.

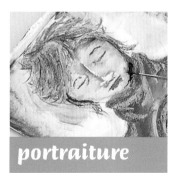

portraiture

proportion

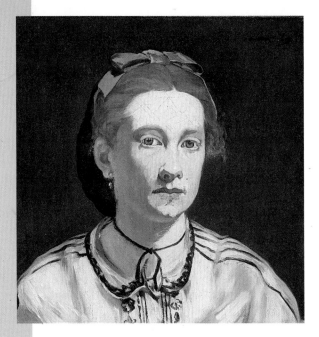

Fig. 10–2. This portrait shows Manet's favorite model; she posed for him for many paintings throughout the 1860s. How did the artist make the sitter's face appear three-dimensional?
Edouard Manet (1832–1883), *Victorine Meurent*, c. 1862.

Oil on canvas, 16 ⅞" x 17 ¼" (42.9 x 43.8 cm). Gift of Richard C. Paine in memory of his father, Robert Treat Paine 2nd, 46.846. Courtesy, Museum of Fine Arts, Boston. Reproduced with permission. © 2002 Museum of Fine Arts, Boston. All rights reserved.

Learning to Paint People

Success in painting the human figure is based on the successful drawing of people, which in turn is based on careful observation. Study how a body's shape and form change as a person changes his or her pose or action. Notice the lines, colors, and textures that make up facial features and such details as hands and hair. Also note how the human form is affected by light and shadow.

If you plan to include people in your paintings, you should constantly practice drawing them. Watch people walking along the street, jogging, or rollerblading and sketch your friends or family members in relaxed or active poses. Look at photographs of people and, if possible, take some pictures yourself. You can use these photographs as the inspiration for your own compositions. Study your own face in a mirror and make drawings of each feature. The more figures and features you draw, the more you will see and learn.

When planning to include figures or faces in a painting, you may face an important concern. How recognizable must a person be for the painting to be successful? As a beginning painter, you will probably discover that it is generally more important for a figure to accurately represent a human being than to represent a recognizable individual. In other words, you should concentrate on creating successful paintings that include people rather than on creating accurate portraits.

Generalizations and Proportions

To help you succeed in using the human figure as a subject, it is important to understand some basic guidelines about figures and facial features. When you include people in your paintings, it is generally important that they appear correctly posed and have accurate **proportions**—the way the individual features and body parts relate to one another and to the whole body. Some simple guidelines and diagrams can help you achieve accurately proportioned figures in your work.

One system that some artists use is to create figures that are approximately eight heads high and two heads wide (when viewed from the front). Actual human proportions are about seven heads high, but many artists find that slightly taller figures appear more visually attractive. Artists also

Fig. 10–3. The eighteenth-century British artist Reynolds is well known for his paintings of children. For this charming double portrait, he dressed the son and daughter of a duke in costumes similar to those worn in Europe in the 1630s.

Sir Joshua Reynolds (1723–1792), *The Young Fortune Teller,* 1775.

Oil on canvas, 55" x 43" (139.7 x 109.2 cm). The Huntington Library, Art Collections, and Botanical Gardens, San Marino, California/ SuperStock.

alter general human proportions and details to suit their personal styles and purposes, as you can see in the artworks in this chapter. Most painters continue to practice figure drawing for much of their lives.

Try It Fill sketchbooks, scratch pads, or sheets of scrap paper with your observations of people. Create sketches using a variety of media and on different surfaces. Experiment with both wet and dry media; such variety and practice sharpens your powers of observation.

Discuss It Fashion illustrators sometimes create figures that are nine or ten heads tall. What are some reasons that they choose to do this?

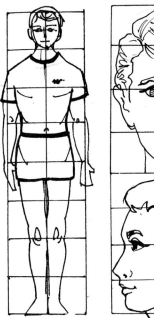

Fig. 10–4. Here, a human face and full figure have been drawn on grids to show general proportions. Of course, you can alter these generalizations to reflect individual characteristics.

Composition and Design

There are two main aspects of every painting involving the human figure: the depiction of the figure(s) and the composition of the work. Some carefully finished portraits appear in poorly composed paintings, and in some well-designed compositions the figures may not be well painted. For a resulting work to be pleasing and successful, these two aspects should be balanced.

When a face, person, or group of people is your main subject, be careful to compose the work so that the figure functions as the center of interest. For example, position a

Fig. 10–5. From 1620 until his death in 1669, the Dutch painter Rembrandt produced a series of ninety self-portraits. These remarkable works record his changing appearance from a youth to an elderly man.
Rembrandt van Rijn (1606–1669), *Self-Portrait at the Age of 63*, 1669.
Oil on canvas, 34" x 28" (86 x 70 cm). © Erich Lessing/Art Resource, NY, The National Gallery, London.

face near the center of the work or direct a viewer's attention to it through the addition of details. A full figure placed at the center will also attract a viewer's eye, but such a composition can sometimes seem static or uninteresting. In the self-portrait shown in Fig. 10–5, notice how Rembrandt used light to draw the viewer's attention to his face and also how he left much of the face in shadow to create interest. With a group of figures, try clustering them in an arrangement of overlapping shapes or forms.

Pay the same careful attention to placing figures in a painting as you would to placing objects effectively in a still life or landscape. Be sure to observe the relationship between positive and negative shapes. Also think about the principles of design; for example, strive for a sense of unity, balance, or movement. Whether the figures are abstract or realistic, they should help make the overall composition interesting, dynamic, and effective.

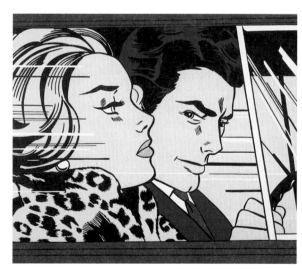

Fig. 10–6. Lichtenstein is known for paintings that resemble enormous magnifications of comic-book stills. How would you describe the feeling that the facial expressions and postures of these two figures convey?
Roy Lichtenstein (1923–1997), *In the Car*, 1963.
Magna on canvas, 67 ¾" x 80 ⅛" (172 x 203.5 cm). Scottish National Gallery of Modern Art, Edinburgh, Scotland. © Estate of Roy Lichtenstein.

Titian

Fig. 10–7. Titian.
Titian (c. 1488–1576), *Self-Portrait,* 1566.
The Prado, Madrid, Spain. Copyright Scala/Art Resource, NY.

Throughout history, artists have painted people in every imaginable style. The great Italian painter Tiziano Vecellio, called Titian in English, is known for his use of contrast and his ability to capture light, color, and form.

No one knows exactly when Titian was born, but it was in the late 1400s. As a young artist, he received training from two renowned Venetian artists, Giovanni Bellini and Giorgione. Some scholars believe that Titian completed his teacher's last major work after Giorgione died from the plague in 1510.

Titian's earliest known **commission** —a contract or order for an artwork—is a series of frescoes completed in Padua, Italy, in 1511. Five years later, he became the official painter of the Italian Republic of Veneto, a region that included the important trading center of Venice. His religious paintings at this time made him famous, and the artist was sought after to produce works for many local churches.

By the 1530s, Titian was both rich and famous. He was even asked to paint a portrait of Emperor Charles V. One story, which may or may not be true, tells how the emperor visited the painter in his studio. Titian dropped a paintbrush, and the emperor—one of the most powerful people in the Western world—bent to pick it up! Regardless of the story's truthfulness, Charles V was so delighted by Titian's work that he asked him to become his court painter.

In later years, Titian traveled to Rome, where he met Michelangelo and saw his recently completed frescoes in the Sistine Chapel. While there, Titian also painted a portrait of Pope Paul III. The artist continued to paint his large works even in the last decades of his life. Titian may have been near ninety years old when he died in 1576.

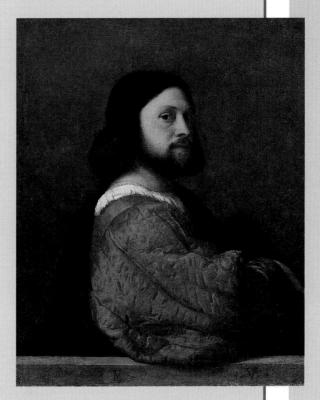

Fig. 10–8. In addition to religious works, Titian is known for his portraits and paintings based on mythological stories. His compositions often rely on diagonal lines to create a sense of movement or tension. Notice how the sitter's nose and jawline echo the strong diagonal of the billowing sleeve.
Titian (c. 1485–1576), *Portrait of a Man,* c. 1512.
Oil on canvas, 32" x 26" (81.2 x 66.3 cm). © The National Gallery, London.

Figures in an Environment

When you paint a full figure or group in a particular setting, you should carefully consider the relationship between the people and their environment. A figure should fit comfortably into a setting and not appear to be cut out of one painting and pasted into another. Remain aware of proportions both among figures and between a figure and the surrounding objects. As you plan the drawing for your painting, check that windows, doors, chairs, and plants are proportionate in size to the people. Also, be consistent: make the figures match the rest of the painting in style, brushwork, and technique. If you treat each figure as you do all the other objects in a painting, the work will have a sense of wholeness.

Note It Sometimes figures are only incidental parts of a painting, with buildings or a landscape as the main subject. In such cases, the figures should be treated as an integrated part of the composition. They should not act as the center of interest or be too prominent or detailed; otherwise the figures may draw the viewer's attention away from the main subject.

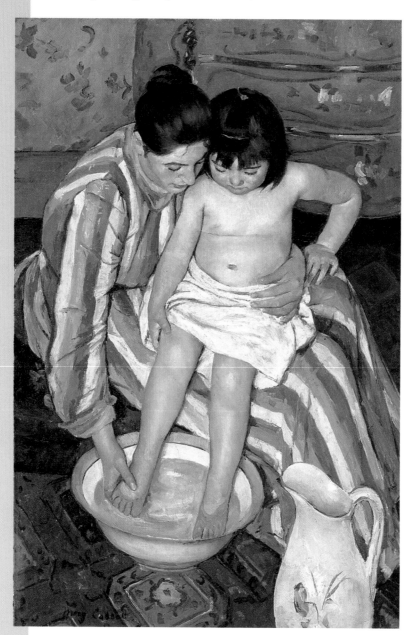

Fig. 10–9. Cassatt was the only American artist to become a member of the Impressionist group of painters working in Paris. Notice how she contrasts the child—a solid area of light values—with the patterns and darker values of the mother's dress, carpet, and background.
Mary Cassatt (1844–1926), *The Child's Bath*, 1893.
Oil on canvas, 39 ½" x 26" (100.3 x 66 cm). Art Institute of Chicago, Robert A. Waller Fund, 1910.2. Photograph © 2002, The Art Institute of Chicago, All Rights Reserved.

Animals

Artists from all cultures have painted animals—both real and imaginary. Ancient Egyptian artists created images of cats, crocodiles, and cattle. In ancient China, artists often depicted tigers, waterfowl, and horses. Horses are also prominent on Greek vases, which show goats, lions, and dogs as well.

In Northern Europe, Renaissance and Baroque artists drew and painted exotic animals seen in private zoos. Later, during the westward expansion in the United States, such artists as Frederic Remington and Charles Russell recorded scenes of the plains filled with buffalo, horses, and cattle. And today, wildlife artists treat birds, fish, and other animals with extreme realism.

Over time, artists have assigned symbolic meanings to animals to help send important social or cultural messages. Just as objects in a still life may represent a deeper meaning or complex idea, animals often symbolize other concepts. Some artists have used animals to represent human qualities, such as a lion for power or a dog for loyalty. Others have created fantastical and frightening animal images that carry religious meanings known only to a particular group of people.

Much as artists practice drawing people, they must also sketch animals to become familiar with their shapes, gestures, attitudes, and textures. Artists often begin by creating **contour drawings**, in which they show only the outline of the animal. It is usually necessary to work quickly to show animals at rest or while running or flying. To capture the animal's movements, an artist makes a **gesture drawing**, one with little detail that is done quickly to capture action.

Fig. 10–10. How did this African artist use pattern in his painting? Describe the sense of space or depth depicted in the work.
Pilipili Mulongoy (b. circa. 1914), *Pintades (Guinea Fowls),* c. 1950.
Oil on masonite, 49 3/16" x 97 1/4" (125 x 247 cm). Courtesy National Museum of African Art, Smithsonian Institution. Washington, DC. Museum purchase 92-15-4. Photograph by Franko Khoury.

Figures in Action

To paint figures in action, you must be aware of the articulation of human joints and limbs. This can be done by: (1) studying and drawing a **mannequin** (a small, jointed model of the human figure) in active poses; (2) photographing students and athletes in action; (3) drawing stick figures in action poses; (4) drawing silhouettes of posed models; and (5) studying sports photographs. Active figures look most convincing when placed in a corresponding environment. Slashing brushwork, soft or blurred edges, and asymmetrical compositions can also help you to emphasize a sense of motion in your painting.

Fig. 10–11. Which parts of this figure are realistic and which are abstracted? How did the artist emphasize a sense of motion in this work?
Jon Williams (age 16), *Zarin's Way*, 1998.
Acrylic and colored pencil, 16" x 20" (40.5 x 51 cm). Asheville High School, Asheville, North Carolina.

Figures in Abstraction

Abstraction is just one of many painting styles. Painters who work in abstraction are not trying to paint realistically but rather show us different ways of seeing people. In an abstract work, an artist often emphasizes one particular element of design (line, shape, color, texture, etc.) or reduces faces or figures to geometric simplicity, patches of color, or dots of paint. Some painters break up figures in their works and put them back together in unfamiliar arrangements. Look for examples of abstraction throughout this book to give you ideas for stretching your figure-painting efforts in new and exciting directions.

Fig. 10–12. Although he often painted the human figure, Modigliani preferred to work from memory rather than from live models. How did the artist add visual interest to this almost perfectly symmetrical composition?
Amedeo Modigliani (1884–1920), *The Little Peasant*, 1919.
Oil on canvas, 39" x 25" (100 x 64.5 cm). Presented by Miss Jenny Blaker in memory of Hugh Blaker 1941, Tate Gallery, London. Copyright Tate Gallery, London/Art Resource, NY.

Fig. 10–13. In this painting, the artist copied and enlarged an old black-and-white photograph. What message, do you think, is Richter attempting to communicate by accurately reproducing such a blurred effect? Gerhard Richter (b. 1932), *Frau Niepenberg*, 1965.

Oil on canvas, 55" x 39" (140 x 100 cm). Astrup Fearnley Collection, Oslo, Norway.

Proportion

In art, proportion—the relationship of a part of something to the whole—is most often associated with the human figure. Most people are alike in their proportions; that is, the relationship of one body part to another and to the whole body. People's faces also have similar proportions, from the width of the mouth to the placement of the eyes, nose, and ears.

In traditional **portraiture** (the art of making portraits), an artist usually creates a figure with realistic proportions. But altering traditional human proportions can create many different effects, from humorous and cartoonlike to surreal and frightening.

Studio Experience
Nontraditional Portrait Painting

In this studio experience, you will use a resist technique to create a nontraditional portrait of a classmate. What do you think of when you hear the word portrait? Many traditional portraits are realistically painted pictures in which a person is seated and looking straight ahead at the viewer. But a portrait doesn't have to be traditional. Sometimes, an artist chooses to depict a sitter in an unusual pose or in such a way that he or she is not recognizable at all.

Before You Begin
● Look at the portrait painted by Gerhard Richter (Fig. 10–13). How is this painting different from the others shown in this chapter?
● Work with your classmates to brainstorm a list of ideas for interesting facial expressions or unusual poses of the human figure. Then choose a partner with whom you will work to create a portrait of each other.

Create It
1. Choose one or two portrait ideas from the list that you brainstormed, or develop another idea. For example, try turning or twisting your body into different forms or wrinkling your nose with your eyes closed.

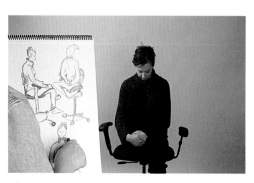

❶ Fig. 10–14.

2. Take turns modeling for each other in different poses. Draw two or three crayon or oil pastel sketches of each other on watercolor paper. Try drawing one in which you show your model's whole body and one in which you depict only his or her face. You might draw one or more poses on a page with several colors of oil pastels or crayons.

3. Review your sketches with each other. Which have the strongest or most interesting compositions? Which best convey your intended purposes? You should select a drawing as the basis for a portrait painting. Think about the role of the background in the composition. Also decide how to create a center of interest.

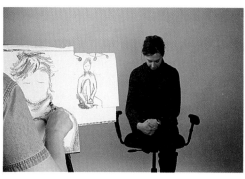

❷ Fig. 10–15.

4. If your crayon or oil pastel lines are not very heavy, trace over them again bearing down harder so that they will be thick enough to resist watercolors or ink.

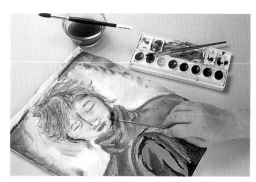

❸ Fig. 10–16.

5. Paint over your drawing with watercolors or thinned inks in colors that contrast with your crayon or oil pastel lines. Try using a variety of colors and brushstrokes to suggest your model's personality or mood.

Check It

In what way is your portrait unusual or nontraditional? How did you achieve a center of interest? Explain the relationship between your subject and the background. Did you use this resist technique successfully? Explain. What did you learn from this project?

Sketchbook Connection

Sketch your hand in different poses. For some sketches try looking only at your hand, not your paper. In these drawings go slow, noticing details such as fingernails and creases at the joints. In others, concentrate on your hand's proportions. How long are your fingers compared to your palm?

Rubric: Studio Assessment

4	3	2	1
Nontraditional Approach · Pose/Expression · Composition · Level of realism/abstraction · Representation of personality			
Ample experimentation with composition or style. Final image is highly non-traditional yet conveys strong sense of personality or personal characteristics. High risk, unusual, effective portrait	Sufficient experimentation with composition or style. Final image is nontraditional, conveys sufficient sense of personality or personal characteristics. Moderate risk, effective portrait	Some experimentation with composition or style. Final image somewhat traditional OR personality or personal characteristics is unclear. Moderate risk, conventional	Little experimentation with composition or style. Final image very traditional AND/OR personality or personal characteristics not communicated. Low risk, conventional
Media Use · Student choice			
Competent crayon/pastel use. Exceptional technique: expressive brushstrokes convey mood, create varied effects. Sparkling washes, colors. Skillful, controlled, appropriate	Appropriate crayon/pastel lines. Competent brush technique/use of color convey mood. Proper use of wet/dry surfaces. Competent, appropriate	Crayon/pastel lines too thin OR watercolor technique needs work. Weak brushstrokes; flawed washes. Unsatisfactory color use. More practice indicated	Inadequate crayon/pastel lines. Brushstroke technique lacks skill. Mood not conveyed. Colors run together or puddle accidentally. Rudimentary difficulties
Work Process · Brainstorming · Sketches · Reflection/Evaluation			
Thorough documentation; goes above and beyond assignment expectations. Thoughtful, thorough, independent	Complete documentation; meets assignment expectations. Meets expectations	Documentation is somewhat haphazard or incomplete. Incomplete, hit and miss	Documentation is minimal or very disorganized. Very incomplete

Web Links

boston.aiga.org/ pages/lukova/ lukova.htm

Featured article on theatrical poster illustrator Luba Lukova.

www.american illustration.org/ html/artists_index lite.html

National Museum of American Illustration, featuring illustrations of the human figure by a variety of arists.

Theatrical Poster Illustrator
Jim McMullan

Jim McMullan remembers both the British watercolor paintings of his father's homeland and the subtle Chinese watercolors

Fig. 10–17. Jim McMullan.

that were a part of his childhood growing up in a town in north China. In 1941, just at the beginning of World War II, McMullan's family left China from the city of Shanghai and went to live with his mother's relatives in Canada. They then moved to India in 1944, where they lived until after the war. Even in junior high school, McMullan pursued what would become his career, producing posters for school plays.

What first drew you to poster illustration?

Jim I grew up in the golden age of illustration. Looking at *The Saturday Evening Post* and the magazine illustrations, I realized that illustration was a serious thing to do. By the time I got to Pratt Institute in New York, I wasn't interested in the Abstract Expressionists of the day. At the time it didn't seem possible to be a fine art figurative painter. So I decided to become an illustrator. I've always been interested in telling stories and evoking emotions through figurative art.

Why was your use of watercolor considered innovative?

Jim Watercolors were considered too weak and too subtle a medium for illustration, particularly in the 1960s, when everything was psychedelic and everyone was using inks, acrylics, and dyes. Watercolors didn't seem dramatic enough.

What is the process of creating a theatrical poster?

Jim An art director hires me. Then I read the play, talk to the playwright and/or director, and digest the information to create a visual metaphor, which I make out of the gestures of the human body—how someone turns, looks, and so on. I consider the character, the situation, and what I can say about the character through body gesture.

After the pencil sketches are approved, I hire models or get one or several actors from the play and take photographs to work from. I paint a series of little paintings, any one of which may be the poster. This process allows me to take more risks when I work.

I've learned not to add the text until the end because the elements can shift, sometimes radically, in the composition. I put the words on an acetate overlay or a separate piece of paper, so that the theater's advertising agency can adapt the image to any use.

Fig. 10–18. This theatrical poster shows people in a variety of poses. How would you describe the mood of this image? What features of the work contribute to the mood?
James McMullan (b. 1934), *Mule Bone.*
Watercolor. Courtesy of the artist.

Chapter Review

Recall What two drawing techniques might an artist use to begin an animal painting?

Understand From another chapter, select an abstract painting of a figure. Why, do you think, did the artist choose to abstract the figure, rather than depict it as realistic?

Apply Draw a diagram showing human facial proportions. Where are the eyes located in relation to the whole head?

Analyze From this chapter, select a painting that shows two figures. Explain how the artist arranged the figures to create a unified composition.

Synthesize Compare the body and facial proportions of a cartoon character to those of the figure in Fig. 10–4. Why, do you think, did the cartoonist change the proportions of the cartoon character?

Evaluate If you could commission any of the artists in this chapter to paint your portrait, which artist would you choose? What aspect of the artist's style influenced your choice? What would you want the artist to emphasize in your portrait?

Portfolio Tip

Study art portfolios of your teachers and other professional artists. Research several artists' portfolios on the Internet. What can you learn about an artist and his or her work from the portfolio? Notice how sometimes an artist's style will change over time.

Writing about Art

Select a contemporary or twentieth-century portrait artist (e.g., Chuck Close, Frida Kahlo). Investigate his or her work in light of portrait painters of the past. Write a report indicating which portrait traditions or artists of the past might have influenced the work of your selected artist. Conclude with your opinion about why this artist might be an important influence on future portrait painters.

Fig. 10–19. Notice the strange sense of unity in this composition. How has the artist created this sense?
Susan Marston (age 14), *Untitled*, 1997.
Shrewsbury High School, Shrewsbury, Massachusetts.

Fig. 11–1. Vincent van Gogh was not interested in realistic representations of the world around him. Instead, he used vibrant colors to express a range of emotions. How, do you think, did van Gogh feel about this house?

Vincent van Gogh (1853–1890), *The Yellow House*, 1888.

Oil on canvas, 28" x 36" (72 x 91.5 cm). Arles: September, 1888. F 464, JH 1589. Vincent van Gogh Museum, Amsterdam.

11 Natural and Constructed Environments

Do you enjoy a drive down a country road, delighting in the hills, mountains, or plains of the landscape? Or perhaps you feel more comfortable in the city, surrounded by the concrete and steel of the constructed environment. As an artist, these subjects have probably appeared in your work. But did you know that you can express certain feelings about your world through artworks that explore the natural or human-made environment?

Artists react to the world around them—they reflect its beauty, record its changes, and critique its advancements. Artists do not merely imitate what they see; their representations often carry social, religious, or political messages. From the contemplative landscapes of twelfth-century China to the precise patterns of contemporary Aboriginal Australian art, artists have used the land to communicate important cultural meanings. In the twentieth century, some artists have celebrated the excitement of the city; others have documented the dangers of industrialization and the isolation of urban life. The world offers abundant subject matter, and contemporary artists work in a range of styles to convey their ideas and perhaps shape their vision of a better world.

landscape

In this chapter, you will learn to identify subject matter in both the natural and constructed worlds. A discussion of perspective and the depiction of space in two-dimensional art will help you create realistic paintings that have meaning for you and that express a personal statement.

architecture

perspective

Landscape Painting

Chinese painters had already worked with landscape themes for centuries by the time European artists turned to such subject matter in the fifteenth and sixteenth centuries. Renaissance artists' interest in **naturalism**—the realistic portrayal of objects—caused painters to look carefully at their natural environment and attempt to accurately portray it on panels and canvas. At first, they used landscape as background in paintings that featured figures and animals. Gradually, pure landscape themes became more dominant, and figures became secondary, merely a part of the natural scene.

Late Renaissance painters sought to depict the characteristic textures, colors, forms, and lines of trees and mountains. Sunlight, foliage, reflections, and shadows were also studied with intense interest. Giovanni Bellini, Claude Lorrain, and Pieter Bruegel were important early landscape painters. Artists in the seventeenth century, including Peter Paul Rubens and Jacob van Ruisdael, expanded on the themes of the earlier artists and led the surge of interest in landscape painting in northern Europe.

Modern landscape painting began with English painters John Constable and Joseph

Fig. 11–2. Münter, a German artist, is known for her use of simple and colorful shapes, which she often outlined in black. How is the effect created by the colors in this work different from that of Fig. 11–4?
Gabrielle Münter (1877–1962), *Staffelsee in Autumn*, 1923.
Oil on board, 13 ¾" x 19 ¼" (34.9 x 48.9 cm). The National Museum of Women in the Arts, Washington, DC. Gift of Wallace and Wilhelmina Holladay.

Mallord William Turner in the early nineteenth century. The Impressionist artists of France and the United States eliminated detail and emphasized the effects of light in their depictions of the natural environment. And in the early twentieth century,

Winslow Homer and Thomas Eakins realistically painted the American scene. Many landscape artists began to value personal expression more than realistic depiction—a trend that continues today.

Fig. 11–3. Chinese artists of the Song dynasty wanted their paintings to show the vastness of nature. How did the artist convey a feeling of grandeur?
Anonymous, *Autumn Foliage Along a River,* Southern Song dynasty, late 12th century.

Square album leaf; ink and light color on silk, 10 ½" x 11" (26.7 x 28 cm). Denman Waldo Ross Collection. 29.2 Courtesy, Museum of Fine Arts, Boston. Reproduced with permission. © 2002 Museum of Fine Arts, Boston. All rights reserved.

Fig. 11–4. Notice the artist's effective use of perspective to draw the eye from the foreground to the background. What mood does her limited use of colors create?
Marion Bolognesi (age 15), *Bonaire,* 1997.

Oil, 12" x 16" (30.5 x 40.5 cm). Quabbin Regional High School, Barre, Massachusetts.

Sources of Subject Matter

Landscape artists work with the basic environmental elements: land, vegetation, water, and atmosphere. They arrange these elements as they are found in nature or in some personal way. They use all kinds of media to express their ideas and reactions to natural surroundings. Landscape paintings can include buildings, people, and animals, but the land should be the dominant element. (See pages 162–164 for a discussion of cityscapes and other architectural subjects.)

With so many landscape elements around you or familiar to you, how do you choose a subject for a painting? Where can you look for possible themes to address? Traditionally, landscape painters receive inspiration directly from nature; they search for themes and subjects outside, wishing to react directly with their environment. Many paint outside as well, or they create studies or sketches (in pencil, watercolor, pastel, or other media) on location to be finished back in a studio.

Sketches often include notes about color, size, mood, light, and the like and can vary from a few simple words to extremely detailed accounts. Some artists prefer to photograph possible subjects and use these records of field experiences to provide ideas and details for later paintings. Of course, other paintings and drawings of natural scenes can also be used as visual information for landscape paintings, but be careful to use them only as sources of basic information and not as compositions to be copied.

Try It Paint a similar landscape subject in three different media. For example, try painting a seascape using watercolor, acrylic, and tempera. This exercise will help you to explore the distinct possibilities of each medium and become familiar with how each relates to a specific type of landscape painting.

Fig. 11–5. In this landscape painting, the artist balances the strong vertical lines of the trees with the repeated horizontal lines of the background clouds.
Lawren Harris (1885–1970), *Above Lake Superior*, c. 1922.
Oil on canvas, 48" x 60" (122 x 152 cm). Art Gallery of Ontario, Toronto, Canada. Gift from the Reuben and Kate Leonard Canadian Fund, 1929. Photo: Carlo Catenazzi, Art Gallery of Ontario.

Aboriginal Painting

What are you reminded of as you look at the painting shown in Fig. 11–6? If you said a map, you are not far from the truth. This work is an example of the paintings created by the *Aborigines* of Australia. Such works record their ancient religious beliefs in visual form.

The traditional forms used by Aboriginal artists include sand paintings, rock carvings, and paintings done on bark. These works not only record the journeys of the ancestors, but they also establish "road maps" across the vast Australian desert. The records provide crucial information, including the location of water and important landmarks.

An important part of Aboriginal religion is Dreamtime, a state of being that Aborigines believe includes the future and the past. During this time, ancestral figures shaped the Earth and its features. Places such as valleys, lakes, and hills are sacred and are the basis for the "ancestor trails" that Aborigines celebrate in song, dance, and painting. Such ancestor trails have become an inspiration for modern Aboriginal artists. The artists use traditional symbols, including circles, dots, wavy and straight lines, and U shapes, that can date back more than ten thousand years to early rock carvings. Their specific meanings are complex and often are known only to the groups of painters who use them.

Many of the works, including the painting shown here, appear to record an aerial view of the landscape. These beautiful and mesmerizing works reflect the strong tie that continues to exist between the Australian Aborigines and the land on which they live.

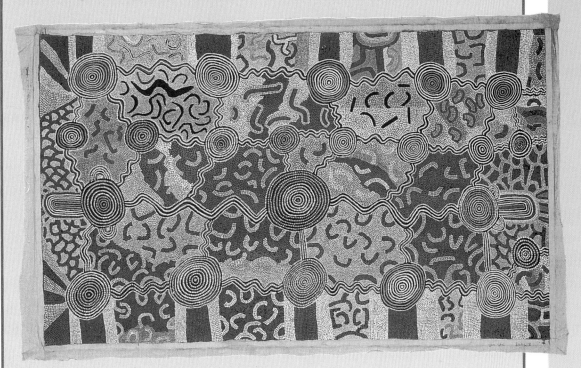

Fig. 11–6. Aboriginal art is painted by men, women, or a group of relatives and often reflects the use of traditional earth tones. This composition records such landscape features as a winding creek, a small patch of grass, a large rock, and a forest.
Yumari Uta Uta Tjangala, *A Sacred Place in the Desert,* 20th century.
66" x 40" (168 x 99 cm). Collection Robert Holmes a Court, Perth, Australia. Jennifer Steele/Art Resource, NY.

Asian Brush Paintings

Asian brush paintings are among the most graceful and complex works in the history of art. The art form, which includes both Chinese brush painting and Japanese *sumi-e* (ink painting), began in China perhaps as long ago as 2000 BC and spread to Japan in the seventh century. Early brush painting is closely tied to Chinese **calligraphy,** the art of beautiful writing, in which artists use fluid brushstrokes to create the characters of the language.

During the Song dynasty (c. 960–1279) in China, landscapes became popular subject matter for brush paintings, and in the fifteenth century, Japanese artists also began to focus on natural scenery. Artists from each culture have used the landscape to convey important social and religious beliefs. Their paintings are not copies of actual scenes; rather, they are carefully arranged compositions meant to inspire the viewer to reflect on deeper issues, such as the place of humans in the world or the changing aspects of nature.

Traditional brush paintings were done on either paper or silk and come in three formats: the hanging scroll, the handscroll, and the fan. Each format invites the viewer to journey into the landscape, entering from the lower right. In a fan and handscroll, the journey winds along to the left, whereas in a hanging scroll, the viewer travels in a meandering, usually zigzag, upward path. To aid the viewer's journey, artists use a system of light and dark areas that lead the eye through the composition.

To achieve dramatic effects, painters use simple, high-quality tools and materials: ink, an *ink stone* (used to grind the ink with water), brushes, and paper. Although brush paintings have a fluid, spontaneous look, artists must practice the special brushstrokes for many years before they are able to attain such an effortless appearance. The brushstrokes are considered the "bones" or structure of the painting, and artists attempt to paint only when they are confident of their technique.

Most Chinese brush paintings are monochromatic, but some contain washes of color as well; all Japanese *sumi-e* are done in black ink with gray washes. The painter may use the *dry-brush technique,* in which the white of the paper is allowed to

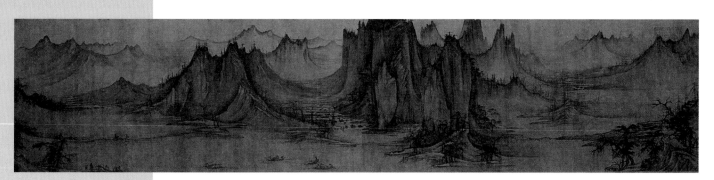

Fig. 11–7. Chinese artists closely studied nature, reproducing as many details as possible. They sought to show the distinctive appearance of each natural subject.
Xu Daong, *Fishermen's Evening Song,* c. 1049, Northern Song Dynasty (960–1049).
Handscroll, ink and slight color on silk, 19" x 82½" (48.2 x 209.5 cm). The Nelson-Atkins Museum of Art, Kansas City, Missouri. (Purchase: Nelson Trust) 33-1559.

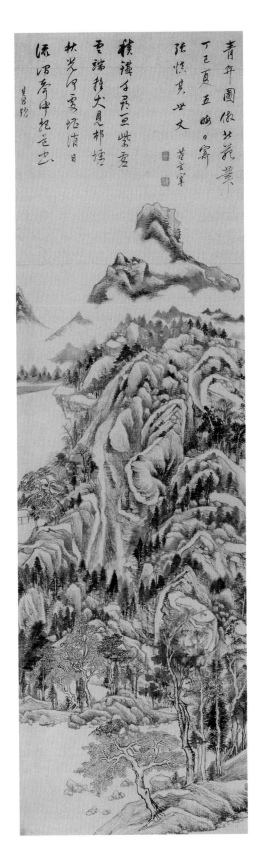

show through the jagged edges of the strokes, or washes of varying densities. Dark lines add accents and make certain parts of the composition stand out.

Try It Use a dark-colored watercolor or washes of thinned tempera or acrylic to create a brush painting of a landscape. Experiment with washes and dry-brush techniques. Also try varying the pressure of the brushstroke and painting on both damp and dry areas for different effects. Use fluid strokes to capture the "essence" of the landscape features.

Fig. 11–8. In 17th-century China, one school of painting preferred the effect created by free brushwork over achieving careful detail in landscapes. These artists were less concerned about how closely a painting resembled nature than the expressive power of the painting itself.
Dong Qichang (1555–1636), Ming Dynasty.
The Qingbian Mountains, 1555–1636.
Hanging scroll, ink of paper, 88" x 26 ½" (224 x 67.2 cm).
© The Cleveland Museum of Art, 2002. Leonard C. Hanna, Jr., Bequest, 1980.10.

Fig. 11–9. Contemporary Chinese and Japanese artists often incorporate influences of Western art into their traditional painting styles. What Western painting style do you think influenced this artist?
Wu Guanzhong (b. 1919), *Pine Spirit*, 1984.
Chinese ink and color on paper. Spencer Museum of Art, University of Kansas, Lawrence. Museum purchase: Gift of E. Rhodes and Leona B. Carpenter Foundation.

Organization and Design

Remember as you work that the responsibility of an artist is to interpret a subject in a personal way, not merely to imitate or copy it. Even artists who work realistically try to express some basic feeling or reaction to a scene. The variety of personal interpretations in this chapter will show you that each artist treats his or her natural subject differently.

Once you choose your subject, think about how to express any personal feelings that the scene inspires. Ask such questions as: How can I best capture the mood or light? What can I add to help communicate my feelings? What is the most important part of the painting? Which colors or values best express my ideas? Your answers to these and similar questions will help you shape a personal statement and create a working drawing from which to paint a finished work.

When you are pleased with a possible arrangement for your landscape, step back and review its composition. Will the viewer have a sense of the size of the scene? If not, perhaps the addition of one or two human elements, such as a small figure or a building, will clearly establish a sense of scale. (Remember that scale is the size of a figure or object in relation to the size of something nearby.) Do the large, simple shapes that make up the picture seem unified and balanced? Does the picture have a center of interest?

Don't be too concerned with adjusting reality; make any changes necessary to create a pleasing and interesting design and to help you communicate your feelings or message. For example, try adding a road or telephone poles to highlight the impact that human habitation has had on the environment. Also think about which areas to paint first (such as the sky or the ground) and which areas of detail to save for last. As with any subject, be aware of the effective use of the elements and principles of design.

Fig. 11–10. How did the artist emphasize the relationship between positive and negative shapes in this landscape painting? Helen Burdon Price, *Red Twilight*, 1997.
Oil on canvas, 40" x 30" (101.6 x 76.2 cm).
A. Jain Marunouchi Gallery, New York.

Note It It is important to realize that you probably cannot paint everything you see in a landscape. Be selective; decide which elements to include and which to leave out. It's a good idea to make several sketches to help you simplify or even rearrange your composition. It is usually more important that the parts of your painting work well together than that they are faithful reproductions of a specific scene.

Space

Space—the empty area between, around, and within objects—surrounds us. In two-dimensional artworks, artists can create only the illusion of space. They often use the system of linear perspective to make a scene appear three-dimensional.

Painters also rely on the system of aerial or **atmospheric perspective**, in which objects that are less detailed and have subtler values (often grayish-blue hues) appear farther away. The distant objects are usually smaller and placed behind more detailed objects that are meant to appear closer to the viewer. Such overlapping and decreasing the size of objects are other useful techniques for creating the illusion of depth.

Fig. 11–11. What makes this an interesting view of a landscape? How did the artist create a sense of scale?
Amanda James (age 16), *Untitled,* 1997.
Acrylic. Shrewsbury High School, Shrewsbury, Massachusetts.

Fig. 11–12. Before painting this panoramic work, the artist created a clay model of the landscape to help give him a bird's-eye view of the scene.
Grant Wood (1892–1942), *Spring Turning,* 1936.
Oil on masonite panel, 18 ¼" x 40 ¼" (46 x 102 cm). Reynolda House, Museum of American Art, Winston-Salem, North Carolina. © Estate of Grant Wood/Licensed by VAGA, New York, NY.

Architecture

Although architectural elements appear in Renaissance religious paintings of the fifteenth century, it was not until the eighteenth century that artists depicted architectural views for their own sake. At that time, the cityscapes of the Venetian painter Giovanni Antonio Canal, called Canaletto, and others were prized by the wealthy as travel mementos. Today, such works continue to serve as faithful records of life and architecture as they existed more than two hundred years ago.

Architecture again became a major painting motif in the late nineteenth century, when Claude Monet explored the light patterns on the facade of Rouen Cathedral, and Camille Pissarro painted the flickering light of the streets of Paris. In the early twentieth century, such artists as Georgia O'Keeffe, George Bellows, John Sloan, and Robert Henri responded to the growth of cities by painting the scenes in their own distinctive styles. Since then, architecture has furnished the subject for many works by such contemporary artists as Richard Estes and Ed Ruscha.

Sources of Subject Matter

Subject matter for architectural paintings is found the world over, in a nearby city or town, or right in your own neighborhood. Traditionally, artists have responded to a wide variety of architectural forms, from magnificent churches and bustling city streets to the quaint charms of a weathered barn or a rural neighborhood. Look around you. You'll probably find that there is more than enough interesting subject matter to choose from within a mile of your home or school. (See pages 156–157 for additional ideas about considering subjects for a painting.)

Fig. 11–13. In this intriguing work, the artist includes faces and figures in the windows and openings of a house and its foundation. What color scheme did she choose for the painting? Ida Applebroog (b. 1929), *Rapunzel, Rapunzel,* 1990.
Oil on canvas, 114" x 66" (290 x 168 cm). Private collection, courtesy Ronald Feldman Fine Art, New York. Photo: Jennifer Kotter.

Fig. 11–14. The artist painted this view of New York from the window of his studio. How did he use contrast in this composition? What mood or feeling does the work convey?
John Sloan (1871–1951), *The City from Greenwich Village*, 1922.
Oil on canvas, 26" x 33 ¾" (66 x 86 cm). Gift of Helen Farr Sloan, photograph © 2002 Board of Trustees, National Gallery of Art, Washington, DC.

Fig. 11–15. Canaletto is famous for his sweeping views of Venice, Italy, a subject that he painted for more than twenty-five years.
Canaletto (1697–1768), *Venice: The Basin of San Marco on Ascension Day*, c. 1735–41.
Oil on canvas, 48" x 72" (121.9 x 182.8 cm). © The National Gallery, London.

Organization and Composition

You can approach architectural subject matter much as you would a still life, a figure painting, or a landscape. You may depict an entire city skyline or a block of suburban homes. Or perhaps narrow your field of vision and limit the scope of your painting. With the help of a viewfinder, move in closer and experiment with focusing on one part of a building, such as an interesting window, an ornate carving, or an unusual roof—whatever forms a strong composition. If it is inconvenient to draw your subject on location, take a photograph and use the slide or print as a source of information.

After you have chosen your architectural subject and a possible composition, consider the different painting media that you can use to record it. Think about whether your subject seems to call for bright colors, symmetrical balance, or a sense of great depth.

Will you emphasize texture, line, or rhythm? Will your subject be more interesting if you depicted it at sunset, during a rainstorm, or in the middle of the night? Experiment with adding three-dimensional elements to an architectural painting; for example, use glue to attach pieces of cardboard, balsa wood, sandpaper, screen, glass, or wire to the surface.

Try It Think of a building that you see every day or one with which you are well acquainted. Draw the front of the building from memory. How many stories is it? What does the roofline look like? Is the entrance in the center or to one side? How many windows make up the facade? Can you remember any carvings or other details? Compare your drawing to the actual structure and note the elements that you forgot or remembered incorrectly.

Fig. 11–16. The American painter Hopper is known for his scenes of both city life and rural New England. What two complementary colors did he use to create contrast in this work?
Edward Hopper (1882–1967), *Two on the Aisle*, 1927.
Oil, 40 ¼" x 48 ¼" (102 x 123 cm). Toledo Museum of Art, Toledo, Ohio.

Vantage Points and Perspective

Unfortunately, you can't pick up a building and move it around like a piece of fruit in a still life. To find an interesting view, you first have to experiment with different **vantage points**, the positions or standpoints from which to observe your subject.

Experiment with looking at a building from an unusual angle—try glancing straight up at it while standing nearby or look down on it from a hill or the top floor of another building. You can also try viewing your subject while inside looking out. Remember: If you still have difficulty selecting a vantage point, you can always rely on your imagination!

Once you've chosen an interesting view, the use of perspective lines can help you to accurately convey a sense of three-dimensional space. Although ideas of depicting perspective date back to the ancient Greeks, the first formal systems were developed during the Renaissance more than five hundred years ago.

There are two basic forms of linear perspective: one-point and two-point. In **one-point perspective**, parallel lines appear to move off into the distance and meet at a single vanishing point. Notice how this system works in the painting *Interior of the Choir*, shown in Fig. 11–17.

In **two-point perspective**, an artist uses parallel lines that appear to meet at two different vanishing points placed far apart from one another. This system of perspective is commonly used to depict three-dimensional space for buildings or objects that are viewed at an angle.

Before you begin sketching an architectural scene, decide whether you will have to use one- or two-point perspective. You may even experiment with viewing the same building from two vantage points—each requiring a different form of perspective.

Fig. 11–17. This Dutch artist sometimes used measurements and building plans to help him achieve precision in his paintings of building interiors. When Saenredam died, he was buried in this church in his hometown.
Pieter Saenredam (1597–1665), *Interior of the Choir of Saint Bavo's Church of Haarlem*, 1660.
Oil on oak panel, 27 11/16" x 21 9/16" (70.4 x 54.8 cm). Worcester Art Museum, Worcester, Massachusetts, Charlotte E.W. Buffington Fund.

Studio Experience
Landscape from a Different Point of View

In this studio experience, you will transform either a familiar architectural or natural environment into an intriguing and interesting composition by choosing to show it from a worm's-eye or a bird's-eye view. Imagine being surrounded by very tall buildings. As you look up at the soaring architecture from your "worm's-eye" view, you notice how the buildings seem to converge at one point above your head. Now imagine looking out of an airplane window onto the land far below. When seen from a "bird's-eye" view, a landscape often looks like a patterned quilt or a child's train set.

Before You Begin

● Look at the Aboriginal landscape (Fig. 11–6) and the painting by Grant Wood (Fig. 11–12). How are these two works different from others shown in this chapter? How are they different from each other?

● Decide whether your painting will show either a worm's-eye view of architecture or a bird's-eye view of a landscape. Think about a familiar natural environment, such as a park, garden, or other area in your neighborhood. Or choose an urban environment, such as your own city or one that comes purely from your imagination.

Create It

1. Select a subject for your painting. Choose an environment that has a variety of features, whether natural (forests, fields or open areas, a river or lake) or human-made (buildings, towers, or monuments). A scene that includes a path or road can also help to add visual interest.

2. Draw a series of pencil sketches of your chosen subject. Try one sketch in which you view a landscape from directly above or you view architecture from below. Remember to add a center of interest, which will help focus your composition.

1 Fig. 11–18.

3. Review your sketches. Which one includes a variety of shapes and lines? Is there one you can crop to improve the composition? Select a drawing as the basis for a tempera or acrylic painting. Make notes about any ideas you have for color usage, textures, or methods of paint application.

2 Fig. 11–19.

4. Choose a working surface that is appropriate to your chosen medium. Decide at what size your composition will work best. If necessary, prepare or prime your chosen surface and allow it to dry. Gather the materials that you will need, including paints, brushes, palette, easel, and containers.

5. Review your preparatory drawing and notes. Sketch in the main shapes and lines of your composition using a pencil or thinned paint. Don't worry about any details at this point.

③ Fig. 11–20.

6. Begin painting. Think about how to create a sense of contrast among the different features. Perhaps try using colors and textures that accurately reflect the landscape or experimenting with bold and exaggerated colors. If you are working with tempera, see page 60 for a demonstration of one possible technique. For a demonstration of acrylic, see page 88.

Check It

Does your painting capture a worm's-eye view of architecture or a bird's-eye view of a landscape? Does your composition include contrast? Does it have a clear center of interest? Have you used your chosen medium successfully? Explain. What did you learn from this project? What will you do differently the next time you work on a similar project?

Sketchbook Connection

Draw an outdoor or indoor scene from an ant-on-the-ground's point of view. Actually get down low to study what this bug might see. What things become large and important?

Rubric: Studio Assessment

4	3	2	1
Visual Interest · Built or natural environment · Real or imaginary · Intrigue and interest			
Image is very mysterious and/or reveals a totally unanticipated view of a familiar environment. Mysterious, compelling, otherworldly	Image is appealingly mysterious and/or presents fresh view of a familiar environment. Fresh, intriguing, evocative	Somewhat ordinary image; some change from the familiar. Potential to grow	Few aspects of the image convey a sense of mystery and/or a new view. Conventional, limited vision
Composition · Point of view (above looking down, or down looking up) · Center of interest			
Dramatically exaggerated, convincing illusion of depth. Strong center of interest. Dramatic, deep, unified	Convincing illusion of depth. Identifiable center of interest. Convincing, deep, unified	Errors in illusion of depth techniques OR weak composition impair image impact. Hesitant, underdeveloped	Errors in illusion of depth techniques AND weak composition significantly impair image impact. Underdeveloped, weak
Media Use · Tempera paint or Acrylic paint			
Masterful brush technique. Inventive color usage; proficient mixing, washes. Sophisticated use of contrast and visual interest. Skillful, controlled, appropriate	Skillful brush/mixing technique. Appropriate use of color, washes, contrast. Appealing visual interest. Skillful, appropriate	Technique problems; OR inappropriate usage; OR weak use of color, contrast. Fragmented visual interest. More practice indicated	Faulty technique. Very limited or unplanned use of color, highlights/shadows; lack of contrast, visual interest. Rudimentary difficulties
Work Process · Visual research · Sketches · Reflection/Evaluation			
Thorough documentation; goes above and beyond assignment expectations. Thoughtful, thorough, independent	Complete documentation; meets assignment expectations. Meets expectations	Documentation is somewhat haphazard or incomplete. Incomplete, hit and miss	Documentation is minimal or very disorganized. Very incomplete

Computer-Assisted Animation

Daniel Sousa

Daniel Sousa was born in 1974 on the Cape Verde Islands, off the western coast of Africa. He recalls that throughout his childhood in Lisbon, Portugal, he loved drawing and painting from his

Fig. 11–21. Daniel Sousa.

favorite comic-book or cartoon characters, from life (family and friends), and from his imagination. He studied painting in high school but later found this art form too limiting. Instead, he craved the added dimension of time and motion—he wanted to create "paintings that moved." Although he trained as a traditional animator (to shoot on film), Sousa found that in today's rapidly changing world, it was impossible not to use computer technology as an art tool.

What, exactly, is computer animation?

Daniel There are a wide range of styles and techniques that can be described as computer animation. The most common is three-dimensional computer animation, as seen in films like *Toy Story* or *Monsters, Inc.* It's completely computer generated, but you still need the animator to make all the acting decisions. There is also computer-assisted animation, which involves scanning hand-drawn images on paper and then painting them or compositing them in the computer. That's closer to what I do. You can see that technique used in most Saturday morning cartoons and Disney films. But if you want to learn animation, don't start with the computer. Try doing some animation by hand first. Try simple flip books, first acting out everything yourself in front of a mirror.

How does computer animation compare to hand-drawn animation?

Daniel Cartoon animation used to be done by drawing twenty-four images for each second of screen time. Those images would then be traced onto sheets of clear acetate, painted, and placed over a painted backdrop. This allowed animators to keep the same backdrop while changing the characters on the acetate for each frame of film. Computer animation, though, allows animators to create just the main poses of each action—what they call "key-frames." The computer then inserts as much or as little of the action in between as you tell it to. This frees up the animator so that he can do more important things, like picking up his laundry! Still, a thirty-second cartoon might take about four months to make.

Fig. 11–22. Artists who create animations have to think about the environments in which their characters are portrayed. What, do you think, did the artist have to consider when planning this image?

Daniel Sousa, *Quik.*

Computer animation. Courtesy of the artist.

Chapter Review

Recall What are three formats of traditional Asian brush painting?

Understand Explain why Aboriginal paintings often resemble maps.

Apply Draw two cubes, one in one-point perspective and one in two-point perspective.

Analyze Observe *Pine Spirit* (Fig. 11–9) by contemporary artist Wu Guanzhong. What qualities of the work suggest the artist's Asian art background? In what ways is the work similar to Western contemporary art, such as that shown in Fig. 3–8 and Fig. 7–3?

Synthesize Choose a landscape painting from this chapter. Write a description of a path that a person might take if he or she were to travel from the foreground to the background of the painting.

Evaluate In your opinion, which landscape in this chapter was painted from the highest viewpoint? Explain why you think so.

Portfolio Tip

Demonstrate your ability to think and visualize in different ways by including a variety of art styles in your portfolio. Include realistic detailed drawings, as well as abstract works. Use a variety of media to show your versatility with still lifes, portraits, full figures, landscapes, and perspective studies.

Writing about Art

You now have worked in a number of painting media and have considered several kinds of subject matter. Carefully consider the materials, subjects, and design elements with which you work best. Write a self-evaluation. What is it about these materials and subjects that interest you? Is there one particular medium that you favor, or several? What about subject matter? Have you worked in series? Do you find yourself structuring your work in a certain way? Do you lean toward particular elements or principles of design?

Fig. 11–23. What techniques for creating the illusion of depth has this artist used?
Iza Wojcik (age 18), *The Dinner,* 1999.
Oil, 30" x 40" (76 x 101.5). Lake Highlands High School, Dallas, Texas.

Fig. 12–1. For more than twenty years, Rothko created mysterious compositions in which he placed large rectangles of color one on top of another. **What do the contrasting colors at the edges of the canvas add to the overall effect of this work?**
Mark Rothko (1903–1970), *Untitled*, 1953.

Oil on canvas, 80 ³⁄₈" x 66 ¹⁄₄" (204 x 168 cm). Gift of the Mark Rothko Foundation, Inc., Photograph © 2002 Board of Trustees, National Gallery of Art, Washington, D.C. 1949.

12 Nonobjective Art

"**A** four-year-old could paint that!" Perhaps you have heard this comment while looking at a twentieth-century painting in a museum. Do you agree with the statement?

When looking at artworks that do not have realistic imagery, it often helps to have some background information to understand the intentions of the artist. These works may appear careless or haphazard, but they are in fact carefully planned compositions that often require much time to produce.

During the second half of the nineteenth century, artists began to move away from realistic depictions of their subject matter. They simplified or modified the subject so that it no longer looked realistic. Early twentieth-century artists pushed abstraction even further and made works that were nonobjective—not showing any recognizable objects at all. Colors, shapes, movement, and textures became the focus of their compositions. Russian artist Wassily Kandinsky painted explosions of color, and Spanish painter Joan Miró was fascinated with organic lines and shapes. The American Abstract Expressionists highlighted the act of creating. Contemporary painters, including Ellsworth Kelly, Helen Frankenthaler, and Frank Stella, continue to stretch the boundaries of nonobjective art, creating works that are innovative and challenging.

shape

In this chapter, you will become more familiar with nonobjective art, including the works of Abstract Expressionists and Op artists. You'll learn to free your mind to new ideas and find subject matter in a variety of unexpected sources. Using the elements and principles of design as your guide, you will create your own nonobjective painting.

color

pattern

Sources for Nonobjective Designs

We are surrounded by nonobjective images, if we teach ourselves to see them. Examine your everyday surroundings—the cracks in a sidewalk, reflections on water, or the colors in a pile of raked leaves. Find unusual visuals, including blurry or distorted photographs, images recorded through microscopes and telescopes, and those seen through kaleidoscopes. Look closely to see such minute details as the grain in a piece of wood, the veining in a slab of marble, or the facets in a gemstone or crystal. Being aware of interesting visual sources will provide you with possible subject matter for nonobjective paintings and inspire you to create your own original compositions.

Patterns are also excellent sources of subject matter. Notice the regular patterns that occur in ceiling tiles, rows of windows, fabrics, and wrapping paper. Also search for irregular or random patterns, such as the stripes of a tiger, the stains made by accidental spills, and the stars in the evening sky. Patterns can help unify a composition and add visual enrichment to a painting.

Organic Shapes and Marks

Nonobjective paintings may be primarily geometric or **organic**. Irregular and informal shapes and marks are organic—similar to many things in nature. They often convey emotional or dreamlike feelings. Although organic shapes and marks are not meant to represent recognizable subjects, they may be interesting or exciting because of their color, texture, or interrelationships. Many nonobjective paintings that rely on organic shapes or marks tend to have a **painterly** quality, meaning that the brushstrokes are evident and important.

When starting to work with a new medium, it is a good idea to explore its possible uses by creating works composed of organic shapes and marks. This way you can concentrate on the handling and quality of the paint itself, instead of trying to successfully paint actual objects or figures. Try listening to music and allow the rhythms and sounds to set your hand in motion. Concentrate on painting the colors and movements that

Fig. 12–2. To create this nonobjective work, the artist painted small, uneven circles and squares of color. What does the painting remind you of? Kyu-Nam Han, *Manhattan Boogie Woogie I,* 1987. Oil on canvas, 88 ½" x 72" (225 x 183 cm). Courtesy of the artist.

the music inspires you to think of, see, or feel. Let the work develop according to chance. For example, place wet pigment along the top edge and hold up the surface to allow the paint to drip downward. Or apply paint thickly to one half of a sheet of paper and then fold it in half and reopen it. Experiment with working on large surfaces to give you a sense of freedom. And try a variety of tools, including twigs, sponges, rags, your fingers, and paint rollers.

Try It Walk around your school or home with a viewfinder. Lay it down on various surfaces. What interesting nonobjective images do you see? Sketch some of these images and study them for possible painting subjects. Place a small viewfinder on one part of a large magazine photograph or on one of your own finished works to discover additional sources for nonobjective designs.

Fig. 12–3. The artist cut shapes from painted canvases and glued them together to form two panels. Gilliam calls such works "quilted paintings," because they are inspired by African American crazy quilts and the textile patterns of West African cloth.
Sam Gilliam (b. 1933), *Open Cylinder,* 1979.
Oil on fabric, 81" x 35" (206 x 90 cm). Smithsonian American Art Museum, Washington, DC. Gift of Mr. and Mrs. Albert Ritzenberg. Copyright Smithsonian American Art Museum/ Art Resource, NY.

Fig. 12–4. The application of acrylic paint in this composition creates the feeling that the work is blurry or out of focus. What kind of balance did the artist use to organize the work?
Prudencio Irazabel (b. 1954), *Untitled 3P5,* 1998.
Acrylic on canvas on board, 74" x 80" (188 x 203 cm). Courtesy of Jack Shainman Gallery, New York. Collection of John Cassese, New York.

Geometric Shapes

Not all nonobjective painting is full of emotion, visible brushstrokes, or random movement. Many artists create hard-edged designs in which no brushstrokes can be seen at all. Such paintings have been called Color Field or classical abstraction. **Color Field** paintings are made up of large, flat areas of color with distinct edges; they are carefully constructed and often exhibit smooth surfaces.

Such perfect geometric designs can be difficult to achieve because of the hard edges, precise shapes, and large areas of even color. Rulers can help you to plan and make the final drawings. To achieve areas of flat color, try applying paint with soft brushes or sprays so that brushstrokes will not be evident. Using drafting tape will help you to achieve crisp edges. Creating and using stencils will also help you paint and duplicate precise shapes.

Fig. 12–5. Color Field artists filled enormous canvases with smooth areas of color. They wanted the viewer to feel surrounded by color.
Michael Snow (b. 1929), *Lac Clair,* 1960.
Oil and paper adhesive tape on canvas, 70" x 70" (178 x 178 cm). Photograph © National Gallery of Canada, Ottawa. Purchased 1987.

One good way to begin working with Color Field methods is to make a preparatory collage from colored papers. This activity will give you a good idea of how the finished design will look. Create a precise sketch on your working surface before you start to paint so that you have guidelines to follow. Whatever subject and method you choose, keep in mind the elements and principles of design—especially pattern, balance, and rhythm. These will help you to achieve successful results.

Pattern

Pattern is the repetition of lines, shapes, colors, and other designs. In nonobjective art, pattern may be a work's subject or emphasis.

Patterns may be planned (repeated in a regular way) or random (repeated irregularly), and they add visual interest to a work. An overall pattern can be a unifying motif that holds an artwork together visually. A pattern, even one made of simple geometric shapes or lines, can be quite complex. Artists often combine and layer several different lines, shapes, and colors in the same motif that, when repeated, creates a complicated and mesmerizing pattern.

Fig. 12–6. Geometric patterns form the structure of this nonobjective painting. The repetition of the motif in four squares creates a symmetrically balanced composition.
Jacqueline Samsone (age 15), *Kaleidoscope*, 1997.
Tempera, 15 ½" x 15 ½" (39 x 39 cm). Clarkstown High School North, New City, New York.

Abstract Expressionism

Abstract Expressionism is an art movement containing many different painting styles that got its name because it was abstract (nonobjective, actually) and expressive (stressing individual feelings rather than design or formal qualities). It burst onto the American art scene after World War II and is also called "action painting." Many art historians refer to the movement as the New York School.

Abstract Expressionist works stress freedom of expression. Many paintings, such as *King of the Hill* (Fig. 12–7) by Grace Hartigan, emphasize organic shapes, movement, and bold brushwork. One of the leaders of the movement was Jackson Pollock (see page 196), whose method of pouring and splattering paint onto canvas prompted the nickname "Jack the Dripper." Although the art movement lasted only about fifteen years, it revolutionized the world of art and continues to influence painters and other artists to the present day.

Elements and Principles

Rhythm and Movement

Rhythm is the repetition of certain elements in an artwork, which also creates a sense of movement by causing your eye to bounce from one element to another across the composition.

In nonobjective art, an artist can create rhythm and movement by the careful placement of motifs or the direction and types of brushstrokes. Placing elements in an even pattern will create a regular rhythm, whereas placing them at different intervals will result in an alternating rhythm. Allowing the elements to be even more inconsistent will create an irregular rhythm with a lot of movement.

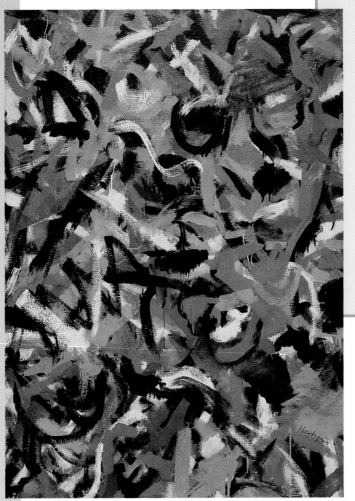

Fig. 12–7. Sometimes, nonobjective paintings don't have a clear center of interest. In this work, overlapping brushstrokes create a chaotic energy that seems to continue outside the confines of the canvas.
Grace Hartigan (b. 1922), *King of the Hill*, 1950.
Oil on canvas, 67 ¼" x 48" (171 x 122 cm). Worcester Art Museum.

Bridget Riley

Stare for a few moments at the work shown in Fig. 12–9. How do you feel afterwards? Don't be surprised if the picture seems to move or if you feel a bit dizzy. This effect is exactly what the artist hoped to achieve.

**Fig. 12–8.
Bridget Riley.**
Courtesy of
PaceWildenstein,
New York.

This painting is an example of **Op Art** (short for Optical Art), an art movement that gained popularity in Europe and the United States in the early 1960s. Op artworks rely on various devices that trick the eye into "seeing" movement, vibration, or illusions of depth. Riley and the Hungarian-born French painter Victor Vasarely (1908–97) are two leading painters of the movement.

Bridget Riley was born in England in 1931. She studied drawing in college and later painting at the well-known Royal College of Art. In the 1950s, Riley traveled to Italy, where the artist admired the work of the Futurists, artists that emphasized speed and movement.

By 1960 Riley was working on a series of black-and-white nonobjective paintings. Having decided to adapt diagrams that scientists use to study the way people see, she filled the canvas with patterns of stripes and wavy lines to create the illusion of movement. Many of these early works convey the impression of flowing water or falling rain. Riley began to add grays and pastel shades to her palette. In later years, she turned to bright colors and has begun to add geometric, diamondlike shapes to her work.

Most of Riley's paintings are enormous acrylics. Because of the size and precision of her compositions, the artist must work slowly and spend a lot of time carefully preparing each work. Some of her paintings are more than seven feet tall and ten feet long. If you think the image here makes you dizzy, image how you would feel if you saw it full size!

Fig. 12–9. Op artists avoid painting methods that draw attention to their brushstrokes. To create optical illusions, they concentrate on line and contrasts of value or color. Although this large work contains only vertical stripes of color, its effect is dizzying.
Bridget Riley (b. 1931), *Late Morning*, 1967–68.
PVA emulsion on canvas, 89 1/8" x 141 5/8" (226.1 x 359.4 cm). © Tate Gallery, London/Art Resource, NY. Tate Gallery, London, Great Britain.

Studio Experience
Nonobjective Electronic Art

In this studio experience, you will create an abstract or nonrecognizable image by using Adobe Photoshop® or another paint program. Focus on colors, shapes, and creativity.

Before You Begin

● Create a list of emotions, and choose one to develop into an electronic painting. What colors and shapes suggest that emotion?

● Close your eyes, and imagine your chosen emotion. What types of images and lines do you see? What colors, shapes, designs, and textures can you imagine? List your ideas to keep as a reference.

Create It

1. You may start with a blank canvas, use a digital camera to capture a visual scene, or scan a photo from another source. For use in your electronic image, collect magazine images that are not recognizable but that convey color or texture. If you are using a digital photo, save the photo to your file. Make a duplicate copy of the image before you change any of it.

1 Fig. 12–10.

2. Open a new canvas, and set the dimensions and the resolution according to how large a file you want to create. A resolution of 72 dpi is adequate for computer viewing and web pages, whereas 300 dpi is best for anything that will be printed. If you are beginning with a photo or an image, select and drag the image onto the new canvas. To fit the image, use the "Edit/Transform/Scale" function. Drag the image to fit the canvas. You can also drag the image to stretch it or abstract it. To open a blank canvas to paint on, choose "New" from the "File" menu, and set the dimensions and background color to your preference.

2 Fig. 12–11.

3. Distort photo images with the "Transform/Rotate" function by moving the image upside down or flipping it. If you do not like something, click on "Edit/Undo," or use the history pallet to delete a step. Experiment with various types and sizes of brushes. Paint with different colors

3 Fig. 12–12.

as if you were painting on a real canvas. Create custom colors in the swatch pallet. You can blend one color into another by using the "Edit/Fade" option and adjusting the opacity of the color or the brushstroke.

4. Try using paint tools to paint over your image. Change the image colors to match your emotion. Cut out things in your picture if they do not enhance its mood. Try changing some items' scale. Save your work periodically as you rework it. Each time you save your electronic painting in various stages, put a number after the file name.

5. Try using various filters on the image. To use a filter on part of the image, select the part with the "Select" or "Lasso" tool, and then apply a filter.

6. Save your art, and print it on photo-printing paper for the best results.

Check It

Is the electronic image powerful? Does it evoke an emotional response? Is there enough in the artwork to hold your attention? Could another person look at this image and feel the emotion you were trying to convey?

Sketchbook Connection

Fill the page with overlapping nonobjective shapes. Pick a direction from which the light might be shining on these shapes, and shade the shapes so that they begin to appear three-dimensional.

Rubric: Studio Assessment

4	3	2	1
Abstraction · Conveys emotion · Nonobjective use of line/shape and color			
Final image is completely nonobjective. Powerful, expressive use of line, shape, and color. Solution is atypical and/or done with flair. Powerful, evocative, unusual	Final image is nonobjective; expresses intended emotion through use of line, shape, and color. Satisfactory, convincing	Some elements in final image are recognizable or very suggestive of actual objects; OR expressive quality is somewhat weak Suggestive or vague	Final artwork may include many recognizable images OR expressive quality is not engaging Recognizable or bland
Electronic Media Use · Use of Adobe Photoshop® tools: transform, paint, fade, crop, and filter · DPI and paper choice			
Expert use of brushes/tools to create interesting effects, editing image, creating colors; colors evoke emotion. Printed version enhances effect. Expert, appropriate, experimental	Competent use of brushes/tools. Proficiency creating colors, editing/cropping image. Color used appropriately. Printed version enhances effect. Competent, appropriate	Inconsistent use of tools; OR lacks knowledge to create colors/effects. Color does not evoke emotion. Cluttered image. Inadequate printing. More exploration and practice needed	Improper technique and/or weak use of color. Lacks understanding of tools, processes. Inadequate printing. Underdeveloped, unpolished
Work Process · Notes, image collection · Sketchbook · Multiple versions · Reflection/Evaluation			
Thorough documentation; goes above and beyond assignment expectations. Thoughtful, thorough, independent	Complete documentation; meets assignment expectations. Meets expectations	Documentation is somewhat haphazard or incomplete. Incomplete, hit and miss	Documentation is minimal or very disorganized. Very incomplete

Public Artist
Samia Halaby

Samia Halaby was born in Jerusalem, Palestine, in 1936. When Israel was established in 1948, her family became refugees and lived Beirut, Lebanon. Halaby excelled

**Fig. 12–13.
Samia Halaby.**
Photograph © 1985 by
Elizabeth Habermann.

in math but found that it gave her a headache. Later, her interest in chemistry was thwarted by the smell of the labs. She then studied design but believed that the passion she had for painting wasn't a "real" career. Eventually Halaby earned a graduate degree in painting, and she turned to abstraction as a kind of rebellion against the realism taught in the university.

Why do you work with computers as well as oil paint?

Samia I call myself a painter in many different media. I love oil paint because you can mix colors with such refined variety and see them at their final color when you're applying them. But when you try to be at the leading edge, if there's a new medium that can make pictures, you must investigate it. When computers came out, I immediately learned how to program. I make pictures in my mind and then tell the computer to do it, using its own language.

What makes your computer painting unique?

Samia I turn the computer keyboard into an instrument like a piano for making abstract paintings, which can be projected onto large screens during public performances. Each button creates a little visual movement, creating abstraction compositions in motion. I do a "jazz kind of thing" that is an Arabic music tradition called *efdiigel*—in jazz it's called "jamming." I work with two African American musicians, and they use African traditions and percussion instruments.

Your materials and style appear modern, but does your art also have ancient roots?

Samia In the kinetic paintings, the shapes are expanding and contracting, pushing against each other and pulling each other simultaneously. Their action fills the space of the flat picture plane. This formal activity is much like that of medieval Arabic abstraction. I have been deeply inspired by the abstract geometric forms of ancient Arab art and its unique and unusual relationship of negative/positive space. Shapes lie on the surface and are overtly two-dimensional, seemingly negotiating for the surface space.

Fig. 12–14. Samia Halaby applies mathematical ideas to her nonobjective works as she creates them.
Samia Halaby, *Day of Our Land*, 2001.
Acrylic and paper on canvas, 60" x 43" (152.4 x 109.2 cm).
Courtesy of the artist.

Chapter Review

Recall What is another term for Action Painting? Who was one of the most famous action painters of the 1950s?

Understand Explain how Op artists and Abstract Expressionists created movement in their art.

Apply Create a painting in the abstract expressionist style and a painting in the color field style. Use the same colors in each.

Analyze Describe the pattern in one of the paintings in this chapter. How does it suggest a rhythm?

Synthesize When, do you think, do images created on a computer become artworks? Explain why you think electronic artworks should be valued less or more than paintings made with traditional materials and tools.

Evaluate Put these paintings in order, from most painterly to least painterly: Riley's *Late Morning* (Fig. 12–9), Hartigan's *King of the Hill* (Fig. 12–7), Rothko's *Untitled* (Fig. 12–1). Explain why you placed them in this order.

Portfolio Tip

To have their work exhibited in commercial art galleries and art shows, artists submit art portfolios to gallery or art show directors. Sometimes artists bring in the original artworks, but more often they leave slides or photos of their art for review. Because there is usually a limited amount of display space, gallery owners and art show organizers must carefully select art that goes with their exhibit.

Writing about Art

Review the careers that were explored in each chapter's Career Profile. Select one of these careers (or another painting-related career that interests you) to research further and evaluate. Using the library and Internet, gather as much information about the career as possible. Prepare a basic data table about the career (e.g., education requirements, salary range, desired skills or experience, best geographic location) and then write a concise description of the job itself. Add an analysis of whether or not you might be well suited to the demands of the career. Conclude with an objective evaluation of the pros and cons of it as a career choice.

Fig. 12–15. How has this artist created pattern and rhythm in this work of art? What other elements and principles of design do you see?
Cory Longhauser (age 14), *Colorful Geometric Shapes*, 1997–98.
Acrylic and tempera, 12" x 18" (30.5 x 45.7 cm). Manson Northwest Webster Community School, Barnum, Iowa.

What is the style of this watercolor? Compare the technique used in this work to that used in Fig. 5–9. In what ways do they differ?
William Henry Hunt (1790–1864), Primroses and Bird's Nest.
Watercolor, 7 ¼" x 10 ¾" (18.4 x 27.3 cm). © Tate Gallery, London/Art Resource, NY. Tate Gallery, London, Great Britain.

Part Four
Student Handbook

A History of Painting

The Prehistoric, Ancient, and Medieval Worlds

Painting has been a form of visual expression since prehistoric times. As early as 25,000 BC, humans applied pigments to cave walls, creating painted scenes of abstracted figures and animals.

Wall painting became popular in many cultures. Ancient Egyptians decorated public buildings and private tombs with images related to their religious beliefs. The art form was also common in Asia as early as the sixth century, when Chinese artists painted the walls of tombs and buildings, and Indian artists created stunning wall paintings at religious sites such as the caves at Ajanta, a Buddhist monastery.

Fig. 1. Painted images on rocks and cave walls are the oldest known paintings, and those of the native Aborigine of Australia represent the world's longest continuous artistic tradition. These paintings were created with pigments made from ground minerals or plants and applied with brushes made from bark, feathers, or frayed sticks. They are sometimes called "x-ray" paintings because they seem to show both the inside and outside of the figures. Some contemporary Aborigine believe that the figures represent *mimi*, spirits who taught humans how to hunt and paint in the time known as the Creation Period.

Aboriginal rock paintings with symbols, including hands. © SEF/Art Resource, NY. Alice Springs, Northern Territory, Australia.

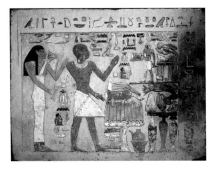

Fig. 2. Because of the hot, dry climate and sealed tombs of Egypt, many ancient paintings have survived. Artists decorated walls and steles such as this one by painting tempera onto a dry, plastered surface, a technique known as *fresco secco*. This stele shows the deceased priest Amenemhet and his wife making offerings to the gods. Such depictions were common in tombs, as they were believed to magically ensure a bountiful afterlife for the deceased. The static pose, precise proportions, and combined frontal and profile view of the figures are long-standing characteristics of ancient Egyptian painting style.

Egypt, Middle Kingdom, *Wall Fragment from the Tomb of Amenemhet and His Wife, Hemet,* Dynasty 12 (1991–1784 BC). Painted limestone, 12" x 16 ½" x 2 ½" (30.6 x 41.7 x 6.3 cm), Museum Purchase Find, 1920.262. Photograph by Robert Hashimoto. Photograph © 2002, The Art Institute of Chicago, All Rights Reserved.

Fig. 3. The ancient Greek culture painted ceramic vessels as early as the Proto-Geometric period (c. 1025–900 BC). The term *proto-geometric* refers to the geometric patterns artists used to decorate the pots. Beginning in 575 BC, two styles of Greek vase painting appeared: red figures on a black background, and black figures on a red ground. This hydria (a vessel for carrying water) is an example of black-figure ware. Greek ceramics were utilitarian, and their decorative paintings depict a wide range of subject matter, from religious and mythological images to scenes of everyday life. This scene of soldiers and a chariot may derive from the story of the Trojan War.

Ancient Greece, Attributed to the Antimenes Painter, ca. 530–510 BC. Black-figure earthenware, height: 16 ½" (42.2 cm). © The Cleveland Museum of Art, 2002. Purchase from the J.H.Wade Fund, 1975.1

Artists in ancient Crete perfected the technique of fresco, which later Roman artists used to decorate building interiors, especially their homes. Although scholars believe that ancient Greeks also painted frescoes, none remain. The sophisticated painted ceramic vessels of ancient Greece have survived, however, proof of that culture's strong painting tradition.

Artists painted on many other surfaces as well. With the invention of paper in the second century, the Chinese developed brush painting, an art form that spread to Japan. The practice of illustrating texts with paintings, which had first appeared in ancient Egypt, flowered during the late Roman Empire (c. 284–395). This tradition of manuscript illustration (illumination) later flourished during the Middle Ages (c. 400–1400) in Europe.

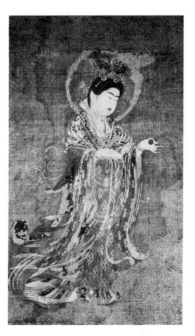

Fig. 4. During the Middle Ages, most paintings were manuscript illuminations or decoration for church interiors. Before the invention of the printing press in the 1400s, books were copied by hand and illustrated with small, detailed paintings. Artists used tempera and often gold leaf to paint on the vellum pages. This painting has no indication of space or three-dimensional form. With the advent and spread of Christianity—and its emphasis on the spiritual rather than the physical—the interest in realism in Western painting began to decline.

England, Anon., *Bury Saint Edmund's,* **illustration from the** *Life, Passion and Miracles of Saint Edmund, King and Martyr,* **c. 1130.**

10 ½" x 7 ½" (27 x 19" cm). J. Pierpont Morgan Library/Art Resource, NY.

Fig. 5. While churches in the Byzantine Empire were primarily decorated on the interior with mosaics, frescoes continued to be the preferred decoration in western Europe. Early Christian frescoes continued the technique used during the Roman Empire. Stylistically, the frescoes were much less concerned with realism than Roman examples, although the body types are based on late Roman figures. The emphasis on the symbolism of the Crucifixion has eliminated any interest in background or the simulation of depth. Simple shapes hint at a background landscape, while lesser participants are treated in hierarchical proportion to the main scene.

Rome (Early Christian), *Crucifixion,* **nave fresco from the Church of Santa Maria Antiqua, Rome, 7th century.**

Fig. 6. Chinese painting styles spread to Japan in the late seventh century, at the height of the Chinese Tang Dynasty (618–907). This is a painting of a goddess who was incorporated into Buddhism from Hinduism (India). It was an object of reverence called *Kichijo kekae* that was very popular during the Nara period. Large quantities of pigment were applied to hemp that had been painted white. The goddess' features are modeled on the Tang Chinese ideal of court beauty.

Kichijoten
© Sakamoto Photo Research Laboratory/Corbis.

The Age of the Renaissance

Religious subjects and portraiture dominated painting during the Renaissance in the West (c. 1400–1550). Manuscript illumination evolved into panel painting in both northern and southern Europe, as primed wood became the preferred painting surface. Fresco painting on walls and ceilings of churches and other buildings continued in Italy. The interest in realism and the accurate depiction of objects was growing among artists, who closely studied their surroundings and the natural world. Oil paint, which had been used as early as the eighth century, became widespread in the 1400s. Flemish artists were the first to prefer oils, which they sometimes mixed with tempera.

Fig. 7. Frescoes played a significant role in the decoration of religious buildings during the Renaissance. The art form, which had flourished since ancient Roman times, reached a high level of realism with the introduction of one-point perspective. Artist and scientist Leonardo da Vinci's search for a more lasting fresco led him to combine tempera and oil paint with wax in the wet plaster. Unfortunately, Leonardo's technique was unsuccessful, and the fresco began peeling from the wall. Leonardo himself had to repaint parts of the fresco five years after he had first created it.

Leonardo Da Vinci (1452–1519). *The Last Supper,* **ca. 1495–1497.**

Fresco, 29' 10" x 13' 9" (460 x 880 cm). Refettorio del Convento di Santa Maria delle Grazie, Milan. Restored. Electa Archive, Milan.

Fig. 8. In their quest to create naturalistic paintings, Italian Renaissance artists studied the anatomy of humans and animals to create more lifelike and realistic-looking figures. They also pioneered the system of one-point perspective to accurately depict three-dimensional space on a two-dimensional surface. This system allowed artists to create the illusion of depth. Uccello was particularly fascinated with perspective. In this battle scene, he arranged the lances and bodies on the ground to form the receding lines (orthogonals) that converge at a single point on the horizon (the vanishing point).

Paolo Uccello (1397–1475), *The Battle of San Romano,* **ca. 1450.**

Tempera on panel, 71 ½" x 126" (182 x 320 cm). © Erich Lessing/Art Resource, NY, National Gallery of Art, London, Great Britain.

The art of painted books was important in cultures worldwide. Native cultures in Mesoamerica and South America produced manuscripts filled with elaborately painted scenes and symbols. Such manuscripts were a continuation of earlier mural painting traditions. Islamic artists in South Asia and the Middle East also painted beautifully detailed manuscripts. They copied the Koran or stories of real and legendary heroes and kings, decorating the illustrations with complex floral and plantlike designs and geometric patterns.

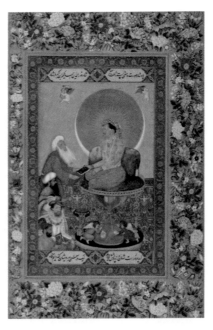

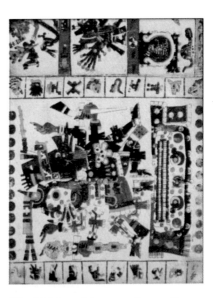

Fig. 9. Unlike Italian artists, Renaissance painters in northern Europe were not interested in such scientific systems as anatomy or perspective. However, they did stress richly detailed realism in their works. These artists worked in oil, building up as many as seven semi-transparent layers of color. Such layering allowed light to pass through the paint to create a glowing surface. And because oil paint could be reworked as it dried, artists were able to create many fine details. Jan van Eyck was one artist who delighted in re-creating minute details, especially those of costume and interiors.

Jan Van Eyck (c. 1390–1441). *Giovanni Arnolfini and His Wife,* **1434.**
Oil on panel, 32" x 23" (82 x 60 cm). © Erich Lessing? Art Resource, NY, National Gallery of Art, London, Great Britain.

Fig. 10. Islamic conquerors of northern India brought with them Persian artists who had been influenced by western European painting traditions, especially illuminated manuscripts. Artists worked primarily in gouache, or opaque watercolor, and created Islamic manuscripts for both sacred and nonreligious purposes. This illustration from a text on the accomplishments of Emperor Jahangir, shows that the ruler preferred religious learning to the worldly trials of being emperor. The painting features the gemlike colors, allover patterns, and rich details characteristic of Islamic miniatures.

India, *Mughal School, Jahangir* **(ruled 1605–27)** *Preferring a Sufi Shaikh to Kings,* **early 17th century.**
Color and gold leaf on paper, height 10⅜" (26 cm). Freer Gallery of Art, Smithsonian Institution, Washington, DC. Purchase, F1942.15a.

Fig. 11. Many Mesoamerican cultures excelled in the art of painting books. Spanish conquerors mistakenly used the term codex (plural codices) to describe such works, comparing them to western European books. The Mesoamerican artists used vegetable pigments to paint onto a piece of deerskin that was accordion-folded to form the pages. Some scholars believe that such codices were meant to be opened and displayed like a mural. This codex was both a ritual and a historical text. It explains theories about the nature of the universe (known as cosmology) and describes the religious practices based on the 260-day Mesoamerican calendar.

Mexico, Mixtec/Aztec, *Borgia Codex: Quetzalcoatl and Michtlantecuhtli,* **c. 1400.**
Pigments on deerskin, 10 ⅕" x 4" (27 x 10 cm). Vatican Museums, Rome.

The Baroque Period to the Nineteenth Century

By the beginning of the Baroque period (c. 1600–1750) in western Europe, artists worked primarily in oil. Soon canvas replaced wood as the preferred painting surface. Fresco painting also continued as a means of decorating the walls and ceilings of buildings. Oil painters became particularly skilled at achieving strong contrasts in light and dark. Baroque compositions are often large and dramatic, and the placement of visual elements creates a sense of dynamic movement.

In the Asian countries of China and Japan, painting reached its height between the sixteenth and eighteenth centuries. The hand-scroll painting was the most popular format in both cultures.

Fig. 12. The Baroque period marked the emergence of still life, landscape, and genre scenes as subject matter. Such subjects were popular with the Dutch working people, who wished to buy paintings that showed objects and activities from their daily lives. De Heem, a contemporary and countryman of Rembrandt van Rijn (1606–69), was among the most prominent Dutch still-life painters. He became famous for his cut-flower arrangements, which was a specialty of Dutch still-life painting. This work shows the rich colors, strong contrasts, and dynamic composition characteristic of Baroque art.

Jan Davidsz de Heem (1606–1684). *Vase of Flowers,* ca. 1660.
Oil on canvas, 27 ³⁄₈" x 22" (70 x 57 cm). National Gallery of Art, Washington, Andrew W. Mellon Collection 1961.61.1.

Fig. 13. Japanese artists developed special formats for their paintings, most notably the screen. Screens were used in Japanese homes to divide living areas and provide privacy. They were often painted with bright colors and decorated with dazzling gold leaf, in contrast to the monochromatic scroll paintings. Japanese artist Ogata Korin produced scroll-format paintings but was best known for his dramatic painted screens. The forms of the natural objects in this painting show the influence of Chinese art.

Ogata Korin (1658–1716). One of a pair of two-fold screens: *Red Plum Blossoms,* 1710–1716.
Color, and gold leaf on paper, 61 ½" x 68" (156 x 172 cm). Museum of Art, Atami, Japan.

Landscapes and scenes from nature were the dominant subjects, and such paintings were most often monochromatic.

In the early seventeenth century, Spanish conquerors began introducing western European styles to the native peoples of present-day South American countries, such as Peru. By midcentury, native artists were trained in oil painting techniques, producing mostly religious subjects in a Spanish Baroque style.

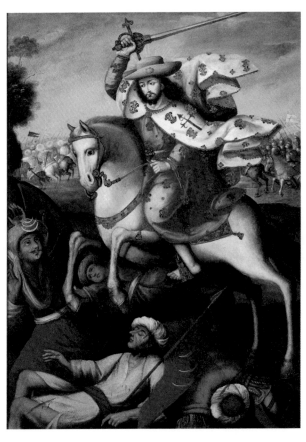

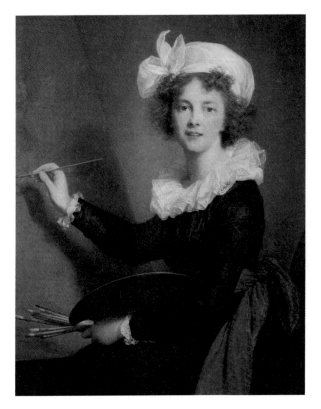

Fig. 14. The Inca, the native peoples of Peru, had a long tradition of painting murals and pottery. When the Spanish conquered the area, they taught the Inca European painting styles and techniques of working in oil. What emerged was a native interpretation of the Baroque style popular in Spain. Post-Conquest Peruvian painting is characterized by glittering surfaces decorated with patterns and gold leaf. Because the Spanish also tried to convert the natives to Christianity, religious scenes became the dominant subject matter. Portraiture and other nonreligious subjects did not become important in Peruvian painting until independence from Spain in 1824.

Peru, School of Cuzco, Saint James the Moorslayer (Santiago Matamoros), 18th century.
Oil on linen, 62 ¼" x 45 ½" (159 x 116 cm). New Orleans Museum of Art: Museum Purchase.

Fig. 15. Painting techniques and styles changed little during the Baroque period. Religious subject matter declined in importance, and portraits and history subjects became the most honored subjects. By the late eighteenth century, many women were becoming professional painters, a rare occurrence in earlier times. Vigée-Lebrun was among the most successful portrait painters in the late eighteenth- and early nineteenth-century Europe. She painted in the traditional style that she had learned from her father, a painter and teacher at an art academy in Paris. This work shows the softer and pastel-colored Rococo style pioneered in France that gradually replaced the earlier, dramatically lit Baroque paintings.

Elisabeth Vigée-Lebrun (1755–1842). *Self-Portrait,* 1790.
Oil on canvas, 8'4" x 6'9" (254 x 206 cm). Galleria degli Uffizi, Florence. Giraudon/Art Resource, NY.

The Nineteenth Century: Transition to Modern Painting

Europe

Painting styles and techniques changed rapidly during the nineteenth century. The new styles, including Neoclassicism, Romanticism, and Realism, challenged traditional subject matter. Neoclassicism, which first appeared in the eighteenth century, was inspired by ancient Greek and Roman art. Romanticism featured dramatic representations of exotic places, often with a comment on social issues. And Realism showcased accurate representations of nature.

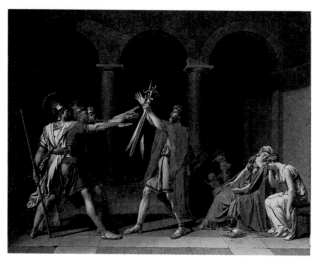

Fig. 16. Neoclassicism became popular in France at the time of the French Revolution in 1789 and lasted until about 1815. Neoclassical artists were interested in reviving the classical styles of ancient Greek and Roman art. David was a leading Neoclassical artist who used the style to teach the French people about the principles of democracy. In this scene, David equates the sacrifices of the French people during the Revolution with three ancient Roman brothers who gave their lives for Rome.

Jacques-Louis David (1748–1825). *The Oath of the Horatii,* *1786.*
Oil on canvas, 51 ¼" x 65 ⅝" (130 x 167 cm). The Toledo Museum of Art. Purchased with funds from the Libbey Endowment, Gift of Edward Drummond Libbey, 1950.308.

Fig. 17. Turner's dramatic landscapes of exotic places are characteristic of the Romantic movement. The artist delighted in capturing a scene's moods created by different light. His fascination with showing such atmospheric conditions was a hint of the Impressionist movement to come. In this painting, Turner contrasts tiny buildings and a bridge with the towering landscape. Such a contrast is an example of the Romantic emphasis on the power of nature and humankind's helplessness before it.

Joseph M.W. Turner, (1775–1851). *Luxembourg, c. 1839.*
Watercolor and gouache on paper, 5 ½" x 7" (14 x 18 cm). © Tate Gallery, London/Art Resource, NY. Tate Gallery, London, Great Britain.

Realism led to Impressionism, a movement that revolutionized traditional painting techniques. Rather than working in the studio from sketches made outdoors, Impressionist artists painted outdoors *(en plein air)* to capture the changing effects of light on color. More important, they painted directly on the surface of the canvas, without the traditional underpainting.

By the end of the century, the Post-Impressionist movement appeared. Artists were interested in showing not only the structure of things but also their feelings about them. Still other artists experimented with a scientific approach of placing dots of color side by side so that they visually blend on the canvas. This technique was called Pointillism or Divisionism.

Fig. 19. Cézanne began his career by painting in the Impressionist manner, but soon realized that he wanted to emphasize form in his painting. He was influenced by Baroque and Renaissance ideas about using geometric shapes and forms to create structure in an artwork. This still life has an Impressionistic palette and expressive brushwork. But the balanced composition—created by arranging the elements in a pyramid—reveals the artist's study of Renaissance art. Cézanne later experimented with breaking down compositions into basic shapes, thus leading the way toward abstraction.

Paul Cézanne (1839–1906). *Still Life,* c. 1900.
Watercolor and graphite, 19 15/16" x 24 7/8" (48 x 63 cm). The J. Paul Getty Museum, Los Angeles. © J. Paul Getty Museum.

Fig. 18. Monet, primarily a landscape painter, began all his paintings outdoors and finished them in his studio. He is famous for his series—paintings of the same scene at different times of the day. These series capture each moment's special light and color changes. While analyzing the light, Monet built up thick layers of paint (impasto). In this painting, one from a series of paintings of Rouen Cathedral, the textures created by the impasto add to the illusion of the reflecting light and changing colors on the cathedral's walls.

Claude Monet (1840–1926). *Rouen Cathedral Façade, Tour d'Albane (Morning Effect),* 1894.
Oil on canvas, 41 ¾" x 29 ⅛" (106 x 74 cm). Courtesy, Museum of Fine Arts, Boston. Tompkins Collection.

The United States and Asia

The first American school of painting developed during the second quarter of the nineteenth century. It was called the Hudson River School because painters featured scenes of the Hudson River valley in New York. The artists, led by Thomas Cole (1801–48), were influenced by British landscape painting of the eighteenth century. The Hudson River School artists favored realistic visual descriptions of specific locales. By the end of the century, some American artists began to adapt the French Impressionistic style to their own painting.

Fig. 20. In the mid-nineteenth century, Romanticism was the dominant style in Europe. The Hudson River School style can be described as a blend of romanticism and realism. Church, a student of Thomas Cole, showed accurate details of a place, yet produced an idealized vision of nature. In this landscape, the artist shows the overwhelming grandeur of nature, emphasized by the small scale of the people in the foreground. Church made extremely detailed studies outdoors, but created his paintings in the studio. His studies were often full of notes about color, light source, and other details.

Frederic Edwin Church (1826-1900). *New England Scenery,* **1851.**
Oil on canvas, 36" x 53" (91 x 135 cm). George Walter Vincent Smith Collection, George Walter Vincent Smith Art Museum, Springfield, MA.

Also at this time, many Indian bands were displaced to reservations. Native peoples saw their traditional lands and way of life disappearing. Plains Indian bands began to paint scenes on animal hides as a means of recording their culture. Native men painted visual records of events, whereas women usually decorated hides with geometric patterns.

In Japan, artists continued the tradition of album, scroll, and screen paintings. As in the past, they focused on landscapes and nature scenes. Although they painted in the traditional monochromatic style, artists also began developing new painting techniques, showing a break with the past.

Fig. 22. Few Native American bands created art to record time or historical events. The Shoshone, however, did have such a tradition. Shoshone artists created rock carvings and later paintings on animal hide to commemorate historical events, such as a victory in battle. Painted hides were worn as clothing or used as tepee decoration. The style of this hide painting resembles the rock carvings. The artist depicts general scenes of Shoshone life before the reservation era, including ceremonial dances and a buffalo hunt. The objects and figures float on a neutral background, an effect meant to emphasize their symbolic power.

Cadzi Cody (active 1880–1890). *Scenes of Plains Indian Life,* **ca.1880.**
Elk hide and pigments, 68" x 79" (173 x 201 cm). The Minneapolis Institute of Arts. Gift of Bruce B. Dayton.

Fig. 21. In nineteenth-century Japan, landscape painters created works that differed from those of previous centuries. These artists wanted their landscapes to appear as random, unplanned placements of ink and brush. Despite the "casual" appearance of this landscape, it follows the traditions that date back to the origins of landscape painting in China. The artist creates a sense of depth by piling up forms, and unpainted areas create the effect of distant, mist-covered valleys. The artist also included two scholars contemplating the landscape to emphasize and enhance the grandeur of the scene.

Fujimoto Tesseki (1817–63), *Landscape with Figures.*
Ink on paper. Cleveland Museum of Art.

The Twentieth Century
1900–1950

The twentieth century witnessed the greatest number of art styles and movements in the history of painting, and Europe was the center of much important experimentation. The appearance of the first abstract paintings in the early 1900s was the century's most revolutionary art event. Among the many styles that flourished, Cubism was an attempt by artists to show a subject from different viewpoints over time. Both the Fauvists and the Expressionists used bright colors in striking combi-

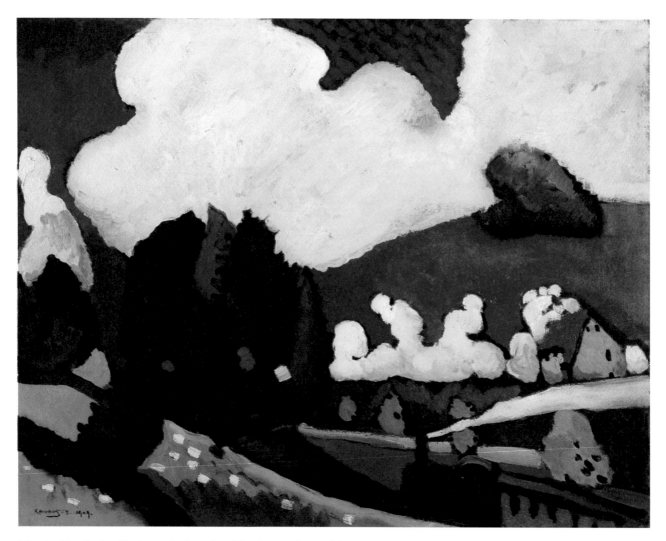

Fig. 23. Kandinsky felt that paintings should reflect nothing of the physical world. The artist also believed in the spiritual power of color and its ability to influence people. He was a pioneer of abstraction—one of the first to produce an entirely abstract composition. In this work, painted three years before his first total abstraction, Kandinsky reduces the forms of the landscape to simple, painterly shapes. Murnau was an artist colony where many Expressionist artists lived, and this work's bright palette reflects the influence of German Expressionist art.

Wassily Kandinsky (1866–1944). *Landscape Near Murnau with Locomotive,* 1909.
Oil on board, 20" x 25" (51 x 65 cm). Solomon R. Guggenheim Museum, New York. Photograph by David Heald
©The Solomon R. Guggenheim Foundation, New York. © 2002 Artists Rights Society (ARS), NY/ADAGP, Paris.

nations. Minimalist artists reduced paintings to geometric shapes and primary colors. And the Surrealists painted random images from their subconscious.

In early twentieth-century Mexico, mural painting saw a rebirth. Murals by such artists as Diego Rivera celebrated the Mexican Revolution and the hope for a better society. Mural painting also flourished during the Great Depression in the United States, as part of the government's public art programs to employ out-of-work artists. American painters worked mainly in realist styles and captured scenes of American life, a movement known as American Scene Painting.

Fig. 25. Early in his career, Rivera was influenced by European artworks that he had seen during visits to Paris. He first painted in a Cubist style. After returning to Mexico, however, Rivera began to paint realistic works that carried a message about society. This style is known as Social Realism. A leader of the Mexican mural movement, Rivera believed that seeing paintings about their rich cultural heritage would inspire the Mexican people to build a better future for their country. This mural shows the prosperity and diversity of the Maya, one of the native cultures of Mexico.

Diego Rivera (1886–1957). *The Market (El Tianguis),* **1926–28.**
Fresco, three connected panels, approx. 184" x 93" (468 x 236 cm) each.
© 2002 Banco de México Diego Rivera & Frida Kahlo Museums Trust. Av. Cinco de Mayo No. 2, Col. Centro, Del. Duauhtémoc 06059, México, D.F. © Schalkwijk/Art Resource, NY. Secretaria de Educacion Publica, Mexico City, D.F., Mexico.

Fig. 24. Picasso explored many styles and subjects throughout his career. The artist often painted the harlequin (a type of clown), sometimes creating self-portraits as the jesterlike figure. Picasso and French painter Georges Braque (1882–1963) developed Cubism. Their idea was to add the fourth dimension of time to a two-dimensional painting. Picasso was especially influenced by the later paintings of Cézanne, who flattened space and broke down forms into geometric shapes. In Cubism, Picasso also focused on form and shape as he rearranged the parts of objects and scenes into abstract compositions.

Pablo Picasso (1881–1973). *Harlequin with Violin,* **1918.**
Oil on canvas, height: 56" x 39 ½" (142.2 x 100.3 cm). © The Cleveland Museum of Art, 2002. Leonard C. Hanna, Jr., 1975.2. © 2002 Estate of Pablo Picasso/Artists Rights Society (ARS), NY.

After 1950

After World War II, the United States emerged as the new art center. American painters, inspired by European styles such as Cubism and Expressionism, began their own experimentation in abstraction. These artists, grouped together under the term Abstract Expressionists, wanted their paintings to express universal themes that all people understand. Some turned to symbols and abstract imagery, whereas others explored the human figure to convey messages about life, nature, and beauty.

Later movements included Pop Art, Photo or New Realism, and Color Field painting. In the 1970s, issue-based painting grew, as artists explored such subjects as gender roles and environmen-

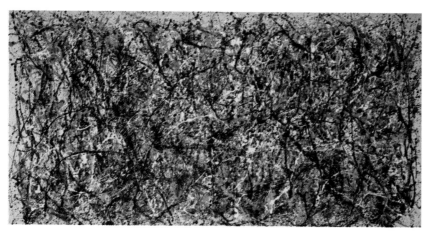

Fig. 26. Pollock was one of the leaders of Abstract Expressionism, the so-called New York School. The artist spent many years trying to develop his own abstract imagery before he happened upon a process that revolutionized painting techniques. He laid his canvas flat on the floor and dripped, splattered, and threw paint onto it. The process was called "action painting." Like many abstractionists, Pollock believed that paintings should not refer to any one idea, feeling, or object. Rather, he felt that the process of creating was more important than the finished work.

Jackson Pollock (1912–1956). *One (Number 31, 1950),* 1950.
Oil and enamel on unprimed canvas, 106 ⅜" x 212" (270 x 531 cm). Sidney and harriet Janis Collection Fund (by exchange). (7.1968). © The Museum of Modern Art/Licensed by SCALA/Art Resource, NY, Museum of Modern Art, NY. © 2002 The Pollock-Krasner Foundation/Artists Rights Society (ARS), NY.

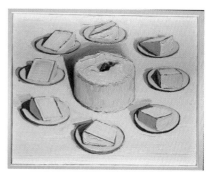

Fig. 27. Pop Art is generally associated with New York, a city many view as the "capital" of American consumerism. Thiebaud, who works near San Francisco, is part of the West Coast Pop movement. Rather than emphasize subject matter, as in New York Pop artworks, Thiebaud focuses on painting technique and creating a painterly surface. In this work, the artist isolates the cake pieces against a neutral background, creating a symbol of America's consumer-oriented society. His use of bright colors, painterly brushwork, and thick buildup of paint recall the work of the earlier action painters.

Wayne Thiebaud (born 1920).
Around the Cake, 1962.
Oil on canvas, 22" x 28" (56 x 71 cm). Spencer Museum of Art, University of Kansas, Lawrence. Gift of Ralph T. Coe in memory of Helen F. Spencer. © Wayne Thiebaud/Licensed by VAGA, New York, NY.

talism. Painting also became a vehicle for artists worldwide to comment on the status of native cultures, disappearing traditions and lifeways, and the loss of identity due to colonization. During the 1980s and 1990s, many previous painting styles were revived, such as Minimalism and Expressionism.

Because of the legacy left by these twentieth-century artists—always seeking to challenge traditional ideas about art—contemporary painters can choose from a wide variety of movements and techniques as they strive to create the next "new" painting style.

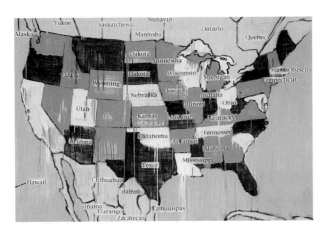

Fig. 28. Like many Native American painters in the late twentieth century, Smith uses a traditional medium from Western art to teach non-Natives about her people. Like the earlier works of nineteenth-century hide painters, Smith's paintings tell a story. This painting shows state names that are navive words, or the names of Indian bands. The artist often combines symbols and words to send a message about such subjects as the mistreatment of Native peoples or the dangers to the environment.

Jaune Quick-to-See Smith (born 1940). *State Names #2, 2000.*
Oil and collage on canvas, 48" x 72" (122 x 183 cm).
Courtesy Jan Cicero Gallery.

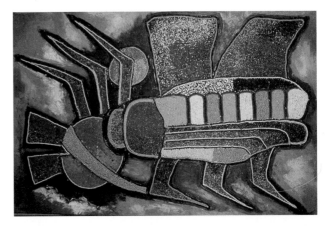

Fig. 29. Prior to occupation by western European countries, many African cultures had no tradition of oil painting on wood panels. Buraimoh was trained in Western painting techniques in the 1960s, but soon the artist created his own unique style. He pioneered many mixed-media techniques and is renowned for his combinations of Western oil painting and traditional Yoruban beadwork. Buraimoh combines modern imagery with traditional symbols. In this work, he fills the painting surface with an insect, a common subject in African arts. The beads, which are both loose and strung, create a glittery, textured surface.

Jimoh Buraimoh (born 1943). *Insect, 1973.*
Oil with beadwork on wood panel. Field Museum of Natural History, Chicago.

Understanding Color

Many of us have learned that red, yellow, and blue are called the primary colors. But what if someone tells you that these are not the only primary colors? You may want proof—such a statement is contrary to what you have learned. You may also wonder what other colors can be primary colors, and under what conditions.

As an artist, it is important for you to understand color and how it works. In this section, you will learn about the science of color and color theories, explore color-mixing systems, and discover the primary colors of different media. This examination will allow you to better grasp the nature of color, how it is perceived by the human eye, and how you can use it to create successful color combinations.

The Science of Color

How does the eye see color? Color is possible because of ambient light, the light that surrounds us. As you may recall from science class, light travels in waves of differing lengths, each producing its own color sensation. The human eye senses color when light waves hit an object and bounce back. Within the eye, light-sensitive cells called cones help us identify a particular color, while those called rods allow us to sense value. Scientists believe that there are three types of cones activated by the colors red, green, and blue, the primary colors of light (see page 200). All other colors in the visible spectrum of light are made by combining different percentages of these three colors. If an object reflects all colors of visible light, it appears white. If it absorbs all wavelengths, the eye sees a black object.

Color Theory

Color theory is the study of colors—how they mix and interact. Three theorists have had a great impact on the study of color. The first is Michel-Eugène Chevreul (1786–1889), a French chemist, physicist, and philosopher. Chevreul, who worked in the royal tapestry workshops in Paris, began experimenting with dyes to produce a wide range of colored yarns. He discovered that when contrasting colors are placed close to each other (as in a weaving), the viewer sees a third color. Such an effect was later called optical mixing. Chevreul also noticed that after staring at a color, that color's opposite appeared to float close by. He called this color the psychological color, or afterglow; today it is known as the afterimage. By studying the afterglow's effects on nearby colors, he found that certain color pairs appeared more intense when used side by side. Chevreul named this effect simultaneous contrast and called the pairs with the strongest contrast

complements. He then designed a color circle featuring twelve major hues (Fig. B).

Next is American color scientist Ogden N. Rood (1831–1902), who used the era's newest optical instruments to study many issues about color, including the additive and subtractive properties of light, optical mixing, and the effect of light on pigments. Rood worked to correct misconceptions about color and color vision. From colorimetry measures he had taken of pigments used at the time, Rood designated ten major hues, as opposed to Chevreul's twelve, and plotted them on a wheel of his own design. He placed yellow at the top of his color circle because of its light value and proposed his own set of complementary colors: red/green-blue, orange/cyan-blue, yellow/ultramarine (blue-violet), green-yellow/violet, and green/purple. (To view an example of Rood's color wheel, go to www.colorsystem.com/projekte/Grafik/26roo/01roo.htm. Click on the image to make it larger.)

American artist Albert H. Munsell (1858–1918), the third theorist, was very influenced by the work of Rood. He created his own color system (Fig. C), in which colors are arranged according to three dimensions or attributes: **hue** (the dominant wavelength—red, green, yellow, and so on), **value** (lightness/darkness), and **chroma** (intensity or saturation). Munsell's three-dimensional color model is known as the Munsell tree (Fig. D). The "trunk" contains a value scale that ranges from white at the top, through gradations of gray, to black at the bottom. Colors are arranged horizontally in a circle around the trunk according to their hue. They are also arranged vertically according to their value.

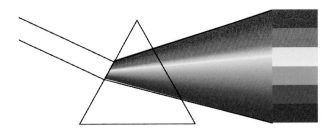

Fig. A. In 1666 Sir Isaac Newton discovered that white light, when passed through a prism, separates into the colored bands that make up the visible spectrum.

Fig. B. Chevreul used a color wheel with 60 color gradations, anchored on twelve major hues and starting with green at the top. In his model, the complementary pairs appear opposite each other on the color

wheel, and are as follows: green/ red, yellow-green/violet-red, yellow/violet, orange-yellow/blue-violet, and orange-red/green-blue. He designated red, yellow, and blue as the primary colors and orange, purple, and green as the secondary colors.

Courtesy of Bibliothèque Nationale, Paris.

Fig. C. In the Munsell tree, complements are across from each other horizontally. Mixing complements produces the gray that is found at that same level on the trunk.

Fig. D. Munsell's color system also has ten hues: five basic (red, yellow, green, blue, purple) and five intermediate (yellow-red, green-yellow, blue-green, purple-blue, red-purple). His complementaries are red/blue-green (cyan); yellow-red (orange)/blue; yellow/purple-blue (violet); green-yellow/purple; green/red-purple (magenta). The color names in parentheses indicate recent changes in response to new art media that use light, such as computer monitors and television screens.

Photo courtesy of GretagMacbeth.

Fig. E. The paintings of Van Gogh show Chevreul's color theories at work. The artist's use of complementary colors creates psychologically charged compositions that seem to vibrate with intensity.
Vincent van Gogh (1853–1890), *The Postman Roulin*, 1889.

Oil on canvas, Rijksmuseum Kroeller-Mueller, Otterlo, The Netherlands. ©Erich Lessing/Art Resource, NY.

Fig. F. Seurat combined the theories of Chevreul and Rood to develop his Pointillist painting technique.
Georges Seurat (1859–91), *The Channel of Gravelines, Petit Fort Philippe*, 1890.

Oil on canvas, 28 7/8" x 36 1/2" (73.3 x 92.7 cm). Indianapolis Museum of Art. Gift of Mrs. James W. Fesler in memory of Daniel W. and Elizabeth C. Marmon 45.195.

Color and Art Media

Just as the color of most objects is a mixture of wavelengths, so art media is a combination of different colored substances. A jar of red paint is probably mostly red but with small percentages of blue or yellow. Such a mixture will certainly affect how this "red" mixes to produce other colors.

In painting media, pigment is also combined with a vehicle, which makes the pigment spreadable. A filler may also be added. There are numerous combinations of pigments, vehicles, and fillers, all of which alter the actual color of the medium.

Artists try to control the color of their media by using only high-quality products. Some even make their own paint to get the purest mixtures. They look to Chevreul, Rood, Munsell, and other theorists for help creating extraordinary effects with color. They understand that color mixing must be both theoretical and practical—nothing substitutes for experimentation.

Understanding the following color-mixing systems will help in your own efforts to learn about and use color effectively in your artmaking. These systems will work with either the ten-step color wheel developed by Munsell (see Fig. D) or the adapted twelve-step model shown in Fig. G.

Categories of Art Media and Color Mixing

Art media may be grouped into three categories: additive; subtractive or subtractive/transparent; and subtractive/integrative or subtractive/opaque. Because colors react in unique ways when used in different media and on different surfaces, a special color-mixing system is needed for each category. More important, each category also has its own set of primary colors.

Additive Mixing

Effects: As light wavelengths are mixed together, the mixture becomes brighter and whiter. Such an effect occurs because more light is created as light wavelengths are added together; "white" light is the result. White is the presence of all colors in light. Black is the absence of all light.

Media: Light.

Primaries: Red, green, blue.

Examples: Light-emitting devices such as television and computer screens, as well as theater lighting and performance art.

Fig H.

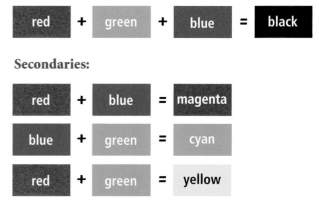

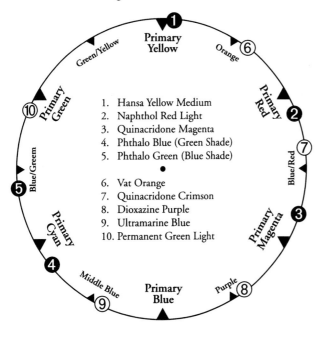

Fig. G.
Courtesy of Golden Artist Colors, Inc.

1. Hansa Yellow Medium
2. Naphthol Red Light
3. Quinacridone Magenta
4. Phthalo Blue (Green Shade)
5. Phthalo Green (Blue Shade)

6. Vat Orange
7. Quinacridone Crimson
8. Dioxazine Purple
9. Ultramarine Blue
10. Permanent Green Light

Subtractive Mixing

Mixing with pigmented transparent media.

Effects: As pigment colors are mixed together, the mixture becomes darker and duller. With each new pigment addition, more light is trapped in the medium and less is returned to the eye, thus producing a darkening of the color mixture. The result is black.

Media: Transparent paints, dyes, and so on.

Primaries: Magenta, cyan, yellow.

Examples: Watercolors, some markers, color photo processing, commercial printing, dyes, and so on.

Fig I.

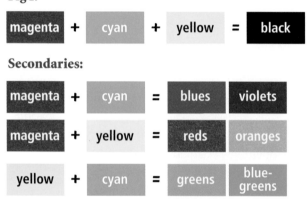

Secondaries:

Subtractive/Integrative Mixing

Mixing with opaque media.

Effects: As pigment colors are mixed together, the mixture becomes darker and duller. With each new pigment addition, more light is trapped in the medium and less light is returned to the eye, thus producing a darkening of the color mixture. The result is black.

Media: Opaque art materials.

Primaries: Magenta, cyan, yellow, red, green, blue.

Examples: Tempera, oil and acrylic paints, as well as pastels, chalks, crayons, and so on.

Exceptions: If an opaque material is thinned so that it becomes transparent, it may mix as either a subtractive-transparent or a subtractive-integrative medium. The result depends on the pigments used.

Fig J.

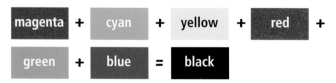

Secondaries: Orange, yellow-green, violet, and so on.

Optical and Medial Mixing

The following two mixing systems rely on the process used to mix the media rather than on the art media itself.

Optical Mixing

Color is mixed "in the eye" rather than on a surface such as paper, canvas, or a screen. Optical mixing requires two conditions:

- Small dots, dashes, or patches of different colors placed side by side on a surface.
- The viewer stands at a distance to "read" the effect of a solid color.

Effects: Because it combines properties of mixing light with those of mixing pigmented media, optical mixing creates a more luminous effect, however it tends to appear grayed out at a distance. When colors are mixed in the eye, all color rays are returned to the eye rather than absorbed by the pigment. The perceived mixture produces a brighter effect than if the pigments were mixed and placed on a surface. Moreover, if the colored dots or hatches are placed far apart, the white space between them also has the effect of lightening the color.

Examples: Commercial printing processes that use dots and lines (halftones and benday screens), color monitors (computer and television), Pointillism, Divisionism, and some Impressionist work.

Medial Mixing

Medial mixing is actually another form of optical mixing. Medial mixing occurs when colors are moving quickly, such as those on a spinning top or in a filmstrip. Medial mixing is halfway between additive and subtractive mixing. In a filmstrip, for example, images from one frame spin past, and that frame's afterimage imposes a color effect on the next frame. Because this effect occurs rapidly, the eye perceives a color mixture. Few visual artists have explored this type of color mixing. This type of color mixing is one with which artists may soon explore/experiment.

Matting and Framing Your Work

Matting and framing are important parts of the painting process. An attractive mat and frame not only protect a painting, they also enhance its beauty and appearance. Artists and collectors often have works professionally matted, framed, and sealed to help preserve them. Yet simpler and less expensive methods achieve similar results.

Matting a Painting

There are several ways to mat a painting. The method you choose depends upon the nature of your painting and the effect you wish to create.

A window mat has an opening cut into a mat board through which the artwork shows. In addition to the traditional rectangular shape, mats can also be round or oval. The edges of the window may be beveled (slanted) or straight. Window mats create the illusion of depth (especially when one is used under another) and give a painting crisp, clean edges.

A float mat is created by mounting, or floating, a painting on mat board, using glue or special linen tape. Watercolorists often prefer this method to highlight the feathery edges (called deckles) of watercolor paper. Although they are easier to make than window mats, float mats are not always appropriate. For example, glue or tape may show through a painting done on thin paper.

Choosing Size and Color

Select the size and color of your mat carefully. A mat that is too small crowds a picture; one that is too large overwhelms it. Many painters prefer white or off-white mats because the neutral colors do not draw attention away from the artwork. If you prefer a colored mat, echo a color used in the painting. A white inner mat, called a liner, can further accent the artwork.

Cutting a Window Mat

Matting is demanding work. Be precise and neat; a crooked or smudged mat will detract from your artwork. If you choose to cut your own mat, follow these steps.

Step 1 – Determine the size of the mat opening

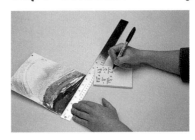

Measure your artwork. The mat opening should be slightly smaller so that the work doesn't fall through. A good rule is to make the opening ¼" smaller on each side, for a total of ½" smaller per dimension. For example, if the artwork measures 8 ¼" x 6 ½", the mat opening will be 7 ¾" x 6". Record the dimensions, then double-check your math.

Step 2 – Determine the overall mat size

A 2–3" border on each side of the opening usually works best. In Step 1, you calculated an opening that measures 7 ¾" x 6". To create a 2" border, add 4" to each dimension. Therefore, the mat size will be 11 ¾" x 10". Record the dimensions, then double-check your math.

Step 3 – Cut the mat

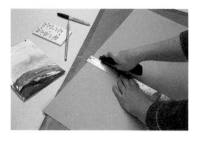

Cut the mat board, using either a paper cutter or a utility knife and metal ruler. If you use a knife and ruler, place a piece of scrap board under the mat to protect your cutting surface. Press the ruler firmly against the mat to prevent it from shifting and to produce a clean edge. This will also protect you from accidental cuts.

Step 4 – Cut the opening

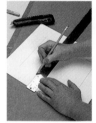

On the back of the mat, measure the width of the border (from Step 2) from the outside edge. Mark lightly with a pencil, repeating at several places on each side. Use a metal ruler to connect the lines and create guidelines for cutting the opening. Place the scrap board under your mat. Then lay the ruler along each pencil line and cut. Press firmly to prevent slipping and accidents.

Step 5 – Attach the art

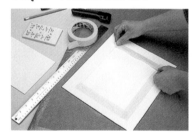

Center the image in the opening, securing it to the back of the mat with masking tape. Now you are ready to frame your work.

Safety Note Use X-acto knives with extreme care. Use a sharp blade; it does not require as much pressure when cutting.

Try It Before cutting your mat, experiment with cropping by placing strips of white paper over the painting's edges.

Framing a Painting

There are many types of frames, from unstained or painted wood to metal or synthetic materials. Think carefully about your painting and test a variety of framing options. Choose a frame that echoes or complements the artwork's style.

Of course, not every painting requires both a mat and a frame. You may decide just to mat a work or cover it with a protective sheet of acetate or plastic. However, keep in mind that a well-chosen frame often gives a finished, professional appearance to an artwork.

Framing Options

Inexpensive metal or wood frames are available in such sizes as 8"x 10" or 11" x 14". Easy-to-assemble metal frame kits are also available in many sizes and colors. Other economical options include simple glass-and-clip or plastic box frames. Some artists use thin strips of wood to cover the edges of a painting done on stretched canvas; such strips may be painted or stained before being nailed to the finished work. If you decide to have a painting professionally framed, be sure to first receive an estimate, as custom framing is expensive.

Displaying Your Work

Once your painting has been matted and framed, it is ready for display. Select an appropriate place to hang your work. An intricately detailed painting, for example, is best placed so that viewers can view it up-close. And remember that adequate lighting is essential.

Note It Avoid displaying a painting close to a heat source and keep works on paper out of direct sunlight. These cause paint to fade or discolor as well as certain surfaces to buckle or warp.

Where to Find More Information

These books, among many others, can help provide background about the art of painting, and show you examples of the work of the world's great artists. Your art department or school library may be able to provide copies for you to study and enjoy.

Arnason, H. Horvard, and Marla F. Prather. *History of Modern Art: Painting, Sculpture, Architecture, Photography*, 4th ed. New York: Harry N. Abrams, Inc., 1998.

Baigell, Matthew. *A Concise History of American Painting and Sculpture*. New York: HarperCollins, 1997.

Brommer, Gerald F. *Discovering Art History*, 3rd ed. Worcester, MA: Davis Publications, Inc., 1997.

Butler, Adam, Claire Van Cleave, Phaidon, and Susan Stirling. *The Art Book*. Harrisburg, PA: Phaidon Press, Inc., 1997.

Goldwater, Robert and Marco Treves, eds. *Artists on Art*. New York: Pantheon Books, 1974.

Hartt, Frederick and Rosenthal Abrams. *Art : A History of Painting, Sculpture, Architectures, Volume I and Volume II*, 4th ed. Upper Saddle River, NJ: Pearson Publications, 1998.

Heller, Nancy G. and Nancy Grubb, eds. *Women Artists*. New York: Abbeville Press, Inc., 1997.

Hobbs, Jack and Richard Salome. *The Visual Experience*, 2nd ed. Worcester, MA: Davis Publications, Inc., 1997.

Janson, H.W. and Anthony F. Janson. *The History of Art*, 6th ed. New York: Harry N. Abrams, Inc., 2001.

Janson, H.W. *History of Art for Young People*, 5th ed. New York: Harry N. Abrams, Inc., 1997.

Martin, Tim. *Essential Surrealists*. Bath, England: Parragon, 1999.

Phillips Lisa. *The American Century: Art and Culture, 1950–2000*. New York: W. W. Norton & Co., 1999.

Reichold, Klaus and Bernhard Graf. *Paintings that Changed the World: From Lascaux to Picasso*. New York: Prestel USA, 1998.

Remer, Abby. *Enduring Visions: Women's Artistic Heritage Around the World*. Worcester, MA: Davis Publications, Inc., 2001.

Remer, Abby. *Pioneering Spirits: The Life and Times of Remarkable Women Artists in Western History*. Worcester, MA: Davis Publications, Inc., 1997.

Strickland, Carol and John Boswell. *The Annotated Mona Lisa: A Crash Course in Art History from Prehistoric to Post-Modern*. Kansas City, MO: Andrews McMeel Publishing, 1992.

Tansey Richard G., et al. *Gardner's Art Through the Ages*, 11th ed. Florence, KY: Thomson Learning, 2001.

Welton, Jude. *Eyewitness Art: Looking at Paintings*. Minneapolis, MN: Econo-Clad Books, 1999.

These books provide information on techniques and subject matter. Some titles can help you to zero in on a specific topic, but most of the books touch on a variety of subjects.

Barron's Editorial Team. *Learning to Paint: Airbrush*. Hauppauge, NY: Barron's Educational Series, Inc., 1999.

Bowers, Michael, ed. *Painting in Oils*. Kent, England: Search Press, Ltd., 1991.

Brommer, Gerald F. *Collage Techniques*. New York: Watson-Guptill Publications, 1994.

Brommer, Gerald F. and Joseph Gatto. *Careers in Art: An Illustrated Guide*. Worcester, MA: Davis Publications, Inc., Inc., 1999.

Brommer, Gerald F. *Understanding Transparent Watercolor*. Worcester, MA: Davis Publications, Inc., Inc., 1993.

Brommer, Gerald F. *Watercolor and Collage Workshop*. New York: Watson-Guptill Publications, 1997.

Fullner, Norman. *Airbrush Painting: Art, Techniques, and Projects*. Worcester, MA: Davis Publications, Inc., Inc., 1983.

Gatto, Joseph A., Albert W. Porter, and Jack Selleck. *Exploring Visual Design*. Worcester, MA: Davis Publications, Inc., Inc., 2000.

Harrison, Hazel. *Acrylic School: A Practical Guide to Painting with Acrylic*. Pleasantville, NY: Reader's Digest Association, Inc., 1997.

Harrison, Hazel. *Pastel School: A Practical Guide to Painting with Pastels*. Pleasantville, NY: Reader's Digest Association, Inc., 1996.

Katchen, Carole. *Creative Painting with Pastel*. Cincinnati, OH: F & W Publications, Inc., 1997.

Le Clair, Charles. *The Art of Watercolor*. New York: Watson-Guptill Publications, Inc., 1994.

Leland, Nita. *Exploring Color*, Rev. ed. Cincinnati, OH: F & W Publications, Inc., 1998.

Monahan, Patricia, Wendy Clouse, and Patricia Seligman. *Art School: A Complete Painters Course*. London: Hamlyn, 2000.

Norling Ernest R. *Perspective Made Easy*. Mineola, NY: Dover Publications, Inc., 1999.

Rose, Ted. *Discovering Drawing*. Worcester, MA: Davis Publications, Inc., 2000.

Reid, Charles. *Painting Flowers in Watercolor with Charles Reid*. Cincinnati, OH: North Light Books, 2001.

Roukes, Nicholas. *Art Synectics*. Worcester, MA: Davis Publications, Inc., 1984.

Roukes, Nicholas. *Humor in Art, A Celebration of Visual Wit*. Worcester, MA: Davis Publications, Inc., 1997.

Glossary

A

abstract Describing an artwork based on an identifiable subject, but with few or no details, and whose visual elements are simplified or rearranged.

Abstract Art (Abstractionism) A style of art that shows objects as simple shapes and lines, often geometrical, with emphasis on design. There is little or no attempt to represent forms or subject matter realistically.

Abstract Expressionism An art movement of many different nonobjective painting styles, in which individual feelings and emotions are emphasized rather than design or formal qualities.

accent color A small amount of contrasting color used against another color; for example, orange accent in a predominantly blue area.

achromatic (ak-ruh-mat-ik) Without color. (White, black, and gray are achromatic.)

Action Painting *See* Abstract Expressionism.

adjacent colors *See* analogous colors.

aesthetic (es-thet-ik) Pertaining to the beautiful, refined, tasteful, and artistic.

aesthetics (es-thet-iks) The study of beauty, art, and taste.

airbrush A small precise spray gun attached to an air compressor used to create a smooth application of paint or gradations in value and color. Also called an airgun.

alkyd paints (al-kid) Artists' paints, similar to oils but with a faster drying time.

alla prima A painting technique in which the artist completes a work in one session, mixing and blending directly into the wet underglazes.

analogous (an-al-uh-gus) Colors that are closely related, such as blue, blue-green, and green; three or four colors that are adjacent (touching) on the color wheel.

apex The highest point or summit. In a painting, the topmost part of the subject being shown.

aquarelle (ah-cwah-rel) The French word for transparent watercolor.

Art Nouveau (art new-voh) A busy, decorative style of art, popular in Europe and America from the 1880s to the 1930s. This style is usually characterized by flowing lines, flat shapes, and vines and flowers.

assemblage A piece of art made from parts of objects or materials that were made to be used for some other purpose.

asymmetrical balance The organization of the parts of a composition so that each side of a vertical axis contains similar, but not identical, shapes or forms. Also called informal balance.

atmospheric perspective A method of creating the illusion of distance by representing objects farther away, with less clarity of contour, and in diminished color. Also called aerial perspective.

avant garde (ah-vahnt-guard) A term used to describe art that seems to be ahead of its time, unusual, and experimental.

B

background The area farthest away in a landscape, or the area around the subject matter in a painting.

backlight Light coming from behind a subject.

balance A principle of design referring to the arrangement of visual elements to create stability in an artwork. There are three kinds of balance: symmetrical, asymmetrical, and radial.

Baroque (bar-oak) A period and style of European art (seventeenth century) which emphasized color and light. The work was generally large, filled with movement, swirling lines, and emotion.

bichromatic (bye-crow-mat-ik) A term describing a painting created with just two colors.

binder An adhesive used to hold particles of pigment together in paint, and to hold color to the ground.

biomorphic shapes (bye-oh-more-fik) A term applied to shapes that resemble the curves of plant and animal life.

bleed Paint or ink that runs into an adjoining area, or up through coats of paint. Usually undesirable. Also refers to fuzzy edges in a painting.

blocking in Placing the major elements of a painting with simple tone, color, and line.

botanical Related to nature and plants.

brayer A hand roller used to apply color in printmaking or painting.

bright A short, flat brush with a long handle, used mainly for oil, acrylic, and alkyd painting.

broken color Two or more colors placed in a painting so that they seem to create a third color, without actually being mixed on the palette.

brush painting Classic Asian brush painting, which uses traditional visible brushstrokes made with a bamboo brush.

C

calligraphy (cuh-lig-raf-fee) The art of fine handwriting.

canvas A fabric (cotton, linen, jute, etc.) prepared as a surface for painting in oil or acrylics.

cartoon A full-size plan of the intended image and the colors to be used.

center of interest The area of an artwork toward which the eye is directed; the visual focal point of the work.

charge the brush A term used in watercolor painting, meaning to fill the brush with color.

chiaroscuro (key-ah-ross-kyoo-roh) Strong contrast of dark and light values in a painting. A technique for modeling forms in painting, by which the lighted parts seem to stand out from dark areas.

chroma (krow-mah) The intensity, strength, or saturation of color. A color's brightness or dullness.

cityscape A painting that uses elements of the city (buildings, streets, shops, etc.) as subject matter.

closure The ability of the mind to complete a pattern or picture where only suggestion is shown.

collage An art form that consists of pasting or gluing paper or other materials to a surface.

color An element of design with three properties: hue, value, and intensity. Also the character of surfaces created by the response of vision to wavelengths of reflected light.

color contrast The effect of surrounding colors or values upon a color.

Color Field Painting An art movement in which artworks are made of large, flat areas (fields) of color with distinct edges.

color scheme The choice or combination of colors used in a painting, such as monochromatic, analogous, complementary, or mixed.

color triad Three colors spaced equally apart on the color wheel, such as orange, green, and violet.

color wheel Colors arranged in a circle in the order of the spectrum.

colorist A painter known for his or her mastery of color.

commission A contract, or order, for an artwork.

communication A way of telling others about our thoughts, opinions, reactions, and feelings. In art, a way of using visual images to send messages.

complementary colors Two colors that are directly opposite each other on the color wheel, meaning they are in extreme contrast with each other.

contour The outer limit of a figure, form, or object.

contour drawing An artwork that shows just the outline of objects.

contrast A principle of design that refers to differences in values, colors, textures, and other elements to create emphasis and interest.

cool colors Colors in which green, blue, and violet predominate.

cropping Cutting a picture down or trimming its size.

Cubism A painting style in which the subject is broken apart and reassembled to the artist's own design, usually in some geometric pattern.

curvilinear Having curved lines.

D

damping the paper In watercolor, putting water on paper with a brush or sponge before painting.

deckle edge The decorative, ragged edge on some papers.

designer's colors Gouache. A very fine quality of opaque watercolor.

doodle To draw or scribble with little or no conscious thought about the result.

drier A material added to oil paints to accelerate the drying process.

drizzle To drip paint or let it run into a pattern.

dry brush In watercolor painting, a technique in which very little color or water is on the brush, creating a "skipped" effect.

dry brush painting A technique in which moist paint, just wet enough to stroke smoothly with a brush, is applied to a dry surface with a dry brush.

E

earth colors Pigments made from natural minerals: colors such as yellow ochre, burnt sienna, and the umbers.

easel A free-standing structure used to hold a canvas or drawing board while the artist is painting.

edges, hard Sharp lines and forms that do not blend into nearby areas.

edges, soft Blurred areas that blend into nearby areas without a definite line.

egg tempera A mixture of water, powdered pigment, and egg yolk.

elements of design Line, shape, form, space, color, value, and texture; considered the building blocks of art.

emotional color Color used for its emotional effect rather than for realism.

emphasis A principle of design by which the artist may use different sizes, shapes, contrasting colors, or other means to place greater attention on certain areas, objects, or feelings in a painting.

Expressionism Any style of painting in which the artist tries to communicate strong personal and emotional feelings. This style of art began in Germany early in the twentieth century.

extender A substance added to pigment in order to increase its bulk or reduce its color intensity.

F

fan brush A bristle, sable, or synthetic brush made in the shape of a fan. Used to blend colors or to create texture.

Fauvism A style of painting in which the artist communicates emotion through a bright and intense use of color. Started in France early in the twentieth century.

feather To blend an edge so that it fades off or softens.

ferrule The metal part of a brush that holds the hairs or bristles.

figurative Representational painting. A painting showing a human figure that is more real than abstract.

filbert A flat brush with an oval-shaped point.

fitch A long, flat lettering brush with a chiseled edge.

fixative A substance sprayed over charcoal or pastel drawings and paintings to make the pigments stay on the paper.

flat A term describing the finish of a painting as lusterless. Also, applying paint without variations in value or color, and no brushmarks showing. Also, a brush with oblong hairs and a long handle.

focal point The center of interest in a painting.

foreground The area in a painting that seems to be closest to the viewer.

foreshorten To shorten forms in a painting as they move back from the foreground so that their proportions appear natural to the viewer.

form An element of design that appears three-dimensional and encloses volume.

formal balance A composition balanced equally on both sides of the center. Also called symmetrical balance.

found papers Papers not originally intended for artwork and not changed before using.

free-form Irregular in shape; not geometric.

fresco A method of painting in which pigments suspended in lime water are applied to a thin layer of wet plaster so that the plaster absorbs the color and the painting becomes part of the wall.

frisket A transparent paper or plastic material, with adhesive backing, used as a stencil or to protect parts of paintings from washes or airbrush treatment.

G

gel A colorless medium that adds gloss and substance to paint.

genre painting (jhahn-ruh) A type of painting that portrays a phase of everyday life.

geometric abstraction The use of geometric shapes (lines, squares, triangles, rectangles, circles) to design a composition.

geometric shape A shape, such as a triangle or rectangle, that can be defined precisely by mathematical coordinates and measurements.

gesso (jess-oh) A mixture of finely ground plaster and glue that is often spread on a surface prior to painting.

gesture drawing An artwork done quickly and with little detail so as to capture action.

glaze A transparent (can be seen through) layer of paint, applied over a dry area, allowing the underpainting to show through.

gloss medium An acrylic medium that is used to increase the gloss in pigments; can be used as a final varnish.

ground The surface on which a painting is done. Also, a coating of paint or gesso applied to a panel or canvas before the painting is made.

gum arabic A natural gum material from the acacia tree, used as a binder in making transparent watercolor paints.

H

hard-edge painting *See* edges, hard.

hatching Lines drawn side by side to create texture and value. When the lines cross each other, hatching becomes cross hatching.

high-key painting A work painted using the lighter end of the value scale, making a pale picture.

highlight A spot of the highest or lightest value on a subject in a painting.

high surface A very smooth surface on paper.

horizon line An imaginary line that runs across a painting from left to right, and shows the place where sky and earth come together.

hue The name of a color, determined by its position in the spectrum.

I

illuminated manuscript A manuscript, or book, usually a religious text, in which sheets of paper or animal skin are decorated with drawings or paintings.

illumination The art of illustrating manuscripts with fanciful letters, pictures, and designs.

illusionism *See* trompe l'oeil.

impasto A thick, heavy application of paint, applied with either a brush or knife, that stands out from the surface.

implied line A suggested line—one that was not actually drawn or incorporated—in a work of art.

implied texture The perceived surface quality in an artwork.

Impressionism A style of painting begun in France about 1875. Impressionist works give a quick, true glimpse of the subject, and often show the momentary effects of light on color.

informal balance The arrangement of elements in a painting without using bilateral symmetry. Also called asymmetrical balance.

ink stone A flat stone used for grinding a Japanese sumi-e ink stick. The stone is usually flat with a well to hold water.

intensity The strength, brightness or purity of a color; its chroma.

intermediate colors Colors made by mixing neighboring primary and secondary colors on the color wheel; for example, mixing red and orange to get red-orange.

J

juicy Describes paint that is thick, succulent, and workable. Might also describe the quality of a painted surface.

juxtaposition In painting, the close placement of colors or forms; side by side.

K

key The dominant tone or value of a painting: high (light), medium, or low (dark).

kid finish Term used to describe a medium textured paper. Also called vellum.

L

landscape A painting that emphasizes the features of the natural environment (trees, lakes, mountains, etc.).

lay in To apply paint, pastel, or other medium roughly to a ground; the first steps of painting.

lift In watercolor, a term for taking out unwanted pigment using dry brush, sponge, tissue, etc.

light source The place that light appears to be coming from in the painting, as shown by cast shadows and highlights.

line An element of art which is used to define space, contours and outlines, or to suggest mass and volume. It may be a continuous mark made on a surface with a pointed tool or implied by the edges of shapes and forms.

line of sight In linear perspective, the line that reaches from the viewer's eyes to the picture plane, and perpendicular to the picture plane.

linear Having to do with lines. A painting that contains much line work is said to be linear.

linear perspective System in which parallel lines recede toward a common vanishing point, creating the illusion of three-dimensional space on a two-dimensional surface.

liquid mask A liquid frisket (stencil) used to block out areas in watermedia paintings; can be removed by rubbing with fingers.

local color The color of an object seen in white (natural) light, without reflected colors and shadows.

lost and found A painting quality in which lines and edges fade or blend into others, and then reappear.

low-key painting A work painted using the darker part of the value scale; likely to be subdued and moody.

luminosity Brightness.

M

manila paper A buff-colored paper used for sketches. Very rough manila paper is called oatmeal paper.

mannequin A small, jointed model of the human figure.

Mannerism A style of European painting in the late sixteenth century that usually showed emotional distortion and harsh coloring.

masking tape A paper adhesive, pressure-sensitive tape that sticks tighter than drafting tape, but can be removed without damaging artwork.

Masonite A trade name for a building material made from pressed wood, used as a painting surface or a mounting board.

mat board Heavy paper or cardboard used to frame paintings, usually those which are placed under glass.

matte A dull, lusterless finish. (Might also be spelled mat or matt.)

matte medium An acrylic medium used to reduce gloss. Can also be used as a final matte finish.

medium Liquid used to thin paints. Also, material used to make paintings, such as oil, watercolor, acrylic, etc.

middleground The middle area in a painting, between the foreground and the background.

middle-key painting A work painted using the middle values on a value scale (as opposed to high-key and low-key).

miniature A small painting executed with great detail; a small portrait, picture, or decorative letter on an illuminated manuscript.

mixed media An artwork made with more than one art medium.

modular colors A line of acrylic colors already mixed to different values.

monochromatic (mah-no-crow-mat-ic) A color scheme that uses only one hue and its tints or shades.

montage A picture made by mounting other pictures, photos, and the like onto a flat surface.

motif The main idea or theme in a painting. Also, a repeated design or pattern.

movement A principle of design referring to the arrangement of parts in a work of art to create a slow-to-fast movement of one's eye through the work.

multicolor Having many colors; polychromatic.

mural A wall or ceiling painting, painted directly on the surface or permanently fixed in place.

N

narrative art Art that tells or suggests a story.

naturalism Realism in painting, not influenced by distortion, personal feelings, or romanticism. How things actually look.

negative space The space in a painting not occupied by subject matter, but still used as part of the overall design.

Neoclassical A style of art (mainly in eighteenth-century Europe) influenced by classical Greek and Roman art.

neutral In pigments, refers to beige, tan, putty, etc.

non-figurative Without figures. Sometimes referred to as nonrepresentational.

nonobjective art Art that has no recognizable subject matter. Also called non-representational art.

noodling Drawing or painting intricate details; applying intricate calligraphy in a painting.

O

oak tag A tough paper used for stencils and mounting.

oatmeal paper *See* manila paper.

objective In painting, showing the subject as it appears. Representational.

oblique Diagonal.

oil pastels Oil colors in stick form which do not require fixative.

one-point perspective Perspective in drawing or painting that has only one vanishing point.

opaque Opposite of transparent; not allowing light to pass through.

Op Art An art movement in which works rely on various devices to trick the eye into "seeing" movement, vibration, or illusions of depth.

organic line An uncontrolled line in a drawing or painting that flows and does not outline objects.

organic shape A shape that is free-form or irregular; the opposite of geometric shape.

overlapping planes A perspective technique—the artist places one object in front of another, creating the illusion of depth.

overpainting Color applied on top of an undercoat.

P

painterly Describes a painting in which the brushstrokes are evident and important; appears free in style or technique.

palette (pal-ett) The surface on which paint is kept or mixed during painting. Also the colors with which an artist chooses to work.

palette cup A small cup, clipped to the palette, which is used to hold turpentine, thinner, or medium.

palette knife A type of knife used to mix color on the palette; also used to clean off a palette.

panel In painting, a flat piece of wood, Masonite, or other hard board used instead of a stretched canvas.

patina (pah-tee-nah) The thin surface covering caused by oxidation on old objects. The color effect can be imitated in painting by overglazing.

patron A customer; in the art world, someone who pays an artist to create artwork.

pattern A principle of design in which there is a repetition of elements or combination of elements in a recognizable organization.

perspective A way to show three-dimensional forms on a two-dimensional surface.

Photo-Realism An art movement in which artists create paintings that are so realistic in detail that they look like photographs.

pictograph Picture writing that expresses an idea with picture symbols.

picture plane The imaginary plane, like a sheet of glass, at right angles to the viewer's line of vision, on which the image is positioned. It is not the actual surface of the canvas or paper.

pigment A dry, powdered coloring agent used in the manufacture of paints.

Pointillism A style of nineteenth-century French painting in which colors are applied to canvas in small dots, producing a vibrant surface.

polychrome Several colors, rather than one (monochrome).

Pop Art A style of art in the 1950s that used popular, mass-media symbols and products (Coke, Brillo, etc.) as subject matter.

pop colors Bright chrome colors; high-intensity colors.

portfolio A portable case for carrying artwork. Also, the selection of artwork which an artist shows to clients.

portrait A painting of a person, usually three-quarter or full length, but also can be a bust (shoulders and head only).

portraiture The art of making portraits.

positive space The area containing the principal subject matter in a composition.

Post-Impressionism A style of art (late nineteenth-century French) that immediately followed Impressionism. It stressed substantial subjects and a conscious effort to design the painting surface.

Post Modern Art A style of art in the 1980s which featured things of our visible world. A revival of objective painting.

primary color Within a color mixing system, a color that cannot be made by mixing other colors in that same system, but can be used to make other colors in the system.

prime To prepare a canvas or panel for painting by giving it a coat of a glue-like paint, such as gesso.

primer The glue or size (such as gesso) used to prepare a painting surface.

primitive art Paintings produced by an artist who has not had professional training. Also, the art of native cultures such as African, Inuit, or American Indian.

principles of design Unity, variety, balance, contrast, emphasis, pattern, proportion, and movement and rhythm; form the guidelines that artists follow when they combine the various elements of design.

proportion A principle of design in which there is a comparative size relationship among several objects or between several parts of a single object or person.

Q

quire Twenty-five sheets of paper.

R

radial balance Composition based on a circle, with the elements coming from a central point.

rag Paper made only from cloth fragments.

raw color Color straight from the tube.

realism Painting things just the way they are.

receding colors Cool colors (blue, green, and violet) which seem to move back in a painting. Warm colors move forward.

rectilinear Made of straight lines.

Renaissance A period of art in Europe (1400–1600) during which cultural awareness and learning were reborn. An emphasis was placed on humanism and science, and on classic design.

render To make a detailed and accurate drawing. Also, to draw or paint a given subject.

representational art Art in which the artist wishes to show what he or she sees. Also called objective art.

reproduction A copy of an original work of art, made by someone other than the artist, usually by mechanical processes.

resist A painting technique that relies on the fact that wax or oil will resist water, causing watermedia to puddle in clean areas.

rhythm A principle of design that refers to ways of combining elements to produce the appearance of movement in an artwork. Rhythm may be achieved through repetition, alternation, or progression of an element.

rice papers Japanese handmade papers of different textures, sizes, weights, and colors. Used for printmaking, watercolor, and collage.

rigger A long, pointed brush used to paint fine lines and details.

Rococo A style of art (1700s) which featured decorative and elegant themes and styles.

Romanticism A style of painting (mid-nineteenth century) that featured adventure, action, imagination, and an interest in exotic places and people.

rough A quick, incomplete sketch used to explore ideas.

round A pointed brush (sable, synthetic, hair, or bristle).

S

sabeline brush A dyed ox-hair brush used as an inexpensive substitute for sable.

sable brush A brush made of kolin sky, a Siberian mink. The brush is expensive, has good "spring," and comes to a fine point.

saturation The measure of the brilliance and purity of a color. Also called intensity or chroma.

scale The relative size of a figure or object, compared to others of its kind, its environment, or humans.

scrubbing Applying paint with a brush in a scrubbing motion.

scruffing Roughing up a surface area in a painting. Dry brushing color over a rough surface, allowing the underpainting to show.

scumbling To place an opaque color over another color and then remove some of the opaque color using a stiff brush or rag, thus revealing the first layer of color and adding texture to the surface.

seascape A painting that features some part of the sea as the subject.

secondary color Within a color system, a hue that can be made by mixing two primaries in equal amounts.

self-portrait Any work of art in which an artist portrays himself or herself.

shade Specifically, a color mixed with black; however, used broadly to designate a color that is dark in value but may still have a strong chroma.

shape An element of design that is two-dimensional and encloses area.

shaped canvas A painting technique in which the canvas (surface) is not flat, but has objects placed behind it to produce a relief surface.

sighting A way of seeing and mentally measuring the things to be drawn or painted without using mechanical means.

silhouette A flat shape in profile, usually of one value.

simultaneous representation Showing a thing or person in more than one view—from several eye levels—at the same time.

size A gel used to seal the surfaces of papers, panels, or canvas. Also called sizing.

Social Realism A twentieth-century art movement, dealing with social, political, and economic subjects.

solvent A liquid used to thin paint to a spreadable consistency.

space An element of design that indicates areas in a painting (positive and negative). Also, the feeling of depth in a two-dimensional work of art.

spectrum Bands of colored light created when white light is passed through a prism. Also, the full range of colors.

split complement A color harmony using three colors: one color and the two colors on each side of its complement.

stain Painting technique in which an applied liquid dye or tint penetrates the surface of a canvas and imparts a rich color.

stencil Any material that masks certain areas and allows color to be applied to the open areas.

stipple A texture made of tiny dots. Also, the act of making such a texture.

stomp A pencil-shaped stick of tightly rolled paper that is used to blend pastels. Also called a torchon.

stretched canvas Canvas that is fastened to stretcher bars (strips) and ready to prepare for painting.

study A drawing or painting of a section or of a whole composition, usually more detailed than a sketch.

style Refers to the distinctive and consistent similarities in a group of artworks, either those of an individual artist, group of artists, or those from a particular place or time period.

stylize To modify natural forms and make a representation in a certain predetermined manner or style.

subjective color The color the artist chooses to use without regard to the actual color of the objects being painted.

sumi-e Japanese brush painting with ink or watercolor.

Superrealism A style of painting that emphasizes photographic realism. Often the paintings are much larger in scale than the original subjects.

support The foundation on which a painting is made (canvas, paper, panel, etc.).

Surrealism A style of twentieth-century art in which artists combine normally unrelated objects and situations. Scenes are often dreamlike or set in unnatural surroundings.

symmetrical balance The organization of the parts of a composition so that each side of a vertical axis mirrors the other. Also called formal balance.

T

tabouret (tab-oh-ray) A stand to hold an artist's palette, paints, and brushes.

tactile Having to do with the sense of touch.

temperature In painting, refers to the relative "warmth" or "coolness" of colors.

tension In composition, the visual sensation of strain or pull; the dynamic relationship between any of the visual elements.

tertiary colors (tersh-uh-ree) Intermediate colors made by mixing a primary (red, yellow, or blue) and a neighboring secondary color (such as red-orange). Originally, tertiary colors were those created by mixing two secondary colors (green with orange, for example).

tetrads Color harmonies based on four colors—every fourth color on a 16-unit color wheel. For example, one tetrad contains red-orange, violet, blue-green, and yellow.

texture The element of design that refers to the quality of a surface, both tactile and visual.

thin A term describing oil paint diluted with turpentine rather than with medium.

thumbnail A very small, rough sketch.

tight The quality of a painting that is exact, carefully detailed, and usually made with small brushes.

tint Specifically, a color mixed with white; however used broadly to designate a color that is light in value and low in chroma.

tondo A painting done in circular form.

tone Modifying a color by adding neutrals to it. Also, the relative lightness or darkness in a painting.

toned ground A thin glaze or wash put over a painting surface prior to painting.

tooth The texture of paper, canvas, or other ground.

translucent Allowing light to pass through, but not transparent (a quality of paper, for example).

transparent Able to be seen through.

triad *See* color triad.

triptych (trip-tik) A painting made on three separate surfaces.

trompe l'oeil (tromp loy) A painting rendered so realistically that it can fool the viewer into thinking the subjects are real rather than painted. Translates from the French as "fool the eye." Also called illusionism.

two-dimensional Flat. Having only two dimensions: height and width.

two-point perspective The type of perspective in which objects are at an angle to the viewer, and will each have two vanishing points. Also called angular perspective.

U

underpainting The first paint applied to a painting surface, to be overpainted with other colors or glazes.

undertint A transparent undercoat over a white ground. *See* toned ground.

unity The sense of oneness or wholeness in a work of art.

unprimed canvas Raw canvas that has no primer on it.

unsized Refers to paper without any sizing or filler.

V

value An element of design that relates to the lightness and darkness of a color or tone.

value contrast Dark and light values placed close together. Black in proximity to white creates the greatest value contrast.

value scale The range from light to dark, including white, grays, and black. Colors can also be evaluated on this scale. Value scales are usually constructed so that black = 0, and white = 10. Some scales, however, reverse these numerical designations.

vanishing point In perspective, a point or points on the horizon at which parallel lines seem to converge.

vantage point The position or standpoint from which to observe a subject.

variety A principle of design concerned with the inclusion of differences in the elements of a composition to offset unity and make the work more interesting.

vehicle The collective name for the binder and solvent.

vellum *See* kid finish.

viewfinder A small cardboard frame used to isolate or frame a scene. It helps to locate a desired composition. Also called a finder.

vignette (vin-yet) A painting with an irregular outer shape, placed on a conventional, rectangular ground, leaving negative space around it.

viscosity (viss-caws-i-tee) The degree of thickness in paint.

W

warm colors Colors in which red, orange, and yellow predominate.

wash A thin, liquid application of paint. A graded wash varies in color or value from dark to light, or light to dark. When applied over dry underpainting, a wash is often called a glaze.

wash out To remove a painted area of a painting by applying water and washing out the color as much as possible with spray, brush, or sponge.

watermedia Any paint which uses water as its medium.

wet-into-wet Painting additional color into a wet area, creating a soft effect; usually refers to watermedia techniques.

wetting agent A substance that improves the flow of paint on a surface.

worm's-eye view A painting with a very low eye level, with the horizon at the bottom of the picture or below it. Looking up at the world.

Y

yamato-e A traditional Japanese painting style.

Index